S0-BOK-336

EVERY LITTLE STEP

EVERY LITTLE STEP

MY STORY

BOBBY BROWN

WITH NICK CHILES

DEY ST.
AN IMPRINT OF
WILLIAM MORROW *PUBLISHERS*

HarperCollins
PUBLISHERS
Since 1817

The names and identifying characteristics of some of the individuals featured throughout this book have been changed to protect their privacy.

EVERY LITTLE STEP. Copyright © 2016 by Bobby Brown. All rights reserved. Printed in the United States of America. No part of this book may be used or reproduced in any manner whatsoever without written permission except in the case of brief quotations embodied in critical articles and reviews. For information, address HarperCollins Publishers, 195 Broadway, New York, NY 10007.

HarperCollins books may be purchased for educational, business, or sales promotional use. For information, please email the Special Markets Department at SPsales@harpercollins.com.

A hardcover edition of this book was published in 2016 by Dey Street Books, an imprint of William Morrow Publishers.

FIRST DEY STREET BOOKS PAPERBACK EDITION PUBLISHED 2017.

Designed by Ashley Tucker

Library of Congress Cataloging-in-Publication Data has been applied for.

ISBN 978-0-06-244258-1

17 18 19 20 21 RRD 10 9 8 7 6 5 4 3 2 1

This book is dedicated to the little boy in the tree.

"Live fully, create happiness, speak kindly,
hug daily, smile often, hope more, laugh freely,
speak truth, inspire change, and love deeply."

To my mom and dad; brothers, sisters, nieces, nephews,
aunts, uncles, my friends, and most importantly my
children; and my lovely, beautiful wife, Alicia; thank you
for your support through all the years.

This is only the beginning.

—BOBBY BARISFORD BROWN

CONTENTS

INTRODUCTION

I've lived nearly all of my life under the glare of the public spotlight.

I became famous with New Edition when I was just fourteen.

As a solo artist, I released an album before my twentieth birthday that many have noted as altering the course of R & B music, stamping the term "new jack swing" onto the public consciousness. I was just the second teenager in history—after Stevie Wonder—to hit the top spot on the *Billboard* chart.

In my twenties, I fell in love with the biggest music star on the planet. Our marriage kept more than a few gossip tabloids in business. Watching the hell couples like Jay Z and Beyoncé are put through these days, I can't even imagine what it would have been like being married to Whitney Houston in the age of Twitter and Instagram.

Whitney's death was devastating not only to me but to

the entire nation. And I still am trying to grapple with the incredible pain and trauma of losing my daughter Bobbi Kristina.

But despite my three decades in the harsh media glare, the public has never really heard my story. What Bobby Brown is thinking, what he's doing, what he did do, what he didn't do—for the most part what has been said about me has been speculation from people who didn't know what they were talking about. It's usually been wrong—and usually intended to make me look bad.

To some degree, I understand. That's how public images work. They slap a label on you and that's who you are—the facts be damned. Early on, I cemented my reputation as the "bad boy of R & B." And it stuck. For the most part, I embraced it—for thirty years. It was fun—when I was young and foolish. But now that label feels too one-dimensional. Too much has happened and enough time has passed. I feel like I owe it to myself and the ones I love and will always love to be honest. I finally think it's time for me to show the world who I really am. I want to tell the real story.

BECOMING BOBBY BROWN

MY (MUSICAL) ROOTS

When I stretch my mind back to my earliest memories, music was always there. While other little kids in Boston dreamed about playing for the Red Sox or the Celtics, I dreamed about stepping onto a stage and thrilling the crowd with my singing and dancing.

Music was constantly playing in my house, with everybody throwing their own sound into the mix. With six children and my mother and father, we're talking about a lot of sound. Whenever my dad, Herbert, came home from work, he would put on some blues, or maybe funk. Then he would start dancing and acting crazy. We would be laughing so hard our stomachs would hurt. My late father is still the funniest man I've ever met. Not Eddie Murphy or Martin Lawrence. Not Kevin Hart. *Herbert Brown*. And my mother actually sang in a duo with her brother Robert—whom I was

named after—when they were younger, so she had perform-
ing in her blood.

But I think the biggest musical influence on me was my
grandmother, my mother's mom. She had an apartment on
the first floor in the Orchard Park projects; we lived right
above her on the second floor. My grandmother had a mas-
sive record collection. I knew her apartment was a place I
could go and lose myself in music. It became my sanctuary,
where I could get away from the noise and craziness of my
large family and go exploring in her records.

My grandmother loved Duke Ellington, so that's where I
would usually start. I didn't mind the big-band jazz because
I could jitterbug to it. I liked all types of music though; I'd
play the Chi-Lites, the Manhattans, Blue Magic. This was the
mid-to-late seventies (I was born in February 1969), so these
groups were still in their heyday, before disco hurt their pop-
ularity. From there, I would gradually move into the funkier
stuff. My God, funk was everything to me. James Brown,
Bootsy Collins, Parliament, Rick James—damn, I'd lose my
mind. I had no idea how influential Rick James would later
become in my life.

When I put on the funk, I'd start the dancing, working
out the routines I was always putting together. My grand-
mother would be watching me from the kitchen, where she
was cooking, and she'd have a big smile on her face as she
watched me move. I'd be getting down and she'd be getting
a big kick out of it. For me, the best thing about dancing

was making her smile, making her laugh, knowing she was enjoying what I was doing. Looking back on this time now, pleasing my grandma was probably where I got this drive to do whatever I can to please my fans. My grandmother was my first fan.

Eventually my badass brother, Tommy, would come into the apartment. He would get mad that my grandmother was paying me way more attention than him—so he'd have to fuck up everything. He'd pick up a big stack of records and throw them all over the floor—then he'd call out to my grandmother in the kitchen, pointing at me and saying, "Ooh, look what Bobby did!"

He was nine years older and a lot bigger than me, so I had to take his mess. But I'd get so mad. I knew it would all stop when I grew up to be as big as him. I would stand there all mad, thinking, *You just wait a few years . . .*

Everybody in my family thought they could sing. If you asked us, we'd tell you we were the second coming of the Jacksons. That was actually my father's master plan, to make us into a Boston version of the famous family group. The Browns of Boston. Since we were four girls and two boys, the Browns would have looked quite a bit different than the Jackson 5. And my brother was too shy to sing in public, so he was the DJ. But the girls? You couldn't tell them *nothing*. Not a thing. But although my family members played around with singing and performing, I was the only one who was adamant: *This is what I want to do with my life.*

My parents tried to encourage my musical talent by buying me a couple of cheap instruments. First my mother bought me some drums when I was in the third grade. They were cheap as hell, with skins made out of material not much more durable than typing paper. My little sister, Carol, made sure those drums didn't last more than a week or so. One day I came home from school and saw that she had beat them up, putting big holes in the snare, the bass and the tom-toms. Yeah, they were cheap, but they were still mine. So of course I had to beat *her* up.

A year or so later my mother bought me a bass guitar. She knew I had always loved listening to the bass, the smooth rumbling coasting along at the bottom of those records I enjoyed listening to. I played around with that cheap bass for many hours, tinkering in my room with those strings. But I never got any lessons to go along with it, so eventually I laid it down—and didn't pick it back up until several years later, when I got lessons on a New Edition tour from one of the funkiest bass players who ever lived, Mr. Rick James.

Hitting the Stage

My parents were huge fans of James Brown, as most of the black community was in the early 1970s. James was filling black people with a sense of pride with memorable records like "Say It Loud, 'I'm Black and I'm Proud,'" which came out in 1968, the year before I was born. Though I don't re-

member, my parents say I really responded to James Brown's music even when I was a baby. And when I was three, James unknowingly gave me my first chance to take over a stage. My parents brought me along when they went to a James Brown concert in 1972 at a well-known club called the Sugar Shack on Boylston Street. The Sugar Shack hosted all of the top R & B acts in the 1960s and '70s when they came through Boston. At a certain point during his show back then, James would welcome kids on the stage to dance and entertain the crowd. Apparently that was all the invitation my three-year-old self needed. I'm told that I immediately grabbed the attention of the crowd and had them screaming with my James Brown–like dance moves. It would be a telling baptism for me as a performer—for the next four decades, grabbing the crowd would become as important to me as breathing.

It's fascinating for me to watch my son Cassius do the same thing when I bring him out on the stage now. The boy loves to perform, and it's clear he has inherited my all-consuming desire to please the crowd. It's deep in his blood. When I take him with me to a Bobby Brown or a New Edition show, I sometimes bring him out to dance with me to "My Prerogative." The boy swears he's the reincarnation of Michael Jackson; he even told me that one day. He devours Michael's music, requesting that we play songs from different Michael periods—Jackson 5 Michael, *Off the Wall* Michael, older Michael. Sometimes he'll call me into the living room and make me sit down.

"Daddy, watch this new move," he'll say.

Then he'll spin, kick out his leg, and launch into some intricate Michael steps. The whole family will be cracking up, but I'll also be thinking: *Damn, I did the same exact thing when I was his age*—except it wasn't Michael Jackson I was mimicking, it was James Brown. Cassius gets it honestly; his mother, my wife, Alicia, was also a dancer when she was younger. In fact, Alicia starred in one of the most influential videos of the nineties—she was the bikini-clad saxophone player who was the centerpiece of Teddy Riley's "Rump Shaker" video with his group Wreckx-N-Effect. I'm certainly not going to push Cassius into the music business, but if he really wants it I'm not going to stand in his way either. And in the meantime, he'll be getting singing lessons, piano lessons, and whatever else I can think of to keep encouraging his talent.

The first public performance that I actually remember came several years after the Sugar Shack, when I was about nine. I entered a talent show at a local club called the Hi-Hat in Roxbury, the predominantly black neighborhood in southern Boston where Orchard Park was located. In fact, I did so well that I scared the hell out of myself.

Let me explain: Growing up in the seventies in Boston, it seemed like talent shows were everywhere. The Hi-Hat was a nightclub on the weekdays and a community center during the weekends. My oldest sister, Bethy's, friend Norma hosted a lot of the talent shows, so it was only a matter of time before Bethy put me up on that stage. She knew I could dance

and sing. But there's a difference between imitation and stepping out on that stage with all those eyes staring at you. The funny thing was, even though I was always doing imitations and spending those long hours at my grandmother's place listening to her records, I still didn't have any idea that I had actual singing talent.

My sister and her husband decided what I should look like for my big performance. They put me in white pants, a white shirt, and a white applejack hat, with a head full of bouncy California curls. I looked like a baby pimp. Don't forget—this was 1978. We were just coming out of the heyday of blaxploitation movies like *Super Fly* and *The Mack*. It wasn't hard to see where my sister was going with that look.

My song selection was "Enjoy Yourself" by the Jacksons, which had been a big hit the previous year—the first big hit by the Jackson family after they left behind Motown and the name "the Jackson 5." Even Janet sang on "Enjoy Yourself" as a little ten-year-old. I guess that was the first time I connected with Janet— it wouldn't be the last.

The "stage" at the Hi-Hat wasn't really a stage. It was more like a dance floor with space cleared away in the middle for the performers. My sister's friend Norma had asked my sister to serve as a judge, so she was sitting in one of the three judges' chairs set up next to the stage area. When I say that I didn't know that I could sing, what I mean is that I had spent so much time imitating other singers I hadn't yet tried to figure out what my own singing voice would sound like.

And I wasn't sure how people outside of my family would react to my singing. I got my answer real quick. I hit the first few notes of "Enjoy Yourself" and started doing my Jackson-inspired dance moves, just beginning to get into the song—and all of a sudden the girls began screaming.

I had no idea why they were screaming, but I was scared to death. So what did I do? I froze. I stopped singing, looking around with what I'm sure was a crazy expression on my face. Then I did what was probably the most embarrassing thing I could possibly do in that situation—I ran and jumped in my sister's lap. Imagine that: a big-ass nine-year-old, jumping into a woman's lap. And on top of it all, a nine-year-old dressed like a mini pimp. I guess in my mind my sister's lap was the most comforting place I could be at the time.

The announcers tried to get me to come back.

"Come on back out, little Bobby Brown. Come sing that song, little Bobby. You look all sharp. Come finish the song!"

But I was not having it. I was not budging. My sister kept saying, "Leave him alone. He doesn't want to go out now."

But she was also whispering to me, trying to get me back out there. I just kept shaking my head. Then she'd wait for a few acts to go on and ask me again. "You want to do it now?" But I had made up my mind. I told her, "I'll come back next week. And I'll be better when I come back."

As I predicted, I came back the following week—and I killed it. I was wearing the same white outfit, sporting the same curls, singing the same song. I remember having the

curls redone, sitting at the stove while one of my sisters straightened out my hair with the hot comb. I think she even burned me. It was worth it.

Life in the Projects

Though we lived in the projects, I don't think we had any idea that the projects were supposed to be a bad place until we watched the show *Good Times*. Though it fell on harder times in the 1980s during the crack epidemic, in the 1970s the Orchard Park projects for our family weren't nearly as depressing as the Chicago projects where the Evans family lived. There were plenty of fights, confrontations, the threat of violence—but our bellies were never empty and nobody ever tried to kick us out on the streets. Both of my parents had good jobs—my mother, Carole, was a teacher and my dad, Herbert, was a construction worker building big skyscrapers downtown—and there was plenty of love flowing through the Brown household. We were in a good place. Anytime he got the chance, my father would show us the buildings he had helped to construct. I remember his pointing out the Prudential building in particular. He was proud of the work he had done, and he liked to use these buildings as a way to pass along lessons to us, especially to me and my brother.

"A workingman is everything," he would tell us. "When you got work to do, you work hard, do your job and go on home."

I've never forgotten that one.

The Brown family basically *ran* Orchard Park. I don't ever remember having reason to feel threatened or afraid of anybody or anything. There were six of us and I was the second youngest, so I had plenty of older siblings to look out for me. My older sisters were beasts—they were all cute and the biggest gangsters and pimps were always trying to get with them. Plus, I had a bunch of cousins around too. So that meant nobody was going to even think about messing with a Brown. There were just too many of us.

Our family was one of the few in Orchard Park that had both a mother and a father in the household, so we were looked upon as the brown-skinned Brady Bunch. And my mother was one of those generous Mother Teresa types who would welcome and care for anybody who was in need. It sometimes looked like she was cooking for the entire projects. We'd have random people from the streets sitting at our dinner table or sleeping on our floor because my mother had offered them a hot meal and a warm room. Everybody loved Carole Brown.

In addition to my family, the other major force in my life at the time was music. This was at the start of the 1980s, so a new music form was just bursting onto the scene: rap. Ironically, considering how big an influence it would soon have on my life, the first rap song I ever heard was "Rapture" by Blondie, the New Wave band fronted by a skinny blond woman named Deborah Harry. It was recorded in 1980,

right around the time that Grandmaster Flash was cooking up the origins of rap in New York City and the Sugarhill Gang was sending out the first real rap song on vinyl. Deborah Harry even name-checks Grandmaster Flash during her verses, though none of us really knew what the hell she was talking about. But soon after, I heard the more authentic pioneers like Grandmaster Flash and the Furious Five and I fell in love. I fully embraced this new music, with its aggressive, pulsating sound and potent style. I couldn't get enough. I even adopted my own rap persona, a character I called "Flash B"—no doubt influenced by my rap idol Grandmaster Flash. I told everyone to call me Flash B; when I was about eleven, I even got a belt that said "Flash B" on the buckle.

Boston kids in the 1970s and '80s grew up fast—in retrospect, much too fast. When we were still in elementary school, no more than eleven or twelve, we had the freedom to roam the streets. Of course, that meant we were always just a half second off trouble, just inches away from the backseat of a squad car. But we also had the space to explore the things that interested us. For me, of course, it was dancing and music. After my first win, I wanted to do nothing but talent shows, those little showcases and contests where you got the chance to experiment with this thing called show business, even before you understood that it was part of a business. Almost every weekend, my sisters and I would be onstage at some show, delivering a performance. Although violence was always around us, one of the main ways I bat-

tled back then was not with my fists—it was with my dance moves. I wasn't necessarily confident about my singing yet, but I knew I could whup anybody's ass in a dance battle. I was all over Boston, challenging other dancers to battle me. Break dancing, pop locking—man, I was unbelievable. The battles would usually take place at block parties. My crew would hear about a block party going on at another housing project, in nearby neighborhoods like Dorchester or Mattapan, and we'd roll over there. My crew would go up and challenge the best dancer in another crew: "I bet you can't beat him," they'd say, pointing to me.

My go-to song was "Scorpio" by Grandmaster Flash and the Furious Five. When the DJ put that record on, with that dope beat and the strange robotic-sounding voice, I would just wear everybody's ass out. When New Edition hit it big and I got a chance to meet Grandmaster Flash and his crew a few years later, I was so impressed that I started dressing like them, wearing the leather, the spikes, the hats. I just knew I was the shit at all times back then.

I've always been drawn to style, figuring out how to present myself in a way that's different from everybody else. So with rap, I think it was the style of the rappers that drew me in before the music, which is ironic considering that I had dreams of becoming a performer. The style and culture of rap were so profound that it soon became a global force, deeply influencing people on nearly every continent (I say *nearly* because I'm not so sure about Antarctica). Seeing these young

black men who had created their own musical genre and an all-encompassing style to go along with it was transformative to my eleven-year-old brain, particularly since I was a kid who was already drawn to creativity and self-expression. I was the kind of kid who, when I got a new pair of sneakers, would bring them into my room and sprinkle glitter all over them.

One summer when I was down in Alabama at my grandmother's house, where my father grew up, I was watching *Soul Train* and saw this dude doing the moonwalk. So I went outside and put some sand on the ground and started practicing sliding backward while looking like I was moving forward. When I came back to Boston, I showed the move to my friend Ralph Tresvant. His response was memorable: "Damn! Did you see what Bobby Brown just did!"

Once I added the moonwalk to my repertoire, it was over; I couldn't lose a dance battle. My sisters and I would go back to Boston from Alabama on the Greyhound bus, which always stopped at the Port Authority in New York. If you've ever been there, you know all kinds of seedy characters hang around the Port Authority. In the late seventies and early eighties, you'd see a lot of dancers and dance crews there, entertaining the crowd, trying to get people to put money in a hat. When our bus hit the Port Authority, my older sister Leolah, whom we called LeeLee, would cut out, walking around the city in her hot pants, thinking she was Donna Summer, but I would head straight for the dancers. The first time I saw them, I thought, *Oh God, let me in on this!*

Sometimes I would battle other dancers or just put my own hat down and start dancing to collect money. I would pick up some moves, but most of the time I would be showing them moves they had never seen, like the moonwalk. When I realized even these guys in New York couldn't beat me, that's when I really knew I had something special.

On the way back to the bus, I'd usually have to steal something too. It was like I couldn't help myself. I'd snatch a couple of T-shirts, maybe some hats from one of those street vendors. I guess they have a name for that—"klepto." When we got back to Boston, my little sister, Carol, would snitch on me, tell my mother what we had been doing, that we had abandoned her in the bus station. Just a year younger than me, Carol copied everything I did, tried to follow me everywhere I went. But I could always count on her to squeal on me too.

Carol was even in a group with me for a minute—me and four girls in a quintet we called Bobby's Angels. I'm sure the name came from the popular television show at the time, *Charlie's Angels*, which debuted in 1976. We were tiny, just eight and nine or so, performing in a few showcases around town, doing more dancing than anything else. There were so many little kids forming groups back then; it just seemed like the thing to do. We were coming out of the doo-wop and Motown era, when black singing groups dominated the charts, so it was only natural that when we thought of a path to fame and fortune, it was through a singing group.

Though singing groups and talent shows were everywhere in the 1970s, we didn't really have a lot of big success stories to emulate in Boston—until the emergence of Donna Summer. For a few years there in the mid-to-late seventies, Summer was riding high on top of the music industry with hits like "Love to Love You Baby," "Last Dance" and "MacArthur Park." She was from Mission Hill, a neighborhood right next to Roxbury, and her enormous success was thrilling to little black kids like us. We were paying particularly close attention to her rise in my family because we were told we were related to her by marriage—her mother at some point had been married to my uncle Robert Williams, my mother's brother (the one I was named after). I don't think the marriage ended well, so her side of the family never had much of a connection with my side. But that didn't stop me from informing Donna that we were related when I had the chance to meet her a few years later.

New Edition was at an industry event in New York City when I spotted her. I was hesitant at first, but then I decided that I wanted her to know about our connection. After all, we were perhaps the most successful black acts ever to come out of our neighborhood, so this meeting needed to happen. This was in 1984 or so, when her video for "She Works Hard for the Money" was still in heavy rotation on MTV—the first black female artist to achieve that feat (my future wife was still a few years away from becoming an MTV staple). New Edition was riding high after the release of our second

album, which included the hits "Cool It Now" and "Mr. Tele-phone Man"—one of just a handful of New Edition songs that featured me as the lead singer.

"Hello, Miss Summer, I'm Bobby Brown from New Edi-tion," I said when I walked up to her. "Do you know the Browns in Roxbury?"

Surely as a Boston native, she was aware of New Edition. But I couldn't be too sure of anything judging by her reac-tion. I saw a look on her face that might have been confu-sion. Or maybe she was a half second from calling security. But I pressed forward, telling her of the connection between our two families.

"Oh really?" she said politely.

I kept talking, not wanting to stop until she acknowl-edged our bond. I got some nods from her, which I decided was perhaps all I was going to get. That was the first and last time I ever talked to her. I was really sad when I heard she passed in 2012, just three months after Whitney died.

One of the dance groups that had a huge impact on me during this time was a local crew called the Funk Effects, led by dance pioneer David Vaughn. Every time I saw them, the Funk Effects would blow me away. Not only were they in-credible dancers, but Vaughn would turn their performances into these elaborate stage productions that he called "Broad-way." The dancers would come out wearing intricate space-man suits, with dramatic lighting illuminating them as they danced. This made a big impression on my young mind,

demonstrating to me that staging and spectacle were just as important in creating an unforgettable event as talent. Vaughn would later work with New Edition and he would hammer that message into our heads too, while choreographer Brooke Payne was constantly pushing the importance of practicing. These were two lessons I never forgot.

Trauma Shakes My Soul

Though my father, Herbert, was the family comedian, my mother also had her own brand of comedy that would keep her kids giggling. Usually her humor came at my father's expense. She loved to mess with him, tease him, make fun of him. Like a lioness on the African plains, she pounced on his greatest weakness—his fear of snakes and spiders. She would go out and buy rubber snakes and toy spiders and strategically hide them around the house, in places where she knew he'd come across them and damn near have a heart attack. She'd hide them in drawers or put one next to him on the couch while he was watching television. Sometimes she'd even hide a little fake snake in his food and bring him his dinner plate with a big smile on her face. The lively chatter of the family dinner would be interrupted by a sudden jolt coming from my father. We'd look up and see my father staring down at his plate with a mix of anger and horror on his face.

Then we kids and my mom would bust out laughing. My

father would commence to cursing. He'd get mad at her, but he had no choice but to roll with it. He was a grown-ass man; he wasn't going to make a federal case out of somebody scaring him with a toy. But he wouldn't be happy about it either. I remember seeing her walk up behind him with a shoestring and slowly put a rubber spider on his neck. He'd scream out and smack at his neck to get it off.

"I can't take this shit!" he'd grumble, getting up to storm outside, the laughter cascading behind him.

When I think back on it now, I'm struck by how rare and outside-the-box my mother was—a middle-aged black woman in the 1970s scaring her husband and entertaining her kids with toy snakes. It's like something out of a sitcom.

When I was about ten, I found out that my mother was even more outside-the-box than I realized. At one point she was selling dinner plates to people in the projects to make some extra cash. But one fateful day I found out that food wasn't the only thing she was selling: it turned out my mom was also a dope dealer.

I can trace my realization back to when I noticed that she had gotten a heavy black metal door installed in our apartment. But at the time, in my mind, the heavy metal was put in to protect us from the Jehovah's Witness missionaries who were constantly knocking on our door. My little sister and I thought my parents were petrified of the Jehovah's Witnesses because of how they scurried whenever the missionaries came knocking. In the mind of a small child, any-

one prompting such behavior must have been bad news. And that's why I acted out so ridiculously when I was about eight and my sister Carol and I were walking up the stairs toward our apartment. We looked up and saw a pair of missionaries in front of our door.

"Aww, so cute," they said to us. "Do you live here? Are your parents home?"

I looked up at them. I'm not sure what devious thoughts crossed my mind, but what I said next had them gasping for breath.

"Yeah, those motherfuckers is home," I said. I started kicking on the door. "Ma, open this fuckin' door!"

I heard my mother on the other side of the door, laughing hysterically.

The missionaries pushed past us and ran down the stairs in a flash, I'm sure thinking, *Oh no, we can't help them! They're too far gone.*

My mother was such a great cook and food was such an important part of my family culture that at a very early age I was excited that she had started to teach me how to cook. And this led me to my first inadvertent encounter with my mother's side hustle. When I was ten, I decided that I was skilled enough to make dinner for my family. My father was still at work and my mother was hanging out at a local club called the Parrot. Sometimes she would stay there far into the night. So I decided I would use the large block of flour I found in the freezer to make some fried chicken.

I got the chicken parts out of the refrigerator and covered a bunch of pieces in the flour. Then I dropped them in a pan of sizzling oil. I was ten, so I didn't recognize the strangely pungent smell emanating from the pan. When the chicken pieces were nice and brown, I figured I was done. After I had taken a few bites, feeling weirder with each bite, my mother walked in the door. At first she was smiling at the idea that her little Bobby had made dinner. Then her gaze swept across the kitchen and she got hit by the full brunt of the scene—the smell, the mess, the powder. With horror, she realized what I had done: I fried the chicken in her cocaine. A radical new addition to the family's culinary offerings: cocaine chicken.

"Bobby!" she yelled.

Though she explained that the powder I had used was not flour, it wasn't until months later that I truly understood what was going on in my home, what my mother was really selling through the heavy black door. A couple of the local thugs had been sleeping on our floor for a few days. These guys were very friendly with my mother. On this particular afternoon, police officers knocked on the door and said they were looking for the same guys who were staying with us. My mother told the cops they weren't there. The cops left and went downstairs. My mother went downstairs as well. When I looked out the window, I saw my mother in an angry confrontation with the police. One of the officers lifted his billy club and hit her in the face with it. He busted her eye and she staggered back. I remember vividly that she was stand-

ing next to a green Cadillac that belonged to a guy who lived on the first floor. I started crying hysterically as I watched them put her in handcuffs and whisk her away in the back of a squad car. I was deeply upset by what I had witnessed. I mean, I was only ten and I had just seen the police beat my mother in the face. From that moment on, I would harbor a serious dislike of the police.

The next few weeks were a blur of tears and confusion. It turned out my mother had been selling dope for several years and none of us kids knew anything about it. I don't think my father knew either, but I can't be sure about that. We thought her entrepreneurial endeavors began and ended at fried chicken dinners. I might add that she was still a loving woman, the Mother Teresa of the projects. We just discovered that she was Pablo Escobar as well.

Because my father was at work and none of my older siblings were around when she got arrested, the authorities had to find somewhere to stash me and Carol. So they brought us to a local social services center that was somehow affiliated with the Catholic Church. The building had leering gargoyles on the outside and it wasn't far from Orchard Park. I must have stayed there for at least a week, the whole time desperate to get away. After I had been there for several days, something horrible happened to me. One of the priests who worked with the children brought me into a room. To my utter shock, he tried to touch my privates and attempted to stick his finger in my ass. I punched him really hard in his

head and ran away from him. After that, they put me in a little room by myself and threw a blanket and pillow in there with me. I was so upset and aching to leave that place; it was all I could think about. I felt vulnerable and unprotected, wondering where my father was and how he and my siblings could let this man touch me.

I don't really know why it took so long for me to be released from the center. The drug charges against my mother were eventually dropped, so it wasn't like she did any jail time. I heard her and my father arguing about the drugs, so I know he was upset about the whole scene. After I got back home, I really wanted to tell my mother what had happened to me, but I could never find the words to do so. I think she could tell that something was different about me, but perhaps she felt it was due to her being beaten up and dragged to prison, so her guilt kept her silent. It's been more than thirty years, but I can never let go of the horror I felt in that room with the priest. I can understand how victims of molestation develop deep psychological problems.

Even though she could be kind and funny as hell, my mother was the disciplinarian in our household. I was such a badass kid, always getting in trouble, shoplifting, stealing bikes. If she had found out half the shit I did, it would have been over for me. My father was the opposite: he'd be more likely to say, "Aww, Carole, leave him alone." But my mother didn't play that. When you messed up, she'd start reaching for extension cords, whatever she could find, to whup your

ass. And then she'd say, "Your father is gonna get you when he gets home."

When my father got home, he'd take us in a room and act like he was yelling at us and whuppin' us: "Boy, didn't I tell you!" But in reality he'd be trying real hard to keep himself from laughing. And I'd be laughing too. My mother thought he was in there beating my ass. My father was really cool like that.

I can only remember one time when he really beat me. It was a crazy day that I'll remember for the rest of my life. We were in Alabama at my grandmother's and I walked way down to the country store, trying to find something to buy. I was about eleven. While I was wandering around the store, looking, the store clerk called me "nigger." I lost it. I said, "You know what? I'll be right back, motherfucker!"

I went back to my grandmother's house and found my father's army uniform—and his gun. I actually changed into that uniform. It wasn't a perfect fit, but it fit well enough. Then I marched back down to that store with the rifle in my hand. When I went back in the store, I pointed the gun at the clerk and said, "I'll blow your motherfuckin' head off!" I was talking like a grown-ass man, holding this gun like I was Clint Eastwood or something. The dude looked pretty scared. I went through the store, grabbing things that I wanted. Then I left, with the rifle resting on my shoulder. As I was walking, feeling damn good about myself, my father pulled up next to me in his station wagon. I saw the look

on his face and knew I was in trouble. My father got out, took the gun away from me, and proceeded to tear my ass up. When we finally got in the car, I told my father that the guy in the store had called me a nigger.

Yes, we were in Alabama, but this was 1980, not 1950. My father took me back to that store and made me give all the stuff I took back to the clerk. Then he turned his attention to the clerk, addressing the man by his name.

"If you ever talk to my son like that again, I'll kill you," he said.

When we got back in the car, I said, "Pop, I don't want to stay down here anymore."

That was the last summer we spent in Alabama.

In the 1970s in the Orchard Park projects, sex was everywhere. When I look back at that time, I can't believe how young I was when I started engaging in sexual activity with girls in the projects, though I'm not even sure if we were aware we were having sex. I might have been as young as eight when I began to get together with girls. I was already having erections at that age and I would get naked and try to insert my hard penis inside of them. The girls were just as fast as the boys, though I think most of the girls I was messing around with were a few years older than me.

I got much of my concept of sexuality from the porn movies I would find in my brother Tommy's room. Because he was nine years older than me, I discovered at an early age that Tommy's room contained all kinds of wonders. I'd

pop the big videotapes into the VCR and disappear into the misleading world of sexual performance. I think that early exposure put me on a path of using sex as a substitute for feelings, as a way to show that I cared for someone rather than expressing real emotions.

We had to go back to Alabama in 1981 when my grandmother died. It was a sad time for our family, but after I got back to Boston I would experience the most traumatic event of my young life, even worse than the encounter with the priest. The trauma would actually propel me into forming New Edition. Right after my family arrived back in Orchard Park in the summer of 1981, spilling out of our car, I went looking for my best friend, Jimmy. Jimmy was kind of a bad-ass kid who used to terrorize many of the little kids of Orchard Park with threats and intimidation—so naturally I was drawn to him like a moth to light. Ralph Tresvant later described Jimmy as a "bully," and I guess from Ralph's perspective the description might have fit, but to me he was a tough, fun kid who was never afraid to come along with me as we made each day in the projects a great adventure.

On this particular day, Jimmy and I decided to head on over to Dorchester and steal some bikes. Dorchester was right next to Roxbury and was a more stable, middle-class neighborhood filled with single-family houses and lots of white people. To me and Jimmy, it was like a candy store, a damn bicycle supermarket. We hopped on a bus that took us deep into Dorchester. We were about four miles from

Orchard Park when we spotted our prey, two bikes sitting in front of a white wood-frame house with a spacious front porch. They were leaning against the porch, with no locks in sight. Jimmy and I leaped into action. We ran over, jumped onto the bikes, and hauled ass down the block, our hearts pounding and our faces wearing big grins. New bikes! (Or at least new to us.)

We rode the four miles back to OP, laughing and having a ball along the way. When we hit the projects, we came upon a party somebody was having in a ground-floor apartment. We weren't going to miss a party, not in OP. I could never walk away from any opportunity to show off my dance moves. So Jimmy and I went inside, leaving our new bikes leaning up against a fence. A short time later, we emerged from the party and caught a troubling sight—somebody was sitting on Jimmy's new bike. It was a Puerto Rican kid; there were a bunch of Puerto Rican families who lived on the other side of OP. The black kids and the Puerto Rican kids didn't get along so well—it wouldn't be Boston if there wasn't some racial tension.

"Hey, get off my fuckin' bike!" Jimmy said to the kid. Jimmy rushed toward him, already swinging. He connected several times with the kid's face, clearly beating his ass. Jimmy was already an experienced brawler; nobody really wanted to get into a fight with him. One of the other Puerto Rican kids threw a knife to the guy who was getting his ass whupped by Jimmy. He swung it at Jimmy and sliced his arm.

It wasn't a real deep cut, but it drew blood. One of the guys in my crew reacted quickly and kicked the kid with the knife in the back, knocking him to the ground. Still clutching the knife, the kid lunged at Jimmy with it. To the shock of everyone watching, the knife plunged into the left side of Jimmy's chest, right into his heart. Jimmy collapsed onto the ground. I was stunned, but I knew I had to do something.

"Don't move him!" I shouted. I had heard somewhere that when somebody gets stabbed, you should keep them still so you don't further damage any internal organs.

I hauled ass, sprinting toward Jimmy's apartment to get his mother. While I was running, somebody called the ambulance. When I got to our building, my brother, Tommy, saw me and asked what was wrong. We were heading back down the stairs when we saw several kids carrying Jimmy into the hallway of our building. They didn't listen to me and decided to move him despite what I told them, carrying him at least two hundred yards from the scene of the stabbing, across a courtyard. It was ridiculous that they carried him that far instead of leaving him there for the ambulance, but I guess they felt they had to do something. They couldn't just let him die. When my brother and I kneeled over him, we could see that he was turning blue. Blood was everywhere. I started yelling for the ambulance. The high-pitched, terrifying cries of his mother filled the hallway as she watched her boy slip away. Jimmy died right there in our building, surrounded by family and friends. We watched the last breath leave his

body, like he had made a decision that this would be his last day. The ambulance technicians arrived shortly after, but it was too late. Jimmy was gone.

I was devastated, inconsolable. Thinking back on it, I was probably in shock. I had seen a couple of people get shot in OP by then, but that was the first time violence had struck somebody I knew, practically a member of my family. Most of us were still just little kids trying to have fun. We hadn't made the transition to any type of killer mind-set, trying to end it for somebody. Hey, we were still watching fuckin' cartoons. Yeah, most of us carried knives, cheap $10 blades that opened with a flick of the wrist, with "007" carved into the side, surely a reference to James Bond. But the knives were for our protection in a land of predators. We did not see them as tools for murder.

After Jimmy died, I was in such a state of depression, I almost ceased functioning. I sat in the pouring rain on the curb outside our building for two days straight, barely moving, my tears mixing with the water flowing into the gutter. I stared down the block, thinking that Jimmy was going to turn the corner at any moment on his bike, headed toward me wearing a grin. I sobbed so long and hard that my chest hurt and my eyes could no longer summon tears. I didn't even move to use the bathroom. I just held on to a pole on the street, clutching it like it had the power to bring Jimmy back. My mother sat down next to me to keep me company, to show that she understood and shared my grief; she never

forced me to come inside. When she wasn't outside with me, she sat in the apartment window and watched me from above. To her credit, she let me mourn in my own twelve-year-old way.

It seemed like Jimmy's death led to a flood of young boys having their lives snuffed out—kids like Geno and Anthony, boys my age, way too young to be snatched away. There were too many fights, too much conflict, too much blood, with too many of us ignorantly deciding that our enemies were the kids on the other side of the projects, or in another project across town. The family of the kid who killed Jimmy had to leave Orchard Park after their apartment mysteriously caught on fire and was completely torched. I'm sure they were glad to go, fearful that the hostility we all felt for them would lead to one of them getting hurt or worse. The tension between blacks and Puerto Ricans in OP only intensified after Jimmy's death.

Jimmy's getting killed was a catalyst for me. After I emerged from my deep funk, I vowed to myself that I had to get out of OP and out of Boston. It was the only way I could see myself surviving to my eighteenth birthday. And I knew exactly where to find my escape route—music.

STARS ARE BORN: THE RISE OF NEW EDITION

How did my friends and I form one of the most successful singing groups in R & B history? It still blows my mind how far we have come with this over these last thirty years. I mean, how many groups last in this brutal business even one decade, never mind three? We were just some nappy-headed little black boys from the projects. Making R & B history was the last thing on our minds.

It all started with Michael Bivins, me and a dance troupe called Transitions. There were seven guys in the group, but the other guys were a lot older than me and Michael—we were only about nine at the time. Mike and I met at the local Boys and Girls Club, where we played against each other in the basketball league. Mike was a really good basketball player. Ralph Tresvant played in the league too, but we were all on different teams.

Mike and I joined Transitions, and with them we performed in a lot of talent shows, but after a while Mike and I felt like we needed to get out. The rest of the troupe was just too old. They kept wanting us to do crazy things that nine- and ten-year-olds weren't supposed to be doing. We were some badass little kids, but even we knew we weren't supposed to be hanging around with fifteen- and sixteen-year-old guys. One of the guys in the group, Preacher, looked like a very short grown man.

One day Mike and I came up with a clever plan to get out of the group: we would start brawling. We went over to the house where most of the guys lived—they were brothers—and we started fighting each other. It was raining out and we kept beating on each other for what felt like at least an hour, kicking, punching, cursing. When the older guys finally came outside, they got mad at us for fighting. Right then they said we were kicked out of the group. Exactly what we wanted. We were happy as hell—so happy, in fact, that we then snuck into Preacher's house and stole two of the trophies the group had won.

During the next couple of years, while I was beginning to imagine myself as an entertainer, I also discovered another passion: boxing. I kept showing up in the local gym, which was run by Bill Marshall. Along with other kids from the neighborhood, I would train and spar. Mr. Marshall told us if we stuck with it, we could go to the Golden Gloves in New York, one of the preeminent amateur boxing tourna-

ments in the country. I stuck with it over the course of a year or so and got to be pretty good. I always could throw the hands really well. We had a big match at the gym to determine who would make the trip to the Golden Gloves in New York. I beat up my opponent, a kid named Michael Green, and knocked him out.

When we made the trip down to New York, my mother saw the kid I was supposed to fight in my first match. He was this big white boy, already cut up with bulging muscles at like age twelve. My body was starting to get cut up too, but I was still skinny. He looked like he was way bigger than me. Mrs. Carole Brown was not having it.

"Uh-uh. No, son, you're not meant to do this," she said to me.

I was devastated. I had trained hard for this, had lain awake at night envisioning the moves I would make in the ring, how I would be the twelve-year-old reincarnation of my hero Muhammad Ali. Now she was telling me no?

"Ma, please!" I begged her. I could feel boxing superstardom slipping through my fingers. "Please?!"

But her mind was made up, helped along considerably by the sight of that big white boy.

"You're not going to be a fighter when you grow up," my mother declared. "You're going to be a singer."

Now, I couldn't really argue with that, but it didn't make me any happier. When I wouldn't fight, the kid I had knocked out back in Boston, Michael Green, who had made

the trip specifically for reasons such as this, stepped in to fight in my place. At the opening bell, he bounced out there to face the big, cut-up white kid with all the muscles. They sized each other up for a few seconds, then Michael threw his first punch. It connected with the kid's big head, and he fell straight to the canvas. Knockout! I was stunned—and now even more upset.

"Oh my God! Mom!" I said.

"I don't care," she answered, refusing to budge. "Nobody's gonna beat up on your face."

And with that, she effectively ended my boxing career. It was a wrap.

I must say that the time in the ring was beneficial to me. It gave me more confidence in my physicality, which translated into my becoming a better dancer. When you've gone into the ring and come out alive, it gives you a sense of invincibility as you stride through the world. I'd always felt like I was the alpha in any room, but the boxing experience just multiplied that feeling. It's like that movie *Fight Club*, starring Brad Pitt. These dudes from all walks of life confront some of their greatest fears by engaging in bare-knuckle brawling. That's because every dude knows once you've been hit in the face, even if you don't win the fight, you're not really scared of anything. You've encountered one of your greatest nightmares and you've lived to tell the tale. You walk around with a different attitude. *If you bring it to me, I'm going to whup your ass—or even if I don't, I'm not going to be scared.* It was an impor-

tant lesson that I always carried with me after my Golden Gloves training.

After my adventure in the ring, I ventured off to do solo performances at talent shows around Roxbury, singing and dancing. I came in second place at one of the shows, singing the Delfonics song "La La Means I Love You." Naturally I was upset I didn't win, but after the show I got approached by the man who had sponsored the talent show, Maurice Starr. His actual name was Larry Johnson, and he was a local artist who had recorded a couple of R & B albums a few years earlier to little success. Now he was looking to put together some type of group. He told me I should go find some guys to sing background and dance behind me.

The first person I approached of course was Michael Bivins. I already knew he could dance because we had been in Transitions together. I knew Ralph Tresvant and Ricky Bell, two other local guys who had had a duet group together, so I asked them if they wanted to join us. They said yes. In that moment, New Edition was born—though we didn't know it yet. We initially had another member, Travis Pettis, but he had to go down south the summer when this was all coming together and the ship sailed without him.

We only had one chance at a rehearsal before we were going on the stage together at the Hi-Hat. When we started that rehearsal, I thought I sounded a lot like Michael Jackson. This was 1982, and even though his *Thriller* album hadn't come out yet, in the minds of little black boys in

Roxbury he was already the king. His album *Off the Wall* was still in constant rotation, with all those hits. Everybody wanted to sound like Michael, to dance like Michael, to move like Michael. I was just thirteen, so my voice still had a high enough register that I could close my eyes and imagine I sounded like Michael. But then Ralph Tresvant started singing. I was floored. He sounded *exactly* like Michael. He had that high Michael tone, with all the sweetness and energy Michael possessed, and that drew in listeners from the first note. Ralph had it all. I thought to myself, *This is really gonna work.*

There was no doubt about Ralph being the lead. I was cool with being on the side because I knew I had a lot to bring to the table, particularly when it came to dance and movement. We all had different types of voices, different styles. That's what makes a successful group—bringing all these different sounds together to form a beautiful whole.

I had a vast mind for music. I tried to listen to everything—from Buddy Holly and the Beatles to Stevie Wonder and Donny Hathaway, who were also my role models in addition to Michael. I just loved music and I knew there was nothing else in the world I wanted to do with my life. When we got the guys together to form a group, I think we all could sense that maybe this could turn into something special.

For our first gig we decided to sing "Holding On (When Love Is Gone)," the LTD song featuring Jeffrey Osborne in

the lead that had been a big hit a few years earlier. We came up with the choreography, calling out the steps—"Kick ball . . . cross step . . ." We ran through the entire song maybe two or three times during the rehearsal.

We tried to wear matching outfits, but it didn't quite work out that way. Ralph and Michael had on brown slacks, I had on brown corduroys and Ricky had on some rust-colored slacks. Then I went out to a local store and stole some brown bow ties.

We did our thing out there on the stage of the Hi-Hat. It wasn't perfect, but it was starting to look pretty damn good. We actually called out the steps onstage—but the crowd couldn't hear us because they were screaming so loud. We were a big hit; it was exciting to experience the enthusiasm of the crowd.

We wanted to improve our dance moves, and we knew the man to see was a local choreographer named Brooke Payne. Brooke was at the Hi-Hat show, but we were afraid to approach him, arguing about who was going to do it. Finally Mike and I went over and asked him if he could teach us some dances. He had already seen us perform, so he was interested. He told us to meet him at the Boys Club in the Cathedral, which was the name of another project.

Once we got with Brooke, our little group started looking better and better. He tightened up our moves and committed us to the importance of practice. Then we entered a show called Hollywood Talent Night, another Maurice Starr

creation. This time the winner was supposed to get a recording contract. We did a Jackson 5 medley and we tore it up. The crowd went crazy. We just knew we would take home the top prize. But then this rap group came on, these two tall, lanky rappers who pop-locked while they rapped. They beat us. We were devastated; we were so sure we had it that night. But Maurice came over and told us he still wanted to record us, so our gloom was instantly transformed.

We were so excited, jumping around like we had won the lottery. I remember being filled with pure elation that night. And as for the tall, lanky rappers? We never heard from them again. So that recording contract must not have panned out for them after all.

On the Radio

It only took Maurice a few days to get us in the studio. He was a man in a hurry, anxious to bring his master plan to fruition. At this point, everything started happening so fast my head was spinning. Maurice had written this song called "Jealous Girl" and he wanted us to record it. He was obviously going for the Jackson 5 look and sound. He was pushing us like he wanted it pretty bad. Even our name referred to his idea that we were a "new edition" of the Jackson 5. Right after "Jealous Girl," we recorded "Candy Girl." Over the next few weeks we kept recording song after song. In a few short months, some of us were listening to a local college

radio station, WRBB, which is affiliated with Northeastern University. All of a sudden "Candy Girl" started playing. We were on the radio!

To understand how much of a shock this was, consider that Maurice hadn't told us *anything*. We were just doing as we were told, singing the songs he told us to sing. There had been no discussion of recording contracts, terms, percentages, marketing . . . nothing. When we heard it, our first reaction was, "What?!"

As it was playing, we were all screaming and running to each other's apartments. People in Orchard Park were blasting it out of their windows. Looking back now at that moment in time, before we even knew what the music business was, what we were experiencing was pure joy. I was just a thirteen-year-old kid, and my voice was playing on the radio! That was some crazy shit.

After WRBB played our song, it got played on WILD, the AM station. Next it crossed over to KISS 108 FM, which was the big station in Boston at the time. In our minds, getting played on KISS meant you were big-time. But really we were happy to be on any station—happy that people knew who New Edition was. At this point, our mothers got together to try to figure out what this was all about—how we could have a song on the radio and not have any inkling of a contract. My mother was a beast when it came to that stuff, but we still wound up getting screwed.

Our first album, called *Candy Girl*, was released in

March 1983, when I had just turned fourteen, and it sold so many records it was hard for us to keep count. And how much did we make from it? We each got $500 and a VCR—a Betamax, so we could watch our own videos. We knew it was fucked up, but we were still happy—at least we were in the beginning. We all took our first paychecks and went out and bought mopeds. We were excited as hell, cruising around the projects on our mopeds, not having to ride bicycles anymore. But nobody told us we needed a driver's license to ride the damn things. So we all wound up in a local jail after being arrested for operating the mopeds without a license.

Though at first blush that may seem like it would have been an unpleasant experience for me, I actually had a fabulous time that day. The police couldn't put me in a cell with grown men because I was too young, so they decided to stash me over with the women. When I got there, I saw one of my sister Tina's friends, a girl who was way older than me—she probably was at least twenty. But I guess in her mind I wasn't too young for some sexual exploration. We found a hidden corner of the facility and had sex. After my mother showed up and got both of us released, we did it a few more times when we got back to OP. My sister Tina found out about it and was outraged; she's still mad at that girl. Considering the law of the land, I guess she could have been charged with rape, though I was certainly a willing participant.

Around this time we took our first trip overseas, travel-

ing to England and Germany. And let me say without hesitation that we *hated* it. We were just little kids from the projects, not open-minded enough to be able to enjoy different foods and cultures. After a couple of days in London, we all got sick from the food. We were desperate for a McDonald's or anywhere we could get a familiar hamburger. In fact, Ralph was so sick that he wasn't able to perform when we did *Top of the Pops,* a popular British television show. I had to step in as lead singer. I wasn't nervous, but I wasn't feeling too great myself, so I was worried about the bubbling in my stomach. As I recall, it wasn't the greatest performance we ever turned in, but we got through it.

When we hit Germany, it was more of the same—severe homesickness and a desperate search for a hamburger. When the two weeks were over, we were so happy to return to Boston.

New Edition never really found out how many units of our first album we actually sold. So we went out and found these white guys to manage us because we couldn't get answers from Maurice Starr. We agreed to be managed by a production company called Jump and Shoot. At one point one of our managers even told us, "You gotta get ripped off once or twice in your career," like this was some meaningful rite of passage in the music business. We said, "What are you talking about? No, we don't *have* to get ripped off!"

Once we got signed by MCA and started working on a follow-up album, things had gotten ugly with Maurice. We

felt like he had made a ton of money off our efforts and we never saw any of it. But in retrospect it was Jump and Shoot that was collecting most of the cash. We found out that we had been the victims of classic music industry shenanigans: Our contract was actually with Jump and Shoot, our management company, not MCA. Meanwhile, Jump and Shoot signed the deal with MCA. So in effect we, the actual members of New Edition, had no real connection to MCA. Jump and Shoot could pay us whatever they felt like and tell us whatever they wanted.

Let me draw a picture for you of how crazy our lives were in those early days. We would go down to New York City and do shows the whole weekend, starting at midnight on Friday, then shows at one A.M., two A.M., all the way to four A.M. Then on Saturday and Sunday night we'd do the same thing and then head back to Boston once we were done. Once we got back home, the bus or station wagon we were traveling in would drop us off in front of our schools. Ricky, Ralph and I went to the same school, so we'd stumble out of the bus and go straight to class. Yes, it looked crazy as hell. But everybody in the school knew who we were so we got away with it.

Believe it or not, I was a bit shy when I was younger, but I was trying to get past it. Part of the problem was I thought I was ugly. I've always had these heavy bags under my eyes, even when I was a little boy. When I looked in the mirror, in my mind I saw an ugly kid staring back at me. And then there was my skin color. As a community we're slowly start-

ing to get away from our color prejudices, but it was still definitely in effect in the seventies and eighties. Black people can say some mean, dirty stuff to each other. They would call me "darkie" or "black," or "five-head" because I've always had a big forehead. Even New Edition used to say this stuff to me back when we first formed the group. They called me all kinds of names, up until the first time we made it to *Soul Train*. I can remember this one particular day when we were practicing with Brooke. While we took a break he'd let us watch *Soul Train*.

"Man, I'm telling you, I can't wait until we go on there," I said as I looked at the screen. "We're gonna turn that place out!"

The other guys went in on me. "We ain't never going on no *Soul Train,* Charcoal!" one of them said.

"Black-ass dummy!" another one said.

I usually brushed it off, but that time it hurt my feelings because I really believed that what I had said was going to happen. I had dreamed about it. And I turned out to be right: About two years later we did go on *Soul Train* for the first time—and we did turn the place out.

All of them called me names, but Ricky was the worst. Ricky couldn't fight, so he talked a gang of shit. I never understood why he focused so much on my skin color because we were about the same complexion.

"Dude, you're no lighter than me!" I'd say to him.

"Yes I am lighter than you," he'd say back.

"Not even a shade," I'd say.

Then we'd hold our arms next to each other to see.

But then something happened that shut down all that skin-color talk: Ronnie DeVoe, Brooke's nephew, joined the group. When they added Ronnie, everybody else instantly became dark because he was the light one.

Some people might find it ironic that while all these girls around the world were starting to swoon when they saw us onstage or in magazines, I was still dealing with insecurities about my looks. Maybe that's why I dove into the ladies so hard: to prove a point, to show I was desirable.

However, let me emphasize that despite the name-calling, the guys and I had a great time together. We were constantly laughing and goofing around. In those early years, life with New Edition was one big party.

Girls, Girls, Girls

The party got even better when we hit the road and started spending time with the girls who would come to our shows. I was the first one in the group to have sex with one of the fans. It was our first time on the road in an actual tour bus. We were in North Carolina and I met this girl who had been at the show. She was a lot older than me. Man, she showed me something that night. After the show she came backstage, and then I took her on the bus. The rest of the guys were still out in the parking lot talking to girls, so the bus

was empty. I think the other guys were still a little scared of sex, but not me.

I was still so clueless, I didn't even use protection. I don't think it crossed my mind at the time. But that changed real quick when the people around us realized what was starting to go down. I mean, we were becoming teenage sex symbols, with girls screaming at us everywhere we went. It was inevitable that we'd start taking advantage of the situation. They talked to us—and quickly—about the need for us to be safe and protect ourselves. Once we started, they couldn't keep enough condoms on that damn bus.

These girls would have their mothers drop them off at the shows, not knowing what the girls were going to be up to after the show. And I have to admit, even some of the mothers who would stay for the shows and watch us up there onstage pumping and grinding would be getting excited themselves. I could look at them and see the way they were eyeing us. I was always attracted to older women, so it was all good for me.

Our life changed so fast once New Edition blew up. It seemed like overnight we went from one extreme to the next. One minute we were poor young boys from the projects; next thing I knew we were big stars with groupies. By the time I left New Edition, I didn't know where the years had gone.

One of the things that got drilled into us early on with New Edition was the value of practice and performing. To choreographers like David Vaughn and Brooke Payne, practice was the key to putting on a great show. The dance steps

needed to become so familiar to us that we could do them without thinking about them. And if we didn't have to think about them, then we could focus our energy on the crowd and the show. It was a work ethic that became second nature to us. I think that work ethic has been largely lost with the current generation of performers. In R & B, there are only a handful of performers who I can say without a doubt share that devotion to the work. Usher has it; you can see it in how he puts his shows together. Mary J. Blige has it, as do Beyoncé and Janet Jackson; they all really focus on creating an amazing show. The rappers? Not so much. Thirteen mics onstage, dudes wandering around everywhere—there's mostly performance but not much show. Sometimes you can't even tell who's rapping the verse because everybody is singing or chanting along. I'm thinking, *Shut up and let him do it!*

While New Edition has always been just a singing group, we all had to dig into the music to do our job properly. We could all play instruments by ear and we would pay attention to the chords and the changes to be able to sing harmony. If you're going to harmonize, you have to know where you fit in, which can only come from studying the chords. And as a dancer, I learned movement by listening to the music, moving my body to every sound in the song. That's what popping is, reacting to every beat, every rhythm.

Once New Edition started to gain notoriety, an amazing thing happened to us. We got to hang out with our hero

Michael Jackson. We had just signed with MCA and on one of our early trips to Los Angeles, Michael invited us back to his house. This was in 1984, when Michael still lived on Hayvenhurst in Encino. He wouldn't move to Neverland until 1988. While we were there, we met La Toya and Janet. I already had a crush on Janet from afar, so being in the same room with her was exciting as hell for me. Her second album, *Dream Street,* had come out that year, failing to make a big splash. This was two years before *Control,* so she wasn't yet the enormous pop icon she would soon become. She was really sweet—and I was in love. Clearly she was a New Edition fan; maybe she was feeling me a bit too.

Michael was incredibly cool, playful and funny. This was two years after the release of *Thriller,* the bestselling album of all time, so Michael was the biggest star in the universe. We were in awe. He loved playing jokes on people, so he kept running through the house and smacking his sisters on the ass. We ran through the house with him and we all desperately wanted to smack La Toya and Janet on the ass too, but we refrained. I don't even know why he thought it was so funny to slap his sisters on the ass, but I was certainly enjoying the spectacle. He gave us a tour of his house, showing us all the animals he had in the back. There were monkeys and snakes; there might have even been an alligator. The whole experience was mind-blowing. He invited us to spend the night and we were ecstatic—until our manager told us we had to leave because we had a flight in the morning. We were

so hot at him we could barely speak. How often do you get a chance to spend the night at the house of the King of Pop? Some people might want to insert a joke here, considering the legal battles Michael faced later on, but I was and always will be one of his biggest fans.

Michael and I remained fairly close over the years. Though we didn't spend much time in each other's company, we did talk on the phone quite often. He always called me "tough guy" because he said I wasn't scared of anything. He was mainly talking about how I didn't fear the public like he did. He told me that he just had a hard time trusting people. He didn't like people staring at him; being in public made him nervous. He felt that everyone was always judging him, which is definitely a sentiment I can identify with now.

But Michael didn't have that nervous, fragile demeanor when you hung out with him in private. When he was relaxed, he was very goofy and always joking around. I know some people may have a hard time believing this, but he spent a lot of time talking about girls. He'd point out a female walking by and say, "Look at that girl over there, Bobby. She's fine!"

And this wasn't done in a way where you might think he was just showing off for me. Michael was serious about it. He was always flirting with girls, making moves on them. Now, I can't testify as to whether he'd bring them back to his place, but he was definitely interested in them in the most

heterosexual of ways. And he seriously wanted my future wife. When I married Whitney, he told me, "You beat me to it, man, you beat me to it. I thought I was going to marry that girl."

"Yeah, whatever. I thought I was going to marry your sister," I said right back to him.

After New Edition had started receiving some local notoriety, but before our record hit the radio, I met one of the loves of my life. We were performing in a show at the Cathedral, the projects where Ronald DeVoe lived in the South End, right next to Roxbury. A female dance troupe called Phase Force was also performing that night, and my sister Carol was a member. Another member of the group was a girl named Kim Ward. She drew our attention right away because she was the cutest girl in the group—and the one with the biggest butt. She was fine as hell, with long hair and almond-shaped eyes. And did I say she also had a big ol' butt? All the guys in New Edition were checking her out. But after we performed and were in the area that was serving as our dressing room, the girls in Phase Force walked by and punched through the paper that was supposed to be providing us with some privacy.

"I want him," Kim said, notifying the girls in her group. Her finger was pointing at me. "That's the one I want."

All the guys started laughing.

Bivins said to me, "But that's the one I want to talk to, Bob."

"But she want me though, nigga! Sorry, can't help you," I said back to him.

We started seeing a lot of each other, going to the movies, hanging out in OP or in her neighborhood in Dorchester, Talbot Avenue, which was like a mini suburb. She was fourteen, a year older than me. For some reason, in my early days I always wound up with girls who were older than me. We did a lot of kissing, a lot of grinding. It was real hot and heavy. I was in love, and I'm pretty sure she felt the same way.

But there was one problem: Kim had been messing around with this dude named Timmy who was about seventeen or eighteen—way older than both me and Kim. Kim had broken up with him, but Timmy still hadn't reconciled himself to that fact. By the time we got to the summer of 1983, New Edition was well on its way to becoming a national phenomenon. "Candy Girl" was all over the radio and we had become local celebrities. All of these things made Timmy very unhappy when combined with the fact that I was messing around with his (ex-)girl.

One day when Kim and I were dancing together at a neighborhood block party, I found out exactly how unhappy Timmy was. We were getting into each other, dancing real close and enjoying each other's company. All of a sudden, I heard several people say, "Here come Timmy! Here come Timmy!"

Kim leaned into me. "I think you should leave, Bobby," she said.

But I was Bobby Brown and I wasn't scared of nobody. I wasn't running away just because her former boyfriend was coming. It was time for him to find out what was up anyway, that his girl was now my girl. I was eager to confront this dude I had heard a lot about. The fact that he had been locked away in juvie didn't scare me. I had put hands on dudes way scarier than Timmy.

These were the thoughts that went through my mind as I defiantly stayed out there dancing with my girl. The distress on Kim's face should have served as a warning to me. But it didn't.

"What?! I'm not running from nobody!" I said to her.

All of a sudden I heard *pop, pop, pop* and everybody started running. It took me a couple of seconds to realize what was happening: Timmy was shooting a gun. At me! Now I took off down the block, hauling ass, running for my life. My chest was pounding and my legs were pumping. I was by myself because the rest of New Edition had broken out earlier and left me there. So much for group solidarity—you're not supposed to leave your boy at a party by himself, even if he *is* chilling and dancing with his girl.

I was running so hard that I wasn't immediately aware that I had gotten shot. The bullet had entered the front of my knee and come out in the back. I didn't realize I had been hit until I had gotten far down the street and paused at the bus stop to see if I was out of danger. I felt something wet running down my leg, which began to tremble. I was wear-

ing sweatpants and they were beginning to turn red on the bottom half. So I pulled them up and saw a hole in my knee, surrounded by gobs of blood.

"Aww hell!" I said out loud. "I'm hit!"

There was a hospital not far from OP, so I hobbled my ass to the emergency room, now starting to feel the intense pain shooting up my leg. They grabbed me in the ER and put me down on a bed. They saw that it had been a clean shot, straight through my leg, so there was nothing to remove. Luckily the staff at this hospital had considerable experience dealing with gunshot wounds. They wrapped my leg up and sent me on my way. I'm not even sure if they gave me pain-killers.

I didn't tell anybody in my family that I had gotten shot. I went out of my way to hide the bandages on my leg from my mother. That just shows how much more freedom kids had thirty years ago. I could hardly imagine in this day and age my child being able to hide a gunshot wound from me! I only told my mother about the incident years later and showed her the scar. She was stunned.

I did tell my brother, Tommy, that I had been shot when he saw the bandages on my leg. Tommy and I were living together in the breakthrough—our family had gotten the apartment next door and broke through a closet so that we now had one large apartment with six bedrooms instead of three. My older sister Bethy was already out of the house, liv-ing with her new family in the building next door. My older

sister Tina was in and out, leaving Leolah and Carol on one side with my parents. So there was now plenty of space for all of us to have our own rooms. Tommy and I stayed together on the other side, in our little male sanctuary. He was home from college on summer break, otherwise he wouldn't have even been there.

Nobody in Orchard Park knew I had been shot. But I sure as hell told New Edition about it. I was salty as hell.

"Fuck y'all, man!" I said when I saw them. "Y'all just gonna leave my ass up there?"

"You should have come with us!" they said to me.

When I told them I had gotten shot and showed them the bandages, they were shocked.

One might think getting shot in the leg would be a serious issue for a member of a group that relied so heavily on dancing, but a weird thing happened when my leg started healing—my dancing got better. I can't really explain it, but after that I could do anything with my legs. It was like the injury gave me superpowers. When I saw the movie *Forrest Gump* a decade later, I could immediately identify with that scene where his braces fall off and he's suddenly able to run like the wind. I know you're probably reading this and laughing your ass off, but that's really what happened to me.

Kim and I got even more serious after I almost died for her. I was extremely careful when I went to see her though, making sure I got off the bus at a stop that was blocks away from Timmy's house and walking a path to Kim's apartment

building that wouldn't take me anywhere near him. Kim was still in the group Phase Force; so was my little sister, Carol. They would open for us when we did local showcases and they did a great job. They were bad as hell. Carol had this one signature move she would do, where one of the group members would tap her and she would fall back. It was kinda corny, but the crowd seemed to like it. Carol was feeling herself so hard back then that her head couldn't fit through the doorway.

———

A FEW WORDS FROM RALPH TRESVANT

I don't know why the public has believed Bobby and me were feuding, or were in competition, or didn't like each other. For some reason people were always saying that about our whole group. We've had this stigma follow us around for a long time that we don't get along and that's why we all went out and did solo stuff. So every time one of us did a project, people would say we were breaking up—while in actuality we were just taking advantage of opportunities to do different things in this business. Then when we'd come back together to do another record, they'd label it a comeback. And we'd be saying, "Comeback? But we never went anywhere."

Bobby was the only person who ever broke up with the group. He decided he wanted to pursue a solo career, so he left. Our management and the record company and others started coming at the group, telling us we might want to think

about getting rid of Bobby because he was a loose cannon and might mess things up for us. Some of the other members of the group wanted to address it. They were saying this was our ticket out of the projects, we had just started making it and couldn't mess it up now.

I remember we had a big meeting because Bobby didn't show up for *Solid Gold,* then he didn't show up for *Soul Train.* I wasn't on the same page as them. I've known him since we were like six years old. I was ready to pull my lead-singer card and say, "We're not going that way, we're not getting rid of anybody in the group. We all came out of the projects together and we're going to stay together."

But then when I went to Bobby, he said, "I want to do it, I want to go for it." That's what he told me. He said, "Just keep it rolling, man. Keep it alive because this solo thing just might not work."

But of course it did work, in a major way. He and I had been talking about this swing sound. I had these ideas that I had been working on. But I had to go back and do the *Heart Break* album with the group. So I was sitting on this style, this sound. And so my brother—Bobby—did it. I wasn't upset at all. I was excited to see it take off. My reaction was like, *I knew it could work!*

Bobby and I have always offset each other really well, ever since we were little. We each had enough respect for the other that we never felt like we had to fight or be in competition. Sometimes when he's too out there, I'm over here, more mel-

low. But when I'm too mellow and need to be more assertive, he's over here to push me. It just works out.

———

Growing Pains

With each passing day with New Edition, I began to feel more and more constrained, hemmed in. I knew I wanted to go out there and do my own thing. And I also felt like we were being taken advantage of in the group. It was all really bothering me. New Edition was getting paid a half cent on each record sold. What the fuck is half of a penny? People always ask me, *Why did you leave? What did you have to complain about?* Well, you can't live off half a penny, even if you sell millions of records. I knew it was time for me to go.

One day in LA, Michael Bivins and I had another brawl, but this time it was for real, not playacting like it had been years earlier in Transitions. Mike did the nastiest thing you could ever do to somebody. We were headed somewhere and I had hurried to get in the front seat before Michael. When you travel everywhere as a group, the front seat is a major prize because no one wants to be crammed together in the back. In all the commotion, Michael acted like his foot had gotten run over. Soon everybody in the car was laughing at him. So he walked up and spit in my face. Yeah, that's right—*he spit in my face.* I was so mad I couldn't see straight. I got out of that car and commenced to whupping Michael's ass. Khalil, our old road manager and head of security, tried

to break it up, but it continued when we got to the hotel. We kept fighting in the lobby and beyond. I was still kicking his ass. He picked up a fifty-pound weight and threw it at me. I kicked him in the mouth, drawing blood from his lip. It was ugly. I had had enough.

Toward the end of my time with the group, things got really tense. It felt like all the other guys had come together to sabotage me. They started to cut down my parts onstage to give me a smaller role in the performances. They would talk among themselves and the next thing I knew, my part would disappear from the song. One day I couldn't take it anymore and I exploded onstage. They had stopped the music and left me hanging out there. There was supposed to be more to the song, featuring my vocals, but suddenly the song was over. In my mind I said, *Fuck this!* I took the mic and threw it at Michael. I knew he was the one who was behind it—and there he was laughing at me. I said to myself, *That's it. This is my last show with New Edition.*

It was the last show I would do with the group for more than a decade. I left the group, got on a plane and headed back to Boston. It was over. So four years after our crazy odyssey began, I was out there on my own.

―――――

A FEW WORDS FROM TOMMY BROWN

I was a student at Northeastern University in Boston, nearing the end of my third year, when New Edition's first single was released. I remember how excited the family was by my little

brother's success. I'm nine years older than Bobby, so while I knew he was really into music, I was astounded that it was actually his group on the radio. Around this time my mother started telling me her concerns that the boys were being taken advantage of by their management. She told me, "Why am I sending my son away every weekend to perform and they're coming back with no money?"

I felt like I was in a prime position to get more closely involved and see exactly what was going on. I was majoring in journalism, but I had enough understanding of how the world worked to look after my brother's interests. My first official act with Bobby and the group was to accompany them to London in 1984, where they went to film three of their early videos, including the video for "Popcorn Love." Ricky Bell's mother also went on the trip with us.

At this point, the boys were constantly going on trips and getting dumped back in the projects before school, so we needed to find out where the money was going. We knew somebody was making money on these trips, but it wasn't the boys, who were still thrilled about all the fame and attention—which made sense, since they were just fourteen and fifteen. So they sued Streetwise and were released from their contract. The lawyers who brought the lawsuit were Michael and Steve Machat, who, along with Bill Dern and Rich Smith, ran the company that subsequently managed the group, Jump and Shoot.

We kept pushing the issue of finances with Jump and Shoot, but they could never give us a proper accounting. We

were new to the industry and my family could tell that the boys were being taken advantage of. Their first record was a big hit, all over the radio, and they were spending every weekend on the road, yet none of them were making anything. My mother was in Bobby's ear, telling him this wasn't right. But she didn't even need to tell him; he already knew. He was getting frustrated; everybody was getting frustrated. Even choreographer Brooke Payne and Travis Gresham, their first manager, were coming home broke because Jump and Shoot was getting all the money. As the story has been spun over the years, people have wanted to point a finger at Maurice Starr and say he ripped off the boys, but Maurice just produced that first album; he never managed New Edition. He never had his hands on the money either, so he didn't have the ability to rip them off.

When my family started making noise, the families of the other members got upset at us, telling us we were going to mess it up for everybody. They were saying we should just leave it alone. But my mother's response was, "Are you crazy? They're robbing these kids!"

Bobby didn't have the mentality to take this kind of mistreatment. He comes from a family that's not going to tolerate that. I remember the management company coming in from New York to have a big meeting with the five families that took place in our apartment. They were supposed to be coming with an accountant to give us a rundown of what was happening with the money, but instead they gave us some wishy-washy bull. So my mother got totally fed up and kicked them out of the apartment.

"Get moving—get out of my house!" she said to them. "I don't want to hear any more. See you all later!"

After that it got really rough with the other families. They were pretty upset with us. But we soon saw what the management company was up to when they came to us and started talking about Bobby going solo. While they were talking to us about a solo career, the management guys were going to the other members and telling them that Bobby was causing trouble for them and they should think about getting rid of him.

At one point they even had my mom at a meeting in a Boston restaurant talking about Bobby leaving the group and going solo, while at the same time somebody else on the management team was meeting with the other New Edition mothers at a different restaurant on the same street. My mother actually went to the other mothers and told them that the management was trying to play both sides, but they wouldn't hear it. Management's strategy was divide and conquer, making sure they didn't have to split up that pie. So they just built another pie that they could dig into. They went to the other members and encouraged them to take a vote to kick Bobby out, but at the same time they had big plans for Bobby as a solo artist. It was a very confusing and frustrating time.

If you want to understand the demise of New Edition and Bobby's separation from the group, listen to the last song he recorded with the group, called "Who Do You Trust." Study the lyrics, because Bobby spelled it all out in that song, on which he was the lead singer. The writing credits went to David Hurst

Batteau and Danny Sembello, who clearly had some sense of what Bobby and the group were going through.

In my opinion, this moment is where the whole "bad boy" reputation started, when he left the group. Despite what was going on behind the scenes with the shady financing and deceitful managers, Bobby got labeled as arrogant and un-cooperative. A troublemaker. A bad boy. That's where it all began. After all, who would walk away from a multimillion-dollar group? And to top it off, word got out that the group had voted to kick him out because he was irresponsible and missing rehearsals and shows, trying to destroy an extremely popular group. That was the official story fed to the press.

That's where the stigma started.

———

BEING BOBBY BROWN

ON MY OWN

My life changed pretty quickly when I left New Edition. It went from one extreme to the other. My first problem was I didn't have any money. I was seventeen years old, back in Boston, and I had to figure out what I could do to survive until I made my solo record. So I started selling weed. But that didn't last long—my brother found out. He was not happy and shut that down right away.

I then started writing and going into the studio and recording as much as possible. I would send songs to people I knew at MCA, and they liked what they heard. MCA had already asked me if I wanted to do a solo album, but I needed some time off from the grueling travel with New Edition. So I went to work on my first solo album, which would fulfill my part of New Edition's two-album obligation to Jump and Shoot. We called my solo album *King of Stage*. I've always felt that was the most accurate description of my performing tal-

ents. I may not be the most gifted singer in the world, but once I got out on that stage I didn't think anybody could match me. Years later my first wife would try to call me the "King of R & B," but that was never a title I claimed.

I had a big hit on that first solo album, a song called "Girlfriend" that climbed to number one on the *Billboard* R & B chart in 1986. I made enough money with that song to move my entire family out of Boston to Los Angeles—my mom, dad, sisters and brother. Everybody moved out west with me. I was fulfilling that vow I made to myself after Jimmy died to get out of the projects—though I had no idea it would all happen so fast.

While it was cool to have a hit song on my first album, I wasn't even close to satisfied. I wanted to do big things. I had a lot I wanted to say. But nothing could have prepared me for *Don't Be Cruel*.

Blowing Up

At one point when New Edition was out on the road, we were touring with the incredible Rick James. I spent a lot of time with him; I was drawn to him like a magnet. How could you not be drawn to Rick James—he was larger than life. I'd always loved his music, ever since those days dancing to my grandmother's records in her living room. But now he became a very dear friend to me. I learned so much from him, about life, about music, about women.

I would often go into his dressing room before the shows, just to absorb all the knowledge and wisdom I could. He was trying to teach me how to play the bass, that instrument I had always loved, so while we were having our lesson, he'd start talking. When he found out that we were smoking weed on the tour, he got pissed off. He was adamant—he'd say to us, "Don't ever do drugs, it'll kill you." And he'd be smoking a joint while he said it!

We said, "But you smoke it!"

"That doesn't mean you should smoke it," he said. "You're kids. When you get to be twenty-one, then you can talk to me about smoking weed."

My response was, "Man, whatever." I didn't stop smoking weed.

But beyond the weed discussion, Rick was a huge influence on me and the music I created for my second solo album. I wanted to take a little bit of Michael, a little bit of Prince, and a little bit of Rick, and mash it all up in a ball. That's the artist I wanted to be. From Prince, it was all about his originality. That was everything to me. And every move he made was cool, mysterious. I wanted to take Rick's wildness. When I got up on that stage, I wanted it to be like I had been let out of a cage. Growling, stalking, like a wild animal. And with Michael, it was about his precision. His mastery of the craft we all used, which is entertainment. I wanted to put all of those elements together and become this super-entertainer, jumping off risers and things like that.

To make my new record, I crisscrossed the country, working with great producers like LA Reid and Babyface, and Teddy Riley. When we were finishing our sessions on the West Coast with LA and Babyface, I just felt like we weren't quite done. I wanted to add more aggression to the album, something that had a harder edge to it. That's what brought me to the East Coast and New York City, where I was walking down the street when I literally bumped into Teddy Riley carrying his Casio keyboard under one arm. Though he was only two years older than me, Teddy had been a hot producer for years. He had started working on some stuff with his new group, Guy, but they were still a couple of years away from releasing their groundbreaking album, *The Future*.

"What's up, Teddy?" I said, genuinely pleased to see him.

"What's up, Bobby?" he said.

"Dude, we need to get together, do some songs," I said.

"Man, that would be great. I would love that," he responded.

So that's how I wound up messing around in his little studio in his apartment in Harlem, where he grew up. I took out my cassettes and played him a few grooves I had been working on. We were just brainstorming, throwing stuff out there and vibing off each other. He put down a pounding drumbeat and I immediately thought of this groove that had been bouncing around in my head for months. It haunted me; I would play with it every time I got on a keyboard. So when I heard Teddy's drumbeat, I got on his keyboard and

I played it for him. *Da dadadadum*. Teddy loved it. That became the unmistakable, addictive hook for "My Prerogative," which many consider my signature song—and the song that announced the arrival of a pounding, rhythmic, hip-hop-inspired approach to R & B that came to be called new jack swing. With "My Prerogative," I was definitely trying to make a statement about leaving New Edition and being on my own. I could do what I wanted, play what I wanted, spend my money where I wanted. Because of a contract dispute he was embroiled in at the time, Riley isn't listed as a writer and producer on the credits of "My Prerogative." He just got credited with mixing, but his influence is all over that record.

When *Don't Be Cruel* came out, it was like a bomb exploded on the American music scene—and in my life. I don't think I was fully ready for it. I was in awe of the success of that album. We stayed out on the road almost three years touring on that record, traveling across the globe. The first single was "Don't Be Cruel," and I rapped at one point in the song, so the radio wouldn't play it. This was 1988 and there were still many pop radio stations that considered rap some kind of scary black thing. So we took out the rap interlude so that we could get pop radio play. But then a funny thing happened—MTV started playing the video, featuring my rap. After that, the pop stations started playing the original version of the song, with my rap included. MTV set the standard.

We recorded forty songs and picked the best twelve. Nine of the cuts wound up going out as singles, nearly the whole

album. I became the first teenager since Stevie Wonder to hit number one on the *Billboard* chart, topping both the pop and R & B charts. *Don't Be Cruel* wound up as the top-selling album of 1989, selling over five million copies in that year alone (and more than eight million total over the years). I won a Grammy in 1990 for Best Male R & B Vocal Performance.

Along with my swagger and my music, I also introduced the world to my haircut, which came to be known as the Gumby. The haircut actually came about as an accident. I had a flattop at the time, and I was sitting in the chair of a famous barber in New York named Dinny Mo. Something happened and the razor slipped out of his hand. I think he actually said, "Oops." But I saw it in the mirror and thought we might be onto something. I liked the way my hair swerved asymmetrically. I told him to give me some parts coming down here and over there. Then I wet my hair and put some gel on it. My hair is naturally curly, so that completed the look.

"Yeah, this is gonna work," I said when I looked in the mirror. I was feeling it.

After I wore the style in the "Every Little Step" video, I started seeing it everywhere. To this day there's a whole little society in Japan called the Bobby O's, thousands of kids who follow everything related to Bobby Brown. They cut their hair like me and even dye their skin. It's been more than twenty years and the Bobby O's are still going strong.

A FEW WORDS FROM KENNETH "BABYFACE" EDMONDS

The creation of Bobby's *Don't Be Cruel* album was like the forming of a perfect storm. In the late eighties, LA Reid and I were out in Los Angeles, trying to sell records as the Deele and also trying to establish ourselves as writers for other artists. During a meeting we had at Universal, they mentioned that we might want to meet with an artist named Pebbles [who eventually became LA's wife], and they also mentioned Bobby Brown. At the time Bobby had that song out, "Girlfriend," and of course we remembered him from New Edition, but we didn't exactly jump on it.

We left the meeting and got in our car to drive back to our apartment on Highland. As we were driving, Bobby Brown came on the radio. He happened to be on a radio show where he would do a live performance. He was singing his song "Girlfriend" and at some point he went for a note he couldn't reach. Bobby got mad and he said, "I don't want to sing this song anyway." We were shocked. We said, "Can you believe he did that?" That changed everything for us. That told us this guy was crazy. We loved his crazy energy; he just didn't care. We loved who he was. Right then we knew, *This guy is a star*. That made the decision easy for us. We wanted to work with him.

When we finally got with Bobby, I don't know that he was that crazy about working with us, to be honest. He fought us on a couple of things. He fought us on "Don't Be Cruel." He

didn't necessarily think it was a good song. He fought us on the vocals. He was trying to *sing* and we were trying to keep him simple. When we put all the songs together, we did the best we could. But nobody knew Bobby was going to blow up.

We thought we did a good job. We knew it was unlike anything that had been out before. There were no songs like "Don't Be Cruel." It was unique; nothing that followed "Don't Be Cruel" has sounded like it. The whole structure of it was kind of different, the whole choral thing in the beginning. When Elvis did "Don't Be Cruel," we liked the words, and we wanted Bobby to have that kind of energy.

When the record came out, there was a moment that we knew it was really happening. Bobby was on tour with Al B. Sure and New Edition. We went to see the show, somewhere in North or South Carolina. Bobby started that tour opening up the show. He had already performed when we got there; a lot of people didn't see him. Al B. Sure was on the stage at the time. We visited Bobby backstage. We had seen that "Don't Be Cruel" was going into the top ten and would maybe even be a number one record. That was great. But what happened at that concert was more significant. We walked to the side of the stage with Bobby. The people who saw Bobby on the side of the stage just lost it. *While Al B. Sure was onstage.* Al was hotter than you could get at that point, but Bobby standing on the side of the stage caused such pandemonium that we were like, "Oh shit, this is crazy. He's getting ready to blow."

It was based on the song that was playing on the radio. It had already started.

We saw his energy in the video, we knew he brought something to the table as a performer. There was no question. But when he stood on the side of that stage without doing anything and they loved him, that told us something. It was maybe two months later that they changed the tour. Suddenly Bobby was closing the show. It happened that fast. I don't know of any situation I can think of where someone started out a tour as the opening act and in that short period was headlining.

It's not that Bobby has ever been a great singer. Bobby has been a great entertainer. Some people were just born to entertain. In my opinion, to this day there has not been another Bobby Brown. There are people who can dance, people who can sing, but when you look at Bobby Brown in his prime, the way he worked the stage, his entire persona, it's hard to touch that. The only thing close that I've seen, people who have a persona like that, you have to go back to James Brown and how he commanded the stage. You have to go to Prince, how he commanded a stage. Or Michael. Bobby Brown commanded a stage in that way. That was the magic of Bobby. And add to it his being a bad boy. Singing those love songs, the way he brought an edge to it. That just worked. He was the original bad boy of R & B.

————

The Bad Boy Is Born

There was an undeniable sexual energy I brought to the stage, even as a teenager. It became clear to me very early on that whatever I was doing had a serious effect on the ladies. Everywhere I went, I was swimming in a sea of beautiful faces. They couldn't get enough of me—and the feeling was very mutual.

Hollywood stars, starlets, singers, dancers, groupies, regular girls, church girls—I screwed them all. I was with some of the most beautiful women in the world. Just imagine: The year I had the number one album in the country, 1989, I was only twenty—a twenty-year-old who suddenly had millions in the bank and women climbing all over him. A twenty-year-old who just a few years earlier had thought he was too dark and ugly.

To put it mildly, I went buck fuckin' wild. My thinking was, get as much as you can while you can.

I remember one particular week when I happened to be in LA and one of my friends was dating a woman who danced with Madonna. Madonna told her friend to have me come to the studio, where she was working on an album. In 1989 she was at the height of her powers—and her sexiness. *Like a Prayer* had just been released and it seemed like everybody was talking about her and her knack for pushing the sexual envelope.

As soon as I got to the studio, we were introduced. Be-

fore I knew it we were in the bathroom. We got together a few more times, but I wasn't interested in dating her—she was just too wild, even for me.

———

A FEW WORDS FROM MARVIN "MARVELOUS" McINTYRE

Growing up in Roxbury, I was a good friend of Tommy Brown, Bobby's older brother. Bobby was just a nappy-headed little five-year-old when I met him for the first time. As he got older, Bobby used to tell me, "Marvelous"—which is my nickname— "when I get on, you need to roll with me. You're the smartest kid I know from the hood, so I want you around me."

I wasn't sure if I should feel complimented—after all, I wanted to be the smartest kid he knew, period. Not the smartest from the hood. But I always remembered what he told me. So in 1988, I was working in corporate America in Atlanta when Bobby called me. I was twenty-six and had graduated from college in New Hampshire. He was about to go on the *Heart Break* tour with New Edition and Al B. Sure and he said, "Marvin, I want you to come with me." He had recorded the *Don't Be Cruel* album and they had just released the singles "Don't Be Cruel" and "My Prerogative," which were starting to blow up.

I told him, "If I'm going to do this with you, I'm not doing it for the money—I'm doing it for the challenge and the experience." So that was my introduction to the music business. Almost thirty years later, I've never looked back.

When we went out on the *Don't Be Cruel* tour, I was the tour manager. Between 1988 and 1992, Bobby Brown was arguably the biggest artist on the planet minus Michael Jackson. It was amazing to watch. It was also hard to comprehend because I was seeing it and living it at the same time. Everywhere he went, he was a one-man PR firm, a one-man show. People of all nationalities around the world knew who Bobby was. It was truly an exceptional thing.

When we went to Japan, there was an enormous audience of Japanese people who didn't speak a word of English, but they all were reciting every word to "My Prerogative" and "Don't Be Cruel" and "Every Little Step." When we were down in Columbus, Georgia, they had this lewd-act law on the books, saying you couldn't gyrate on the stage. So being the bad boy that Bobby Brown is at the time, he's going to do what he wants to do. So he went out on the stage and did what he does best. He got arrested. They took him to a holding cell and locked him up. But as he was leaving—and I will never forget this—the sheriff and the officers who had locked him up bring this kid down to the jail cell. When Bobby walked out they wanted him to take pictures with the kid. That's when I knew this stuff ain't fair—I mean, you're going to lock this guy up for doing something, but then you want to do a photo op with him? Of course Bobby graciously obliged.

As tour manager my responsibilities were everything from advancing the next city, advancing the next show, to making sure folks got paid and doing all the administrative and logistical things pertaining to Bobby's moving around. It was excit-

ing; it was challenging. I've always embraced the art of being behind the scenes and structuring and development.

Overnight Bobby Brown became a name. When you said "Bobby," you meant Brown. Bobby was so hot that a promoter in London wanted him so bad that he flew him back to America on British Airways' Concorde so that he could meet a show obligation. At the time the Concorde was the fastest passenger jet in the world. I'm from Roxbury, Massachusetts, and here I am flying on the Concorde. I have so many amazing stories, amazing memories.

What made Bobby so successful was that New Edition was straitlaced: dress right, choreography, image, trim haircuts. Then this offspring of New Edition comes out with saggy baggy pants, the Gumby haircut, cussing, gyrating, doing all the things that don't represent the New Edition brand. The young girls of America looked at that and said, *Ooooh, he's giving me this? I want more more more.* Bobby Brown ignited the birth of the Ushers, the Chris Browns, the Trey Songz, the Ne-Yos.

What I always used to love about Bobby was his work ethic. He was such a hard worker that it was clear why he was so good onstage. This is something people might not expect to hear because of his reputation. But you don't get to be that good by accident, without putting some work in. I would tell him, "Robert"—I never call him Bobby—"you make it look so easy, make it look so unrehearsed." That's a true test of a star: if you can make stuff look so easy, like you don't have to rehearse it.

———

LOVING BOBBY BROWN

GROWING UP

I met Malika Williams through her sister, Mona, who had been dating Ralph Tresvant. Mona and Malika were from Los Angeles; Ralph and I started hanging out with them during one of New Edition's trips to the West Coast. Malika was a beautiful, sweet girl. I was seventeen and she was about the same age. She didn't even have a driver's license yet. As a matter of fact, neither did I.

Speaking of driver's licenses, it was an incident on the road that drew us closer. It was also the first of many unpleasant encounters I would have on the road with the police, encounters so frequent they sometimes feel like they comprise the CliffsNotes version of my entire life.

We were staying at the Franklin Plaza Suites in Hollywood, the hotel New Edition always stayed at when we were recording in LA. Her stepfather had this big-ass Lincoln that

her sister had used to drive the two of them to the hotel. Malika and I decided to go get some food for everybody, so we got into the Lincoln and took off. As I said, neither one of us had a license, but I was convinced that I was a good driver so it wouldn't be a problem. I was wrong.

I was driving along on Sunset Boulevard when I heard sirens and saw a fire truck coming toward us on the opposite side of the street. But instead of pulling over, I kept driving. Unfortunately, there was a police car just ahead of us. As I passed them, they turned on their flashing lights. But I kept driving. Malika was beside me in the passenger seat, freaking out. I finally pulled the car over.

When the officer walked up to the car, he learned that I did not have a license, but Malika was also not sure under what name the car was registered. I'm certain that in the officer's mind we were two teenagers out for a joyride in a stolen car, and nothing we could say would convince him otherwise. Next thing I knew, we were in the back of a squad car in handcuffs. A very promising night with a beautiful girl had quickly turned into a nightmare.

We were placed in holding cells at the police station. I was able to bail myself out, but they wouldn't let me bail out Malika. Finally they let her go because they didn't really have any charges against her. Eventually, she made her way back to the hotel. For some reason, the shared trauma of the experience brought us closer together. We had sex that night, without protection.

A couple months later I was on the road somewhere with New Edition and I got a phone call from Malika.

"Bobby, I'm pregnant," she said.

I let the words sink in. Right away I knew a couple of things: 1) I had no interest in trying to get her to get rid of the child; 2) I had to grow up real fast.

When her sister called and told me Malika had gone into labor, I hopped on a plane as fast as I could. But she had delivered Landon by the time I arrived in LA. Part of the reason I moved my family to the West Coast was so that I could be with Malika and the baby. I bought a big house in Tarzana and Malika and Landon moved in.

Having Landon come into my life changed me in profound ways. With the knowledge that I had a son, I felt stronger, more invincible, like his presence in the world turned me into a superhero. I felt everything through him; he became my strength, my motivating force. It's hard to explain but I felt the *King of Stage* album through him; I felt the *Don't Be Cruel* album through him. He gave me the strength to walk away from New Edition and do my own thing. He was my strength to get away from the projects and not take the little crumbs New Edition was willing to accept. He was my strength to move out of Boston to California.

As I look back now on my relationship with Malika, my overriding thought is that I was way too young to become a father. I was hardly ever there for them because I was doing

so much touring. I was still messing around with girls in every tour stop. I never slowed down for a minute, not even with a girlfriend and a baby back home. I'm a bit ashamed now by how I acted, how I treated her. She was extremely understanding, and I was an asshole. But at the same time, I never hid from her what was going on. I never pretended we were now in an exclusive, monogamous relationship just because we had a child.

She and Landon stayed in the house with my family for a bit, but soon it was time to move out. I got them an apartment that I called our new home, where we could try to be a little family unit, but I still wasn't ready. I was still cheating, leaving for long periods on the road. Understandably, Malika eventually couldn't take it anymore. She needed to be free, to stop pretending we were in a serious relationship.

Next thing I knew, she was dating a friend of mine, the actor Carl Payne. They eventually got married and had four kids together. They've now been married more than twenty years. At first I was upset that a friend of mine would move in on my woman, even if I wasn't being faithful. What made it worse was that he lived in the same building where her apartment was located, so I figured that he had been eyeing her while we were still together. This was after his appearances on *The Cosby Show* but before he became a star on *Martin*. Eventually, I got over it, though, and was happy for my girl. When things ended with Malika, I went back to Kim in Boston, my first love. Over the next few years we wound up hav-

ing two children, LaPrincia and Bobby Jr. Of course, I love them both dearly.

Through it all, I tried to make sure I took care of Landon. I would frequently take him on tour with me for extended periods of time, even when he was very little. I'm sure it was a pretty crazy life for him, to go from the normal day-to-day with his mom to becoming part of my entourage traveling around the world. He was growing up to be a very good-looking young man—and I could tell because one day when he was still in junior high school, I noticed some of the women on the tour looking at him extra hard. I couldn't believe it. I told them, "Girl, I'll fuckin' kill you if you go near my boy!"

But I knew that stuff was right around the corner. I couldn't believe how fast the time flew, how quickly Landon became a man. Now he's damn near thirty years old—a grown-ass man with a wife and an adorable little girl who is only a few months younger than my son Cassius. Yeah, Bobby Brown the grandfather. Has a nice ring to it.

———

A FEW WORDS FROM MALIKA (WILLIAMS) PAYNE

When I suspected I was pregnant, I called Bobby and told him. He didn't lose it or anything. We had become really good friends, aside from being intimate.

"What are we going to do?" he asked me.

"That's what we need to talk about."

So after some discussion, we decided we would have the baby. His mother was not very happy about that. That was understandable—she didn't know me from a rock. As for my mom, she wasn't happy about being a grandmother so young. My stepfather was disappointed, but he didn't go crazy or anything. I think Bobby's family was a lot more upset than mine was.

Back then you couldn't go to a regular public school if you were pregnant, so I had to do most of eleventh grade living in a residential dorm for pregnant teenagers. I would go home on weekends and spend weekdays in the dorm while attending classes. Bobby actually came to see me while I was in the dorm. He would come and hang out with me. But I would always make sure we were away from the building because I didn't want Bobby Brown up there around all these teenage girls. This is when he was going through all his turmoil with New Edition and parting ways with the group, so his name was in the gossip columns and teen mags all the time. It would have been ridiculous if Bobby Brown had walked into that dorm. I didn't even tell anyone who the father of my child was. It would have been way too much drama.

When the baby was born, Bobby wanted me to name him Jimmy, after a best friend of his who got killed. He also offered up the name Terrad. I don't know where he got that one from. My sister said maybe he thought it was "terribly radical." My son hates to hear the story about where I actually got his name: There was a report on the news about a missing child.

He was a little Mexican boy who was the cutest thing I ever saw. His name was Landon.

I knew Bobby was with other women all the time. In fact, he was kind of in my face with that stuff. It was kind of like, when he's here we're together but when he's not, we're not. He was still very young and he was doing whatever he wanted to do. I've always been an old soul, even when I was young, and I had an understanding of how things worked. He had a lot of money, he was very famous, and women would literally be throwing their panties at him everywhere he went. And he would succumb to all of that—over and over again. At some point I got tired of that. If we weren't going to have a real relationship, which I knew we weren't, I didn't want to do it anymore. At one point he even asked me to marry him. We were having dinner at a restaurant and he said, "If I asked you to marry me, would you?"

I said, "No, because you're a whore and I don't see you ever wanting to be with one person. I think you will always be this way."

His mouth just fell open.

"Did you really just say that?" he asked.

"Yes I did. It is what it is."

Eventually it was just over between us. It wasn't a formal thing. We didn't sit down and talk about it and mutually decide to end it. One day after he popped up again and expected us to be together, to be intimate, I just told him, "Look, you can't keep doing what you're doing. I'm not doing this anymore."

After Bobby and I went our separate ways, we stayed in contact with each other over the years. We had a child and now have a grandchild together, so we were able to remain really good friends. Throughout it all, I've always thought Bobby was an awesome person. I love him to death and I would never want to see anything bad happen to him. Behind closed doors when there's nobody else around, he's a good guy. But his intentions and his actions have not always matched. I think from a young age he always had freedom to do whatever he wanted. There really had never been anyone around him who could control him. With most of us, when we were young and dumb, there was somebody around to say no.

Bobby has been a breadwinner since he was fourteen or fifteen years old. So he's always called the shots. And from a very young age he's been on his own, not home with his mom and dad. He was a young teenager on the road by himself, figuring out how to be an adult. Nobody gave us lessons on how to be an adult, how to behave. It was something you made up as you were going along. As a result, for many years he was wild and crazy.

But he's a different person now. I tell him happy Father's Day and happy birthday every year, and he always calls me to say happy Mother's Day. I think we've been able to maintain a good relationship.

———

Around the World

In the early days of New Edition we used to have contests to see who could get the loudest screams onstage. Ralph always won—nobody could beat him. The girls were in love with that crazy motherfucker. But I tried—and I was always a strong second. Ralph had the voice, the smoothness, so I had to use my sexiness. It was always there. But when I went solo, it was like a beast was unleashed, like someone had opened a cage and just let me out. I guess in this analogy the cage is New Edition. When I went solo, I had total control—of my music, my show, my moves. I sometimes asked Brooke Payne to help me with the choreography, but most of it was me—an entire routine sprouted from my imagination.

On January 25, 1989, four days after the *Don't Be Cruel* album hit number one on the *Billboard* chart, where it stayed for six weeks, I was arrested by a police officer in Columbus, Georgia, for violating the city's "lewd law." It had only been on the books since 1987, when the city council came up with the ridiculous law following a crazy Beastie Boys concert. The Columbus ordinance prohibits performers from "simulating sexual intercourse" onstage. At the time I was outraged, thinking it was extremely unfair since I hadn't even touched the girl the police officer said I was dancing with in a lewd way. It was a regular part of my act, bringing a female fan up to dance suggestively with me onstage. I know offended authorities had threatened to arrest Elvis back in the 1950s

for the way he danced, claiming he was corrupting America's youth, but I incorrectly figured we had made progress in the three decades since then. I got arrested in the middle of my Columbus show and dragged down to the police headquarters. After posting $652 bail, they let me go—and I went back to the arena to resume my concert an hour later. Surely that was one of the strangest intermissions in music history.

Although I was highly pissed at the time, I eventually realized that the arrest was the best thing that could have happened to me when it came to album and ticket sales. With all the media attention that was directed at me due to my arrest, literally overnight I became more famous than ever. Another layer was added to the "bad boy" persona.

In 1988, just as *Don't Be Cruel* was being released, I embarked on a national tour with my old bandmates New Edition. Joining us was Al B. Sure, who was also blowing up that year with his huge album *In Effect Mode,* which included the hits "Nite and Day" and "Off on Your Own (Girl)." There was a bit of tension with the New Edition guys. In fact, when they heard that we were going to record my stage performance of the hit "Roni" to use as the song's music video, they insisted that their show also be filmed. But I don't think anything was ever done with the New Edition footage.

When promoter Al Haymon approached me to splinter off on my own separate tour for *Don't Be Cruel,* I was ready. I got some really talented dancers—four girls, two guys—to back me up, and we dove into the minute details that make

up a tour and a stage show. The money was rolling in at an unprecedented rate, and we decided it made sense to buy all the stuff we would be bringing out with us—speakers, system, instruments, wardrobe—rather than rent it and wind up paying a lot more. We changed about three or four times during the show, so we also needed lots of clothes. I laid out a lot of cash to launch that tour.

One of my signature moves during the stage show was when I yelled, "Are you ready?"—then I leaped off a platform that was about twenty feet high, spread-eagled while in the air (like Michael Jordan on one of his signature dunks), and landed onstage in a crouch. My brother would go on the platform when it was being set up and be afraid to drop down—and then he'd try to persuade me to stop being so risky. I did that stunt every night for three years and never once did I stumble or bust my ass. But I do have painful shin splints now, I'm sure from doing crazy moves like that back in the day.

Putting together a tour takes a considerable amount of work, but if you do it right and there is a great demand, you can make a ton of money—as long as you have the right people on your team who aren't trying to rip you off. After the experiences I had had with New Edition, the only person I really trusted at the time to negotiate on my behalf was my brother. So we would go into most of the meetings together, and usually emerge with exactly what we wanted. My mother was also involved in looking after my money. For

this tour, we had a sponsorship from Budweiser and guarantees from the venues. If we sold out, we would pull in an additional $200,000 per night. We made more than $700,000 per night on that tour. Of course we had significant overhead, more than $50,000 a night, but I was still walking away with stacks. Actually, I was carrying a lot of it around with me in briefcases. It sounds crazy now, but my trust level was really low at the time. And for some reason having the money in my hand boosted my confidence and made me feel even more invincible. Maybe this is related to growing up in a poor neighborhood, surrounded by a community of people who didn't have anything. But I don't even need to get all Freudian—that shit just felt good. In total, I made at least $30 million on that tour.

I'll admit that I began to take the fame and fortune for granted, perhaps because it came when I was so young. I threw so much money away on silly shit. Don Cornelius once asked us on *Soul Train*, "What are you gonna do with all this money?" My answer? "Spend it." And I surely followed that philosophy. Saving was just not part of my makeup at the time. Once I started making the big money, I didn't ever think I could or would go broke again. My thinking was, *I can always do another show.* Some people who come into big money after being poor hold on to it like it's giving them life, but I had the opposite reaction—losing money wasn't scary to me. Still, I'll admit that I was ridiculous with it, literally tossing cash out the window.

Like a lot of the newly rich, one of my obsessions was buying cars. I had a bunch of young guys who hung around me all the time and we were just crazy as hell. We would leave cars everywhere, and that became one of my things. When I was touring, if I saw somebody driving a car that I liked, I would get off my tour bus and ask them if I could buy their car. I'd be traveling with hundreds of thousands in cash, so meeting their price was never a problem.

Once when we were in San Antonio, I saw this guy driving a gorgeous white Benz, a four-door 500, and I fell in love. Oh my God—it had beautiful rims. I am pretty sure the brother I bought it from was a drug dealer.

"How much you want for that car?" I asked him.

I can't remember exactly how much I paid. I think it was somewhere around $50,000. At this time I was messing around with a girl in San Antonio whom I saw every time I passed through. Sometimes I'd fly in to see her even if there wasn't a concert. My favorite hotel had an ice-skating rink inside of it, so she and I would go ice-skating and do little-kid shit like that.

After partying and driving around in my pretty white car, it was finally time to leave. Mike Tyson was with me. Mike and I spent a lot of time together back then. We were both young (though Mike was three years older than me), extremely rich, and trying to fuck everything that moved. That was enough to create a bond between us.

When we got to the airport, I didn't know what to do

with my new car. I hadn't made any kind of arrangements to get it back to my LA mansion.

"Bobby, what are you going to do with the damn car?" Tyson asked me.

"Let's just park it here," I said, pulling up to the curb right outside the terminal. "We'll come back for it later."

I never went back for it. I don't even know what happened to that car. It was probably towed somewhere and auctioned off. Somebody made out like a bandit. Or maybe they gave it back to the drug dealer—who knows.

This is when Tyson was still champ, so when we hit a city, it was ugly. Together we just knew we were the shit. We thought we could do whatever we wanted. He would follow me on tour; I would go to his fights. One time when the tour was in Cleveland, Mike pulled up to the hotel in a Lamborghini truck. The thing was enormous.

"Man, I'm too fucked up to drive," he said as he climbed down from the driver's seat.

"Nigga, I'll drive this motherfucker!" I said, getting behind the wheel.

I should point out that it was the middle of the winter in Cleveland and there was about a foot of snow on the ground. But of course that didn't deter us. After all, we were in a giant Lamborghini truck. So we bounced around Cleveland in the snow, with no security, just me and Tyson, hitting the clubs, drinking, hanging out. On the way back to the hotel, we heard a loud noise. Clearly, I had run over something. When

we got out to inspect, we realized it was a small car. That's how big this fuckin' truck was—you could run over a small car and just feel a little bump in the road.

"It's all right, Bobby," Tyson said. "I'll get that fixed tomorrow."

I can honestly say our friendship took me by surprise. From afar, Mike didn't seem like the kind of guy you would bond with very easily. When he was champ, he had a reputation as mean and ornery. But we hit it off right away. He had come to one of my concerts and wanted to meet me, so they brought him backstage.

"Damn, champ, what's up?" I said.

"Bobby Brown! Oh shit!" he said, extremely excited. "Man, your concert was awesome!" He did some kind of dance move, I suppose imitating me—but he can't dance at all.

"What are you doing later?" he asked. "Let's go out, do something, have drinks or something."

"You can't drink—aren't you in training?" I said.

"Bobby, I been busting everybody's ass for the longest. I can handle a few drinks," he said.

And thus a great friendship was born.

We got so close that it almost felt like he was part of my family. Actually, he almost *was* a part of my family—he dated my older sister Leolah for a time. At first I was worried, like, "Hey, hold on. You can't be dating my sister and doing all this wild shit." But they got pretty serious. Mike was crazy

about her. And he was always very good to her. My father became a father figure to him; that's how close they were.

The night before Mike got beaten by Buster Douglas, we had been partying together in Japan. I was there because I had just done a show in Osaka. Mike's fight was in the Tokyo Dome. We were up literally all night screwing a room full of Japanese girls. I was staying in a huge, expensive hotel suite that took up the whole floor, and it looked like the suite was absolutely filled with beautiful Japanese women. And we were trying to get with every single one of them.

At one point I looked up and saw it was somewhere around three in the morning, so I said, "Hey, Mike, you gotta get some sleep, man. You don't need to be fucking all these girls. You ain't supposed to be doing that the night before a fight."

His response was vintage Tyson: "Bobby, that's nothing but a fuckin' myth. They just say that to fighters to try to control us. That's ludicrous, Bobby. Just watch me. It's Buster Douglas. The fight will be over in three rounds—if I allow him to go three rounds."

So on the night of February 11, 1990, just six days after my twenty-first birthday, I watched the fight at a huge mansion in Osaka that belonged to a friend of ours. My show was later that night. When Mike went down in the tenth round and couldn't get back up in time, I cried like a baby. My heart just fell out of my chest. I felt like it was my fault. I had kept him up all night partying after my concert. I called my dad and he was crying too.

Mike would later admit in his 2013 autobiography, *Undisputed Truth,* that he had been doing way too much partying and not nearly enough training in the weeks leading up to the Douglas fight, almost as if he wanted to lose to relieve the constant pressure on him. But that didn't take away all the guilt I had been carrying around for twenty-three years.

Even though he held the championship for the last time in 1996 before losing it to Evander Holyfield, I can personally attest to the fact that Mike still hits harder than a mule kick. One time we were working out together, doing some sparring. I've always been pretty confident that I could do some damage with my hands. I had already sparred with Tommy Hearns. I felt like I knew what I was doing. Mike was letting me hit him, but I slipped up and hit Mike in the face with a right cross. With my bare fist.

Suddenly, all motion stopped. Mike looked at me like I was crazy.

"Bobby, why did you hit me so fuckin' hard?! What's wrong with you? I will hurt you, Bobby!"

But I was still delusional, so I didn't take him that seriously.

"Yeah, whatever," I said, all cocky. "You just getting slow."

Yeah, that's right, I was arrogantly mouthing off to the man many consider the greatest, scariest fighter of all time. Not smart.

Mike crouched down, came toward me, and *boom boom boom.* He hit my ribs on my left side in rapid succession. I

thought I was going to stop breathing. I couldn't believe how much it hurt. I dropped to the floor and curled into a fetal position.

"See, Bobby, I told you to stop playing!" Mike said.

Now in our middle age, Mike Tyson and I will sometimes sit around and talk about how much of a waste it can be to give hundreds of millions to a kid barely out of his teens, as our society does with athletes and entertainers. We were let loose on the world with no direction, no financial advisers who really cared about us, not enough people watching our backs. To most of the people around us we represented a paycheck—not somebody they should be looking out for. Because if we had people who were really watching our backs, they would have quietly stashed away money in a trust somewhere so that later on, when things got tough again, they could come to us and say, "Hey, man, guess what? You're not totally fucking broke! I put a hundred million dollars over here in this account just for you, just for this very moment."

But of course, ultimately it was our responsibility, what we did with our money, how we squandered it and failed to do any long-term planning. I'll be the first to tell you we were stupid and immature, lacking the type of role models who might have advised us properly.

When you're young, you want to surround yourself with as many people as possible. I'm not even sure why having an entourage adds to the fun, but it does. I had a whole lot of people out there on the road with me; all my boys were on

the payroll. Everybody on the tour would get their weekly checks, plus a certain amount per week for food—I think it was about $300. But we would always have food backstage, so many of them were pocketing most of the per diem too. I know one dude who never even cashed his per diem checks—he was always with me when I went out to eat, and he knew I paid every restaurant bill.

When the tour stopped in Japan, I wound up dining at the emperor's palace, which is where I developed my lifelong love of sushi. I sat down inside that unbelievable place and stared at a plate of brightly colored food, looking unlike anything I had ever eaten before. I had a smile on my face, but my mind was thinking, *What the fuck is this?* But I had already learned to allow myself to accept new things, new cultures. When I picked up one of the pieces, it melted in my mouth with an explosion of incredible flavors. Oh my God, it was so damn good. After trying sushi for the first time at the emperor's palace, one might think it would all be downhill from there. On a few occasions I have had sushi to rival that, but it hasn't been often—and I'm still on a constant quest. After sampling sushi all over the world, ironically some of the best sushi I eat now is at a less-than-fancy little joint in the San Fernando Valley called Sushi Spot, which is in a strip mall next to the 7-Eleven. They are one of the few places I've come across to serve *toro,* which comes from the fatty belly part of the tuna. That stuff is unbelievable. And though I've been looking for more than twenty years, I still

haven't found tempura as good as what I had that night at the emperor's palace.

The whole tour was mind-boggling, but it brought me immense satisfaction. There was something very gratifying about knowing the whole thing was mine, under my direction, something I created. There was nobody to tell me what to do, when to do it. I had total control of what happened and what I did. I wasn't heavily into the drugs yet at this point. Mainly we were smoking weed and drinking, and mostly beer. And of course there were lots of girls. Way too many girls.

Some of the encounters could be filed under the category of unexpected. For instance, there was the night with Jessica Hahn. This was a few years after she brought down televangelist Jim Bakker with allegations that he and another preacher had drugged and raped her when she was working as their church secretary at the age of twenty-one. At this point she was ten years older than me, and she was apparently a big fan. She attended one of my shows and came backstage to meet me. And she sure as hell did meet me that night.

There were so many sexual encounters, many of them blur together in my mind. But there are others that I remember as vividly as if they happened yesterday. Sometimes I will turn on the television or go to the movies and I will see one of the women, more than two decades later, and the memories will come flooding back to me.

We also had way too many guns. I'm not talking just

regular handguns, I mean like big semiautomatics. I had all this money around and I guess I was paranoid, but luckily some smart thinking by my security detail kept us from getting into real trouble. One night in St. Louis, we had a major beef with these kids who were talking shit to us. When we got back on the bus, all of a sudden we heard gunshots. We realized we were taking fire—those motherfuckers were shooting up our bus! Crouching down to avoid getting hit, we all ran to get our guns and looked for safe spots to shoot from. We found spots where we could safely fire back at them. But instead of gunshots, it was *click, click, click*. None of the guns had bullets in them. Turns out our head of security had taken all the bullets and hidden them underneath the bus. In retrospect it was a genius move because somebody would have gotten killed that day. But at the time we were pissed as hell. We jumped him and started beating his ass.

Triple B Records

After the enormous success of *Don't Be Cruel,* I signed a new contract with MCA that was extremely lucrative. As part of the new contract, I got my own record label, where I could develop and produce my own acts. But I didn't want to do all of that from Los Angeles, which was feeling too confined and incestuous. I wanted to break away and put down roots in a new place. I also saw that when we looked at our royalty reports, 70 percent of the radio revenue was coming from the

South. I realized that our audience was mostly down there. If you wanted to break a new record, you didn't even have to think about the West or the Northeast. You could do it exclusively by concentrating on the South. So I figured, why not relocate to the hub of the place, Atlanta? This was before Outkast and Jermaine Dupri and the development of the Southern sound. Music-wise, there was nothing in Atlanta when we got there. It was all new, fertile ground. We called our label Triple B Records (my middle name is Barrisford). We also bought a full-fledged recording studio that we called Bosstown Recording, so we could do everything from signing the artists to recording their music to mixing and mastering the final album. It was one-stop packaging.

We put together an impressive collection of artists who we knew were going to make a big splash. We had an incredible vocalist named Dede O'Neal, who eventually wound up being signed by LaFace. My younger sister, Carol, who was a talented rapper by the name of Coop B, was part of our camp. At one point we were working with Usher. We had a vocalist named Harold Travis and a hot rapper by the name of Stylz. One of our most exciting acts was an R & B quartet by the name of Smoothe Sylk—a group that turned out to be the label's downfall. The guys in Smoothe Sylk kept coming to me asking for money, saying they were broke and needed to make ends meet. We were just a couple of months from the release of their first album and they came back yet again, looking for more cash.

"Dudes, I don't know what you're doing with this money, but for the next couple of months you better figure something out. Go get a job at McDonald's or something, because I'm not advancing you any more money. Y'all need to budget your money or something."

A few days later, I got a phone call delivering news that I just refused to believe. Two of the guys in Smoothe Sylk had gone out and robbed a bank. They couldn't wait until the release of their album, which everyone was certain was going to be a big hit. The executives at MCA flipped out. If the Triple B acts were going to be this risky, they had serious doubts about the entire venture. In the end, the label put out just two albums—a compilation album featuring all of the artists called *B. Brown Posse* and an album of remixes of some of my songs called *Remixes in the Key of B*.

When I look back on that time now, I feel a certain amount of regret that I didn't handle things differently. I dropped so many balls and it affected many other lives. I immaturely walked away from the business. There was so much amazing music that we recorded that is just sitting in the vault—actually in my garage. Incredible music that no one has ever heard, that could have made a splash in the industry. In retrospect I didn't have the right people working in a management capacity with the label and clearly I wasn't invested enough. Since the whole venture was mine, I'm prepared to take the brunt of the blame. My sister was an extremely talented artist who should have had a long ca-

reer. The same with the rapper Stylz and the vocalist Dede O'Neal. They were all depending on me and I let them down. I shouldn't have allowed them to miss out just because I fell in love and was negligent. We made great, timeless music together—it wasn't bullshit. I had the raw tools to build a real dynasty, but I didn't have the mind-set. I was the first artist to create a personal label and have it backed by a major. Now every other artist does it.

I had a lot of great times in that Atlanta recording studio. I produced and appeared on two songs from Shaquille O'Neal's third album, *You Can't Stop the Reign*. Shaq's raps were written by Peter Gunz and we had the best time working on his music. Shaq is a beast. The sessions were so much fun, I can't help but smile when I look back on them.

I always made sure there were plenty of beautiful, sexy women around the Bosstown studios. And they were eager to make sure the artists coming through there were comfortable and relaxed. They were a hell of a welcoming party.

When I say that my Atlanta mansion was the scene of a three-year-long party, I'm not exaggerating. It was like Hugh Hefner's Playboy Mansion acquired feet and scurried down from California to Atlanta. One of the first houses we were shown by our Atlanta real estate agent was this incredible place that had previously been owned by Mike Thevis, a prolific pornographer who in the 1970s reportedly controlled 40 percent of the American market. Books, magazines, movies, X-rated theaters, adult bookstores, automated

peepshows—Thevis lorded over them all. Known as the "Scarface of Porn," Thevis eventually branched out into the music business, with several Atlanta-based labels. His annual income at one time was estimated at $100 million. Eventually, though, the government caught up to him, first convicting him of distributing pornography, then in 1980 he was found guilty of murdering two of his former associates.

From the looks of it, he'd had to leave this fourteen-thousand-square-foot Tudor mansion in a hurry because many of his belongings had been left behind. I fell in love with the place right away. It was completed in 1972 and originally called Lions Gate, with eighteen sprawling acres behind a grand wrought iron entrance on top of a hill overlooking the magnificent grounds. There was an entire pool complex. There were even stables, not that I cared about horses.

Outside the home were five thousand square feet of patio and terrace areas accessible from all the rooms on the first floor. Inside was a world-class gourmet kitchen, seven bedrooms, six bathrooms and three powder rooms. This joint was crazy. As a matter of fact, I was told that it was the largest home built in the United States in 1972 when it was completed by Atlanta architect Robert Green.

I quickly went to work to put in my own touches. I had windows installed with portraits of me made out of stained glass. We got rid of the murals of angels and demons Thevis had painted on the walls and ceilings. A taxi driver told my brother that he used to drop people off at the house quite

frequently and once saw a bunch of men having sex with young women on the lawn. Well, the taxi driver actually said "raping" women on the lawn.

In my hands, the house took on a younger feel, with my mother in charge of the redecoration. We put in a gold staircase that led to big gold doors outside my bedroom. We installed a giant fish tank that went under the staircase all the way up to the second floor. There were always other people in the house with me—some of my boys actually lived there. Atlanta is a big strip-club town, so many of the local strippers would get off work and come to my house to spend their days. There would be beautiful big-booty strippers walking around all the time, but clothed, because my son and nephews were often there too. One of the house's most memorable features was the pool—it was all black on the bottom, at one end about twenty feet deep, with a bridge crossing over it, giving it the feel of a deep lagoon. To this day it remains one of the baddest pools I've ever seen.

I gave my son Landon a couple of over-the-top birthday parties there in the early 1990s. For one of them, I had the real Teenage Mutant Ninja Turtles come. I'm talking the actual dudes from the movies, wearing their actual costumes. I don't remember at all how much this cost, but it must have been a small fortune. At the time, I certainly wasn't thinking about the pain of writing a check for something like that. Because MCA owned Universal Studios it was easy for me to get the real Ninja Turtles because it was a Universal franchise.

You might ask whether it was necessary to go all out and get the real Ninja Turtles, but my son would have known if they were Turtle impersonators.

A year or so before the Turtles birthday, I dressed up as Batman for his party. He took one look at me and was like, "Uh, you're not Batman, you're my dad."

"No, I'm not your father, I am Batman," I said, trying to disguise my voice.

I then ran into the house and had my brother come out with the outfit on while I strolled out in regular clothes to stand next to Landon.

"Dad! Now that's Uncle Tommy!"

I couldn't fool his ass to save my life, so I figured I needed the real Ninja Turtles.

Despite all the fun we had down in Atlanta, I sensed that a lot of evil shit had gone down in the house while Thevis lived there. To this day I believe that house was haunted. Pretty soon it was a generally accepted fact among my family and friends that there were supernatural presences there. Some of the ghosts were definitely upset. We often would see white women walk down the hallway. People would bust out of their rooms, screaming, "Did you see that?!"

One memorable night, one of the ghosts descended from the ceiling and had sex with me. After you stop laughing, I need you to hear what I'm saying because I'm not making this up. And let me add this: this was before I ever touched any drug besides weed and alcohol. I don't think anybody

can drink enough alcohol to make them think they are actually having sex with a ghost. In my bedroom I had a big round bed with a mirrored ceiling looming above. I always slept in the nude, so one night I woke up to the sensation of a woman on top of me. I looked up and in the mirrors I could actually see a white woman straddling me on the bed. The sensation felt exactly like sex—I could feel my penis inside of her and everything. It was not a dream; I was definitely awake when it was happening. All of a sudden, she was gone—leaving me alone and incredibly excited and terrified at the same time.

The entire time I was in the house, Thevis's brother kept on us about selling the place back to him. He approached us so often that we became suspicious there was a stash of money hidden somewhere. That feeling was exacerbated by the layout of the basement, where Thevis had constructed a maze of little rooms and compartments separated by cinder blocks. At one point we had security crawl the entire length of the basement, which was about the size of half a football field, to see if they could find anything. But they never did.

While I lived in that house, I also experienced a scary incident of extreme racism. It was a real welcome to Georgia. One night we heard a great deal of commotion. When we looked out the door we were shocked to see a cross burning in my front yard. A bunch of us went running outside—me, my nephews, our security guys. We saw a couple of pickup trucks screeching away. One of the security guys squeezed

off a couple of shots but didn't hit anything. Then we saw that one of the trucks wasn't starting. The white guy behind the wheel had a terrified look on his face as we ran toward him. We broke his window and I reached inside to punch him in the face. In the process I gashed my forearm and wrist on the broken glass—I still have the scars from the incident.

We dragged this guy out of the truck and proceeded to beat his ass, punching him and kicking him while he moaned in pain and tried to block the blows. There was no sign of the rest of them; they had left him there. After we were done with him, we put him back in his truck, got it started and parked it right outside my gate. Then we called the police and told them what happened. When they arrived, they asked if we wanted to press charges and make a report.

"No, he got exactly what he deserved," I said. "He should go back and tell the rest of them."

BOBBY IN LOVE

As my star was shining bright with the success of *Don't Be Cruel,* I began an intoxicating, whirlwind relationship with the beautiful, sexy Janet Jackson. Talk about the benefits of fame. This was a couple of years after Janet shook up the music world with her album *Control.* The awesome *Rhythm Nation* album would come a year later, in late 1989. *Don't Be Cruel* was the top-selling album in the country in 1989; *Rhythm Nation* would be the top-selling album of 1990.

Of course I had met Janet a few years earlier when New Edition was running around her brother's house. I had had a crush on her for years, so it was exciting as hell when I discovered that she was also attracted to me. Janet gave off this image of being all sweet and innocent, but when it was just the two of us she could be wild and uninhibited. She was nearly three years older than me, but the age difference

didn't seem to matter much. We were young, horny and extremely taken with each other. Nature didn't need a whole lot of help in getting us in bed.

One vivid memory I will always have is of one of the times we spent the night together at the Le Dufy Hotel, a small luxury spot in West Hollywood. Janet was trying to leave and I didn't want her to go. So when she tried to pull off in her car, I playfully jumped on top of the hood. But as she flashed me that blinding smile, she kept driving the car. Her smile that day was incredible, sexy, sweet, a smile I fell in love with. I think the whole world fell in love with it. A few years later, director John Singleton used her smile as the final image we saw in the movie *Poetic Justice*.

Janet kept slowly driving the car through the garage with me on the hood, daring me to risk staying on when she hit the street. She would stop, hit the gas pedal, and then drive a little bit more. It was a really nice moment. I rode on that hood until just before the car emerged from the garage. If my memory is correct this was one of the last times we were together and it was just pure fun.

Because Janet was already with Rene Elizondo Jr., the guy who would eventually become her husband, Janet and I were sneaking around a lot, with her friends helping us rendezvous in different places. We would meet at one of her friends' house, or her friends would bring her to meet me at a hotel. It was difficult, but I took whatever I could get of her time.

Janet didn't drink, she didn't smoke. She didn't have any of those vices. She would curse sometimes, but that was all. When we were together, we did more laughing, kissing and talking than anything else. I was really into her. I think I was in love with her before I even met her. In fact, I went on TV and told the world that I was in love with her and wanted to be with her for the rest of my life.

One of our favorite dates was meeting at this Häagen-Dazs ice cream shop off Ventura Boulevard. We both really liked strawberry ice cream, so we would get our cones, sit down in a corner and giggle together. In a lot of ways, it felt like high school dating. Or what I imagined high school dating was like. And we weren't all that much older than high school students. Since neither one of us actually went to high school, maybe this was our way of having those types of regular adolescent experiences—even though we were two of the biggest stars in the music business.

This was back in the days when you were allowed to talk on the phone while you were driving, so when we were in our cars we would call each other. Of course our phones were those huge, clunky gray bricks. Remember those?

I was so taken with Janet that I bought her a car for her twenty-third birthday on May 16, 1989. It was a white Jaguar with this gorgeous blue interior. And to add a touch of class, I put an incredibly cute little white chow puppy inside the car. Janet was blown away by the present—but she wouldn't accept. She was still with Rene, so she couldn't be coming

home out of the blue with a brand-new car *and* a brand-new dog. I guess I hadn't thought it out very well. So I wound up keeping the car and the damn dog.

One of the biggest challenges Janet and I faced, in addition to her relationship with Rene, was the fact that we were both so unbelievably busy. I was in the middle of touring for *Don't Be Cruel,* and she was working on what would become *Rhythm Nation,* so we just didn't have much time together, and it was inevitable that things would come to an end. Her friends were telling me she wanted to leave Rene so that she could be with me, but it was hard for her because of her family. It wasn't until a few months later that I found out what that really meant.

When Janet and I officially broke up, it was quite an ugly scene. We were together again at the Le Dufy Hotel when it happened. We were lying together in bed after having sex—as it turned out, for the last time. The talk turned serious. Janet told me she loved me, but she wasn't "in love" with me. Her friends had already told me that her father didn't want her to be with a black man. Then Janet confirmed this.

"Yeah, my father won't allow me to be with a black man," she said.

I couldn't believe it. What kind of woman was she, a black woman allowing her father to make such a crazy ultimatum? I exploded. Cursing the whole time, I pulled her out of the bed and pushed her out of the room, naked. She screamed when she realized what I was doing. Just before I

slammed the door, I saw the shock on her face. She was in the hall without a stitch of clothing. The small part of me that was thinking rationally realized I couldn't do that to her. I mean, this was Janet Jackson. So I opened up the door again and threw a sheet out at her.

If she couldn't be with a black man, then she could get the fuck out of my room.

I was stunned that Janet was so weak, letting someone else control her life like that—never mind succumbing to some self-hating racist shit. How ironic that she had just blown up with an album called *Control*. Here I am, one of the most successful artists in the business, swimming in millions of dollars, and you can't be with me? Because of your father? Who's *really* in control here? It made no sense. I was devastated and confused.

I was so hurt by Janet's rejection that I went in even harder after that, having sex with any woman in my vicinity who was interested. My dancers were fair game, as were many other women in Hollywood. This is when I really started messing around with the beautiful actress LisaRaye McCoy, who was trying to get her career off the ground and a few years later would hit it big in Ice Cube's movie *The Players Club*. I was also seeing a lot of one of my dancers, Shane. I admit it now: I was a fiend.

But then I began a relationship that would not only change my life but also shake the entire music industry to its core.

Whitney

So many words have been written about my marriage to this woman, so many people on the outside wildly speculating about things they didn't know anything about, that I almost feel like I need to draw some type of diagram refuting every crazy rumor that has circulated about us over the years. But instead of focusing on the crazy rumors, I will just give you the details of our incredible love story and let you see how much we were truly made for each other, how much genuine affection flowed through our relationship and our household, how much most of the stuff in the gossip rags was pure bullshit.

It all started at the Soul Train Music Awards in April 1989, at the Shrine Auditorium in Los Angeles. That was the first time I ever met Whitney Elizabeth Houston. "Don't Be Cruel" had been nominated for Soul Train's Best R & B/Urban Contemporary Song of the Year, and the album was nominated for Best R & B/Urban Contemporary Album of the Year, while "My Prerogative" was nominated for Best R & B/Urban Contemporary Single by a Male. (I won Album of the Year but lost Song of the Year to Anita Baker's "Giving You the Best That I Got" and lost Best R & B Single by a Male to Michael Jackson's "Man in the Mirror.") I also performed that year, so I was busy getting up and down to go all night.

As I sat there in the audience before my performance, someone bumped against the back of my head. It was Whit-

ney, but I didn't say anything. She was speaking to the Winans, who were sitting behind me. Then she did it again, like two more times. I got aggravated, so I finally turned around.

"Excuse me," I said.

No response from her.

"Excuse me," I repeated.

Still no response.

What the hell?

Her back was to me, so I tapped her. She turned around. *Slowly.*

"You keep hitting me in the head," I said.

"I know," she responded.

With those two words, she changed everything. I turned back around with her words ringing in my ears. *What just happened?*

But I had to perform, so I pushed it aside. As I walked away, she was sitting on the end of the aisle and just staring at me. I stared back at her. We kept eyeballing each other until I went backstage for my performance.

I stepped out and did my thing onstage, bringing my usual energy and intricate choreography. Ironically I was introduced by Dionne Warwick, who was Whitney's aunt. I was wearing a cream-colored linen pinstripe suit with a long flowing jacket that tied around the waist like a robe. At one point I took off the jacket and threw it to the side.

Whitney told one of her friends, "Go grab his jacket!"

So at the end of my performance the friend snatched

my jacket. When I came off the stage, I was looking for it but didn't see it. By this time Whitney had come backstage. When I saw her, she was holding the jacket in her hand.

"Can I keep it?" she asked with that sly Whitney smile.

"All right," I said. While it was a necessary part of the suit, I didn't think I would ever wear that suit again. "You can have it."

It was clear that something was happening. We exchanged information. This was still 1989, so that meant home phone numbers.

One day a week or so later I got inspired and called her.

"If I asked you to go out with me, would you say yes?" I asked her. It wasn't the slickest line, but it did have its charm.

"Hell yeah!" she said.

And with those words, we began one of the most intense, crazy, passionate relationships the world has ever seen. We shared some mind-blowingly romantic days and nights around the globe; sometimes I'd wake up in some exotic location lying next to one of the most beautiful women in the world and I knew I was living in some kind of fairy tale.

I have incredible memories of our life together that I will carry with me for the rest of my life. One of our favorite spots was Jamaica. We would hang out in our lovely villa, smoking some powerful ganja and eating delicious jerk chicken day and night. If you've ever had jerk chicken, prepared by Jamaicans who know what they're doing, you'll

immediately understand how you could become obsessed with the stuff.

The Bahamas was another spot that we frequented. We were part of the celebrity contingent that opened the Atlantis resort in 1998, so we always had a soft spot for that magical place. We had close friends there, so we'd enjoy hanging out with them and smoking weed together.

But of course our fairy tale couldn't be sustained forever.

Even while I was in it, it would feel like those fifteen years of our lives flew by in a blur.

At the time Whitney and I started seeing each other, I was the hot guy in the industry. Women were talking; word was getting around about me. The way I danced, the way I moved, women wondered if I brought that same freakiness and those same moves to the bedroom. They were curious to find out if the myth was true. So in my mind, Whitney was just putting in her bid.

I should point out that I was still seeing Janet Jackson when Whitney asked for my jacket. One minute I was rolling around with the industry's reigning sex symbol, the next minute I was in love with its undeniable queen. Janet apparently had been doing some talking as well: I found out she was telling her friends how great I was in bed. Our world was so small, once the grapevine was buzzing word zipped through in a hurry.

I thought Whitney was incredibly beautiful, talented and sexy, but at the time I didn't consider her to be my "type." I

didn't really like tall, slim girls. I liked them short and thick. Like Janet. But there was something that happened when Whitney and I were together. We just clicked. We went out on a date and we found out we both smoked Newports. And she wasn't afraid to smoke around me. I couldn't smoke around Janet. Actually I chose not to smoke. I didn't want Janet to know I smoked cigarettes. When I went out with Whitney and she pulled out a Newport, I was like, *Oh damn! Okay!*

Whitney and I had our first date at a cute little restaurant in LA, and then we wound up back at the Hotel Bel-Air. When I walked through the door of her hotel suite, all I could smell was her perfume filling up the room. It was a special perfume that she had imported from Paris and it was intoxicating. When I smelled it, I thought of sunshine and vanilla and all things pretty. She would wear that scent for all the years I knew her. It was her signature. Probably everybody who was close to her will associate that smell with Whitney for the rest of their lives—me included.

When I got to the suite, Whitney wasn't in the living room, but her scent certainly was. I breathed deeply, taking it all in. I was able to take a step back at that moment and consider the craziness of the situation—the fact that I had just stepped into the private hotel suite of this American goddess.

Let me give some perspective on who Whitney was in 1989: She had already become the biggest female pop star in the world by then, at age twenty-five. She had had seven con-

secutive number one singles on the *Billboard* charts. She had already won two Grammy Awards, and her first two albums were well on their way to selling forty-five million copies between them. Yes, forty-five million. As far as black female entertainers go, there wasn't a bigger star in the hemisphere. And only a handful of white performers were as big as her.

When she got into the room, Whitney brought out some champagne for us to drink. It was the first time I ever saw Cristal. We drank the champagne, talked for a while, really enjoying each other's company. I liked being around her. I didn't try to sleep with her that first night. I wanted to approach this situation differently than a normal conquest. But when I went back to my hotel room I couldn't stop thinking about her.

Over the next couple of months we would talk on the phone maybe every other week. We were both incredibly busy. I was still on the *Don't Be Cruel* tour while Whitney was working on her next album, which when completed was called *I'm Your Baby Tonight* and featured productions by LA Reid and Babyface. After the success of *Don't Be Cruel*, everybody wanted to work with those two guys. After *I'm Your Baby Tonight*, which was the top R & B album of 1991 on the *Billboard* charts, Whitney wouldn't release another album for eight years—though she did do some groundbreaking work in 1992 on the soundtrack to her movie *The Bodyguard*.

Around this time, Eddie Murphy invited me to the set of *Harlem Nights*, the movie he was filming with comedy legends

Richard Pryor and Redd Foxx. I had gotten pretty close to Eddie in the last few years. He had been a friend of New Edition since our early days, when we first started going out to LA. Eddie was the first major entertainer who took us under his wing. He'd invite us over to his crib, where he'd barbecue and we'd play basketball and hang around. We were all from the East Coast, we were all young (though he was about eight or nine years older than us), but he had already become a superstar. We got along really well with him.

I knew that Eddie had dated Whitney, so I thought I would casually ask about her. He didn't know why I was asking about Whitney—probably because he was so busy asking me about Janet. It was during a break in the filming when he made his way over to me. He had just finished filming a hilarious scene in the movie where he apologizes to Della Reese for shooting her in her pinky toe, after she had whupped his ass. While Della Reese is in the kitchen making a sandwich, Redd Foxx and Richard Pryor persuade Eddie to apologize to her. All the while, Foxx and Reese are yelling at each other, exchanging funny put-downs filled with every curse word in the book.

After filming opposite Della, Eddie came over to me, pleased to see me on the set. So I took the opportunity to ask him about Whitney, trying to be as casual about it as possible. We were kind of huddled in the corner. My brother and my security guy were nearby.

"She's cool," he said. "She just smokes too much weed for me."

"What? She smokes weed? I didn't know that," I said.

Whitney Houston was too wild for Eddie Murphy? That sure opened my eyes. But instead of chasing me away, it actually made her more attractive.

Eddie leaned in and asked me what Janet was like.

"She's good people," I said.

But Eddie wanted more.

"What about that ass? Is it as soft as it looks?" The man had his priorities.

I nodded. "Yeah, it is."

Eddie leaned back. His mouth dropped open a little bit and I think he even shook his head.

"Damn."

That's all he said. That's all he needed to say. And he had heard what he needed to hear.

I wasn't trying to sneak behind Eddie's back or anything with Whitney. I just wanted to gauge his level of interest in her. Was he in love with the woman? Did he see a long-term relationship with her in his future? Clearly he didn't. I had heard what I wanted to hear too.

Soon Whitney started popping up at my shows in different cities and countries. Unannounced. It was almost like I was being stalked, but in the best way. She booked a show at a festival in Japan, a Dick Clark event, because I was headlining the show and she wanted to be there. And I'm pretty sure she took less money than she would normally have gotten.

In my camp, Whitney's unannounced arrival was greeted

with about the same level of enthusiasm as a venereal disease. Not only did I have my baby LaPrincia with me, but her mother, Kim, was also there, as was my son Landon. But Whitney didn't seem to care. She made it perfectly known that she was interested in me; she didn't pull any punches. On the other hand, Kim didn't care that it was Whitney Houston—she would have been upset no matter who it was. In addition, I was dating one of my dancers at the time. So when Whitney breezed in, I could see the sadness on the dancer's face. It was all in her eyes. I felt kind of bad about that—but certainly not bad enough to send Whitney away.

As for Kim's face? All I saw was anger. Blistering, hot anger.

Usually everybody hung out in my dressing room, eating my food, and I usually didn't care. But this night I made everyone go to their own dressing rooms, and I had Kim put in a different room altogether. So when I got offstage, Whitney was in my dressing room by herself, waiting. It was all pretty crazy and, frankly, awkward as hell for me. I introduced her to LaPrincia, who was still a baby. In all honesty, Whitney wasn't too interested in the baby. She was there for me. She tried to play with baby girl a little bit, but LaPrincia wasn't having it. It didn't take long before she said, "I want my mommy." So I had her taken back to Kim. I wasn't yet thinking that Whitney would one day be the mother of my child, so I should pay attention to that sort of thing. I was still young. I was still playing.

Whitney and I hung out after the show. We still hadn't slept together, but the sexual tension was crazy. She followed us back to the hotel. As I knew would happen, I had an argument with Kim about Whitney. I had previously told her I was in love with Janet; now Whitney Houston had popped into the picture.

"Okay, I can't take this!" she yelled. "I can't believe you would just put it in my face like that."

"But I didn't know she was coming," I tried to explain.

There really wasn't much I could say. I had already told her that she and I couldn't be together because I was in love with Janet. But because we had so much history, we had a baby together and she was still spending a lot of time with me, I could understand if she was hoping that things might change between us. Now, all of a sudden, into the scene sweeps the biggest pop star on the planet? And an incredibly beautiful one, at that? I could see why she was so angry.

After things ended with Janet, they accelerated with Whitney. I knew the time had come for us to take it to the next level.

It happened in London. That was the place where we got to know each other on the most intimate level. Whitney made another unannounced visit, calling me the day she got into town to let me know she was coming to my concert. After the show, I was pretty excited about what might happen that night. When I got back to my hotel, I found out that she had taken the entire suite on the top floor. I was in the

suite right below her, but hers was bigger, fancier. Hey, this was Whitney Houston.

When I walked into her suite, from the very first second everything was magical. We talked. We kissed. We played the piano together. We drank wine. It was heaven. It was wonderful.

Sex with her was different. She caught me by surprise, because she initiated everything. That never happened with Janet or most of the other women I was with. She was the aggressor, but in a smooth, ladylike way. I was playing the shy guy at the time; I didn't want to push up on her.

As we played the piano together, our hands touched. Then we shared a long, soft kiss. It was like a scene straight out of *Casablanca,* some old romantic flick. I knew what was about to happen. My thoughts at the time? I'm embarrassed to say they were maybe not the most, uh, gracious.

Damn! I'm about to fuck Whitney Houston!

We found our way into her bed, where the passion was intense, incredible. From the very beginning, it was clear that our sexual chemistry was explosive. Obviously I had been with a lot of women up to that point, but this felt different, deeper, more intimate and hotter than it had been with any of the others—even Janet. From that moment on, at least in our minds, we were together.

Whitney started telling me her private thoughts, letting me really get to know her. I started doing the same. She told me how Randall Cunningham, the quarterback for the Philadelphia Eagles, was trying to get at her, but she said he was

too much of a punk about it. She told me about a lot of the other dudes who were trying to get at her, but they didn't know how to go about it. They didn't know what to do or what to say. They assumed she would be interested in them because of who they were.

I think Whitney was taken with me because I wasn't what she expected. I was supposed to be this big wild and crazy guy. The bad boy. But that was my persona onstage. Offstage, I'm a totally different person. She was surprised by how humble I was. She expected raunchy but instead she got gentle, courteous, gracious, gentlemanly. Always that. I was taught that by my mother and father.

I have always been truthful with every woman I've been with. If they can't handle that, well, that's another story. But I believe honesty is the best way to conduct a relationship. That's why I had been able to tell Kim about Janet. I knew she'd eventually come around and would understand, even if she wasn't happy about it.

After that night in London, it seemed like Whitney and I were together all the time. She would even come out on the road with me on tour sometimes. Up to that point, Ralph Tresvant still didn't believe I was dating Whitney.

"Nah, I don't believe you!" he said when I told him about our relationship.

"You watch!" I said. "She's coming by tonight."

He saw her when she came by my hotel room to surprise me and I didn't answer the door because I was in the shower.

Ralph came upon Whitney pounding angrily on the door. He sure believed it then.

But Whitney still wasn't eager to go public with our love affair. It wasn't like we were sneaking around, but we would spend most of our time together alone in hotel suites, or in fancy restaurants where we could have some privacy. It can be difficult for celebrities to conduct a relationship if they don't want everybody all up in their business.

I think one of the reasons Whitney wasn't too keen on going public was because she was still sort of stringing Eddie Murphy along. I remember him inviting me to the premiere of *Harlem Nights* and Whitney having to juggle both of us without Eddie knowing what was going on. We spent the early part of the night staring at each other across the room. I still remember what I was wearing that night—a maroon suit and a white fedora. Yeah, I was killing it. Finally Whitney and I saw an opening and we snuck away to a secluded corner for a little while to talk. Eddie was oblivious to everything. All these years later, I've still never had a conversation with him about those crazy days.

———

A FEW WORDS FROM RALPH TRESVANT

At first I didn't believe him. Bobby and I were sitting around one day, just talking, and he started telling me he was dating Whitney Houston. I knew he had just stopped dating Janet. Now he was telling me, "I'm really seeing Whitney like that. We're tight now."

"Get outta here, man!" I said.

"For real!"

But I still didn't believe him. I think my response was, "Yeah, yeah, whatever."

Whitney was a whole other level to me. I just couldn't see it. It didn't seem like Bobby Brown could pull that. But then again, I knew she was an East Orange girl. Still, I didn't really know that side of her. In retrospect, maybe a part of me didn't really want to believe it. I think that might be what was really going on.

But I found out the truth one day when Bobby and I were staying at the Waldorf Astoria in New York with the rest of the guys. We were on tour together, Bobby Brown and New Edition. We were all staying on different floors. I was going to pick up B; we were planning to move around the city, shop, look around. I went to his floor to get him. As I turned the corner, walking toward his room, I noticed three people in the hall. One was sitting on the floor and one was standing nearby, kind of pacing up and down the hall.

I thought they were maybe some fans or something.

"Excuse me," I said. "What's the problem here? Y'all can't be here in front of my man's—"

Before I could finish the sentence, the one who was pacing turned around to face me. I saw it was Whitney. *Oh snap!*

"Yeah, I know that motherfucker is in there!" she said. She started banging on the door again.

I'm thinking, *Aww man, the same day I'm about to find out his relationship with her is real, he's about to mess it all up.* I

thought he was about to lose her. But luckily when he finally opened the door, he wasn't in there with anybody else. He had been in the shower. I was relieved. I really thought I was going to see the beginning of the relationship and the end at the same time. When he didn't open the door, I was thinking, *He must have known she was coming.* But she had caught us all off guard. And that's how I found out he was really dating her.

When I saw how pissed she was, that told me a lot. It showed me she was scared. And that showed me the connection. And then he was pissed that she was pissed. I knew my girl wouldn't get pissed at me for not opening the door unless she cared about me. I saw that what they had together had moved beyond casual dating.

Their relationship was beautiful. We were really young guys in the entertainment business, but I think he saw it was time to settle down, time to start growing up.

One night quite some time later I was backstage at Philips Arena in Atlanta at a Beyoncé concert. We went backstage to see Bey, so we were sitting there talking to Jay Z, waiting for her after the show. Just then Whitney walked up. She had on a Kangol hat and a full-length chinchilla fur coat. This was when she and Bobby were going through some difficulties in their marriage, with a lot of crazy stuff being written about them.

"I got your brother," she said to me. "I got him."

I looked her in the eyes. She was dead serious. I put my hands up.

"All right," I said. "I'm gonna take it just like that, sis."

With all the stuff that was going on, she wanted me to know that she loved that man and she had his back.

The world needs to understand that Bobby's been victimized. He really took it on the chin. He *has* been Mr. Bad Boy; he basked in that for a second, walked in it for a second. But the real Bobby was totally the opposite of the guy they'd been talking about. That's why when you see him with his kids, they *love* him. His kids are just crazy about their daddy. That's the real character of a person, how your children feel about you. That's who you really are. That's why somebody like Whitney could fall in love with him.

———

I attended one of her concerts and afterward she introduced me to her family. She just said, "This is Bobby Brown." She didn't call me "boyfriend" or give me any label, but I could tell the family knew what was going on. If she hadn't told them already, they would have known just by the way she was smiling and acting. They were warm toward me, particularly her brothers, Michael and Gary, and her father, John Houston. I grew to be very close to her dad and talked to him regularly up until his death in February 2003. We would talk a lot about her business. I would assure him that I was watching her money closely. Even at the very end, after he had gotten sick, after all her albums, he was still asking me about it. I think the family members saw how

well I treated her, how much I obviously loved her, so they were supportive of us.

I was courting her in a big way by this time. I've always considered myself a romantic fellow, so I was constantly thinking of romantic gestures that I knew would please her. Whitney and I would compete to see who could buy the most extravagant gifts. She started it off by buying me this gorgeous watch. It was platinum and gold and made by Fred, an extremely exclusive jewelry and watchmaking company based in Paris founded by Fred Samuel. Fred's watch prices easily exceeded $10,000. This watch was breathtaking.

So I replied by having a fabulous bracelet made for her. I had a guy in LA we called "Joe the Jeweler" and he was the baddest jeweler in the country. As a matter of fact, I still use him to this day. He made amazing pieces for Whitney—they just blew her away.

The early days of our romance were like a fairy tale. We both liked the same things, so it was so easy for us to have a great time together. We would meet up in different countries, since we were both constantly on the road. We were desperate for our privacy, so there were a lot of intimate dinners in the corners of fancy restaurants, a lot of days and nights in ritzy hotels. Of course, there was a lot of time spent together in bed, where we enjoyed our wonderful sexual chemistry. We would gamble, play cards. We would sit and play spades for hours, yelling at each other and talking a lot of shit, which all the best spades players know you *have* to do. Whitney was

from Newark and East Orange—she always knew how to talk a gang of shit.

When word did go public that we were dating, I tried to pay no attention to the gossip columns. I tried very hard. But I would look at the stuff in the rag mags, the horrible things they were saying about us. About me. The nastiness of that period is why I don't read any of that stuff today. 'Cause the nastiness can hit your heart. Sometimes it takes a long time to come back from what people think and say about you.

Whitney was really good at turning the other cheek, but not me. If they were saying something about me that was a lie—and it almost always was—then I'd want to fight. I'd want to bust somebody's ass. I'd want to find out who wrote it, find out where they got their information from. That's just me. I have to have truth around me. I don't like dishonesty. If you're going to say something about me, please say it to my face—so I can straighten you out. That's the Orchard Park projects right there.

At first the media were mainly focused on how old Whitney was and how young I was. And that I was the bad boy and she was this goody two-shoes. That one was so wrong because we were definitely compatible in every way. We were two young, rich kids who found each other and were falling in love. But I guess the world couldn't accept that.

Whitney was acutely aware of her image because that's how she made her money. She was always neat about ev-

erything she did—the way she dressed, her hair, her skin. Whenever she got ready for anything she always had to look picture-perfect. I was the same way—I always wanted to look my best. We would have designers make clothes for us that sort of matched, so that when we walked in the room everyone would know we were a unit.

During the first year or so of our courtship, we started talking about marriage, but in a general way—not necessarily getting married to each other. We acknowledged how hard it was in our industry to find someone you would want to be with for the rest of your life. We loved Ruby Dee and Ossie Davis and what they represented, having stayed together and apparently in love for decades, despite being in an industry that chewed up married couples and spit them out. We would get a thrill out of seeing them together in movies and then together in real life, how they carried themselves, how they treated each other. We really admired them. That's how we looked at ourselves. We had a chance to meet them several times and they would also tell us they loved how we were together. The admiration was mutual.

As I thought about our bond and my love for her, I decided that I wanted to spend the rest of my life with her by my side. It was time to ask her to marry me. When I decided to propose, I went and had a conversation with her father. I wanted to do it old-school, like a perfect gentleman. I met with him in New York City and I told him my plans.

What he said at first kind of threw me.

"You sure she wants to marry you?" he asked me, looking a little surprised.

I was thinking, *Damn, why wouldn't she—what the fuck is the matter with me?*

He looked at me closely. "I don't trust you," he said. "How much money you making?"

I happened to have a bank stub with me showing my account balance that day. That particular account had several million dollars in it. He looked down at the stub and nodded his head. "All right. You can be with my daughter because you don't need nothing from her," he said.

Then he kind of shrugged and said, "All right, if she wants to marry you. If y'all in love."

Then he paused and added one more thing.

"Just treat my baby right," he said.

I nodded my head and told him I would.

I didn't plan anything elaborate for the proposal—but I did have one trick up my sleeve. I went to my jeweler and told him I was about to propose to Whitney Houston, so we had to come up with something special. He had these twenty-carat diamonds that were two of the cleanest cut stones in the world. One had a little yellow to it; the other was incredibly clean. I bought both of them for $250,000 each. I had him make the clean one into a beautiful ring. I put the other one in a safe. Then I got the idea to also get another ring, one that was still very nice but not nearly as impressive. It was just six carats. I think he actually gave it

to me for free, after I had already spent a half mil on the other two.

Whitney was in Miami, so I flew there to meet her. She picked me up at the airport; we were riding together in the backseat of the limo, snuggling close, glad to see each other. It was the middle of the day in April, so it was bright and sunny outside.

I pulled the box out of my pocket and handed it to her. I saw her eyes starting to widen. As I said, we had been giving each other incredibly extravagant gifts for years, so this wasn't the first time I had handed her a jewelry box. But it *was* the first time I mouthed these words:

"Will you marry me?"

"Yes!" she said. She started crying as she opened the box. It was the smaller, six-carat ring. She held it and admired it as she sobbed.

I had the twenty-carat monster on my finger.

"Are you sure?" I said. I presented her with the real ring and she went nuts. It looked like a big lovely crystal ball on her finger, like you could look into that thing and see the future.

"No, you didn't!" she said, hitting me. "Why would you fuck with me like that!"

It would have been even funnier if the first ring had been a puny little thing, but I couldn't do that to her. That would have been too mean.

I was excited as hell about the idea of spending my life

with this lovely, incredibly talented goddess. Of course I knew there would be a lot of backlash. We had already gotten a significant taste of that. But I think I still believed that most people, when they saw how in love we were, how good we were for each other, how much fun we had together, would come around and support our union in the end. We wanted to be together. So we dated, we fell in love and now we were to get married. What could be wrong with that? After all, that was the proper order of things, right?

Oh my God, wrong. Dead fucking wrong. From the moment we announced to the world that we were going to get married, we became the target of a media and public campaign that had the single goal of tearing us apart. Were we really the only ones in the world who wanted our marriage to succeed? Sometimes that's exactly how it felt. But we decided that we weren't going to let the negativity get to us. We wouldn't give the outside world the satisfaction. They didn't know anything about us, how close we were, how perfect we were together.

We would show the world that we were stronger than the bullshit.

In the months leading up to our wedding, Whitney was occupied with the filming of *The Bodyguard* with Kevin Costner. She was extremely nervous about making her acting debut in such a big role, opposite one of the biggest movie stars in the world. I was nervous too, but for a different reason—I didn't trust her playing the love interest of Costner. I

wasn't that familiar with how movies were made and what went on behind the scenes of a movie set, which heightened my suspicions even more. I saw the script and knew it contained some love scenes. I knew how smooth Costner was—hell, even my mother was in love with him. So I told her I needed to be on the set too. But Whitney wasn't going for that—she told me my presence on the set would make her uncomfortable and she couldn't have that.

I was also concerned for another reason—Whitney was pregnant. Or so I was told. So I was concerned that she would be putting herself in such a stressful situation. I had already told her about Kim's being pregnant with another child, so I was worried that our relationship was on shaky ground at the time. I love my son Bobby Jr. more than I thought possible, but I was still upset with myself for getting drunk and having sex with Kim while Whitney and I were together, resulting nine months later in the birth of Bobby Jr. I was beating myself up over this misstep—and Whitney wasn't letting me forget it either. So when she told me she was pregnant as well, I saw it as a chance for me to make amends.

One day when I was out on tour, I got word that Whitney had suffered a miscarriage on the set of *The Bodyguard*. I immediately jumped on a plane to go spend time with her on the set. As soon as I arrived, I started to get suspicious. I'm no medical doctor, but she was not acting like a woman who was in the throes of mourning a lost baby. As a matter of fact she was back to filming just a couple of days after it had

happened. I never saw any evidence of her pregnancy or her miscarriage, so I started to think that the entire story was a ruse created by her PR team. When I confronted her about it, she was insistent.

"Bobby! Yes, I was pregnant!" she said.

But I didn't believe her. To this day, I believe her pregnancy was a story that was concocted by her people to explain to the public why she would marry Bobby Brown. In other words, if you're confused about why she would get with the "bad boy," here's an explanation for you: knocked up. After all, that's what bad boys do—wander the countryside knocking up innocent women. She was supposedly several months into the pregnancy, yet I never saw any hint of a belly. As slim as Whitney was, a belly would have been visible right away—as was the case when she finally did get pregnant with Bobbi Kristina months later, right before our wedding.

Once the film wrapped, Whitney dove into the wedding planning with gusto. The plan was to have the wedding at her New Jersey mansion in July, so that gave her just three months to do the planning. But when money is no object, you can do anything in three months. She wanted it to be just right, to have the best of everything. I stayed out of the planning completely.

HUSBAND AND WIFE

On July 18, 1992, Whitney and I said our vows and became husband and wife in a glorious ceremony at the mansion she had bought in Mendham, New Jersey. It was a memorable day that was big news in virtually every newspaper and magazine in the free world. But for me the path to the actual nuptials was one of the craziest times of my life.

In the months leading up to the wedding, Whitney told me that since I was only twenty-three she wanted me to get all the partying and fucking around out of my system before we said "I do." I thought that sounded like a grand idea, so I planned a trip to bring my boys around the world with me for the most outrageous monthlong bachelor party any groom-to-be had ever created. It made *The Hangover* look like a Boy Scout convention in comparison.

I'm not going to go into all the details here to protect

the innocent and the guilty, but I will say that even a twenty-three-year-old hits a party wall at some point. I rented a private jet that took us to all the well-known party spots, from Las Vegas to New York City to Miami to Paris. You might think of it as me trying to complete my fucking bucket list—strippers, midgets, you name it. Let me say the night with the midget blew my mind. You can do things that just aren't possible with an average-sized woman. The midget came in the middle of the thirty days. By the time we got to the end of the run, we found ourselves in California. We had all gotten to the point where we had had enough women, drugs and alcohol to last us a long time. Though I'm sure she didn't intend for me to dive into the concept with such gusto, in effect it worked: I had no interest in straying for a very long time after that because I had had my fill. But I don't think you should try this at home.

Toward the end of the thirty days, we found ourselves in Southern California in the middle of a major earthquake. The June 28, 1992, earthquake was 7.3 magnitude, the largest quake in the US in forty years. There were only three deaths and minimal damage, because the epicenter was out by the Mojave Desert. This quake was far more powerful than the 6.9-magnitude quake three years earlier in San Francisco during the 1989 World Series, but that one was right in the middle of a major population center and resulted in sixty-three deaths.

After partying all night on Saturday, we were awakened

at five A.M. on Sunday by the feeling of our hotel suite trembling. My first reaction was to wonder if it was all a figment of my drunk imagination, but I soon realized that I was in the middle of my first earthquake. If you live in LA long enough, you're going to experience your share of shakes. But that was my first and I didn't like it one bit.

Some might say the earthquake was a sign of what was to come in the marriage, but I didn't see it that way. I just wanted to get the hell out of LA.

My partying continued right up until the night before the wedding. Therefore I woke up the morning of the wedding feeling odd, uncomfortable and still a bit high. I guess prewedding jitters are normal for brides and grooms, but I was suddenly paranoid that I was making a mistake. It might actually be misspeaking to say I woke up because I don't think I had actually gone to sleep the night before. I had alcohol and weed in my system and even some cocaine, which I had tried for the first time during the preceding thirty days. With all of that coursing through my body, how did I react when I realized what was about to happen in a few hours? I cried.

I started wondering what I was about to get myself into. I knew I loved Whitney with all my heart, but I was starting to feel like I didn't know much about her. She still wasn't talking openly about our relationship in public and of course I had been reading and hearing all the rumors about her possible sexual relationship with her friend Robyn Crawford, so

in my mind I started to play with the idea that maybe this all really *was* a publicity stunt on her part.

Then I started thinking of the women in my life I would be walking away from. I had broken up with Kim, but I had gotten her pregnant again at the same time as I was dating Whitney. In addition, I had also been dating the actress Lisa-Raye McCoy, and I hadn't really told her much about how serious it was with Whitney. I felt like my affairs were sort of a mess, and my emotional state was about the same.

My friends tried to talk to me, to get me to a better place. At one point on the morning of the wedding day, I even talked to Alicia Etheredge, my longtime friend (who would eventually become my wife almost exactly twenty years later). Alicia came into the bathroom where I was hiding and persuaded me to come out and be happy that I was about to marry a woman I loved—how's that for irony?

As the ceremony grew closer, I decided that I wanted to get together with my bride and have a quickie before we walked down the aisle. Maybe I was looking for some sort of proof of her love to ease my mind. We were always horny, always sneaking off to inappropriate places to get busy, so I thought this was a perfect time for some quick intimacy. I wasn't thinking about traditions or superstitions or any of that stuff. I just wanted to find Whitney and spend some time in that place I loved. I left the mansion's large garage, where all of the groomsmen were getting dressed, and I went in search of Nippy (Whitney's nickname).

I found Whitney in her room. When I opened the door, I was shocked to see her hunched over a bureau, snorting a line of coke.

"You want some?" she said, looking up at me.

"No," I said.

"Okay, well now you know—I do coke sometimes," she said. "I'm so fuckin' nervous."

I was unnerved to see my woman doing cocaine, but her brother Michael had already told me she indulged. Turns out he's the one who introduced her, as he admitted to Oprah many years later. While I was disturbed, I was also a bit impressed that she was clearly not the princess the world thought she was.

Oh, she's a fuckin' G.

That's what I was thinking. I had already felt that way, but that sight in her bedroom really hammered it home. She was classy and street at the same time. She was the first person to introduce me to Cristal champagne; it was her preferred drink. I mean, we gave away bottles of Cristal to our eight hundred wedding guests. Can't get much classier than that—it costs over $200 a bottle. But then here she was, getting lifted on one of the biggest days of our young lives.

When the ceremony time finally came and I stood there watching my gorgeous bride float down the aisle in a $40,000 lace wedding dress at her father's side, I was very aware of the stakes for me. I was thinking about the fact that I was marrying into power, moving into a situation that would bring me

to the next level of influence and clout. I could feel the power surrounding me, especially when I looked out at the crowd to see some of the most influential men and women in my business and many others.

Nobody can fuck with me now. I have money, power, and the most beautiful woman in the world. What?

After Marvin Winans presided over the vows inside the house with a smaller contingent of our close family and friends, we went outside for the reception with eight hundred people. *Way* too many people. One of the most dramatic moments was when we released a dozen lovely white doves. As if on cue, they soared over the festivities and drew gasps from the crowd. It was exactly as we had pictured it. But what we didn't picture was that three of the doves would like our property so much that they decided to stay. For at least three years, they made a home on the roof above our bedroom. We thought it was a powerful omen, that these symbols of peace and love had chosen to stay, as if they were blessing our bedroom.

One day I looked out into the backyard of our estate and I came across a chilling sight: the carcasses of the doves were strewn about in the yard. They had been attacked by crows and eaten. I might have taken that as another omen about our marriage and relationship, but I didn't think of it that way. By that time, I was doing drugs nearly every day, so I viewed the dead doves in a haze. I'm sure my thoughts were more along the lines of, *Damn. Dead doves. That's fucked up.*

A FEW WORDS FROM LEOLAH BROWN

When my brother and Whitney got married, it was actually the first wedding I had ever attended and I had the honor of being a bridesmaid. Oh my God, it was so beautiful! All seven groomsmen and seven bridesmaids wore purple, which was Whitney's favorite color. Whitney's gown, which was form-fitting and all lace, designed by a woman from East Orange named Diane Johnson, was unbelievable. From start to finish, everything about that wedding was just perfect. I distinctly remember the glow that was in Bobby and Whitney's eyes. My family was so happy because Bobby decided to invite so many of the people we grew up with back home in Orchard Park. And of course there were celebrities everywhere you turned—Gladys Knight, Patti LaBelle, Donald Trump, Dick Clark, Ashford and Simpson, LA and Babyface, basketball star Isiah Thomas . . . the list goes on. My brother Tommy was practically drooling over Phylicia Rashad.

When Reverend Marvin Winans was talking, I was looking directly at Bobby and Whitney, trying to figure out what they must be thinking. I focused on their eyes and I felt the love between them. When they said their vows I couldn't hold back my tears. The whole spirit in that room was beautiful, so real. There was no faking it. You knew that they loved each other because of the feeling you got just being there and seeing them together.

When we went outside, their good friends the wonderful

Bebe and Cece Winans sang to them and then they released all those beautiful doves. It was such an amazing day, I will remember it for the rest of my life.

After the wedding, I asked Whitney why she loved my brother. She and I talked a lot. I'm five years older than Bobby, so Whitney and I were almost the exact same age. We were both born in August, her in 1963 and me in 1964. We got along so well that I eventually became her full-time assistant.

She thought about my question for a few seconds, then she said, "Because he allows me to be myself."

She said Bobby was never anybody but himself, which was important to her. She said she had dated men who were always acting too timid and too shy because of who she was. But she said Bobby was different. He didn't give a damn. He was himself, take it or leave it. She said she loved that about him.

"He's not starstruck—he's just real," she said.

The world wanted to paint this pretty picture of Whitney, but she didn't like that at all. I think she was always trying to get away from that.

———

After Whitney and I got married, the media coverage of us changed and became much nastier. The gossip was so bad and so ridiculous that we stopped caring what they said. We felt that as long as we did our business, took care of our ca-

reers, we couldn't give a damn because we were an unstoppable force.

One of the worst things that was written at this time concerned our honeymoon, when it was reported that I cut Whitney's face, like I was some kind of knife-wielding thug. I couldn't believe it. That was so far from the truth of what actually happened. We were all playing on a boat in Italy. As I told you before, my father, Herbert, was the funniest man in the world, so my siblings and I used to imitate him all the time. Whitney and I were eating breakfast, laughing and having fun, when I did this imitation of my father. I slammed my hands down on the table like my father would and inadvertently hit the edge of a fork, which popped up and hit her in the face. It was the craziest, freakiest accident. I looked up and saw that her face was bleeding. I was like, *Man, what the fuck?*

We had to rush her to the hospital because we saw that the cut was pretty deep. The Italian police officers who helped us wanted to kill me because they didn't know what had happened. They just saw this black man and they saw Whitney Houston with a cut on her face, blood pouring down. I'm sure they thought I had assaulted her. If they *did* know who I was, that didn't help, because there were many reports that I was cheating on Whitney and treating her badly. This, of course, couldn't have been further from the truth. But to those Italian police, I was either some random black guy who had assaulted America's princess, or the bad-boy husband.

Either way, they looked like they wanted to seriously fuck me up.

I had to sit on her legs and hold her hands while they stitched her up. She was looking up at me and crying. It was just terrible, really terrible. I felt extremely bad. Her brother was with us and he let me know, "Man, it was an accident. Don't beat yourself up about it."

"But that's her face!" I said. "That's how she makes her money."

After they put in the stitches, her face swelled up so much that it was scary. I was worried that she was going to have a scar. And she did have a little scar when everything healed. When we got back to the US, it became clear that when they stitched her in Italy they didn't do it correctly. They didn't stitch the muscle first; they stitched it all together. So she had to have reconstructive surgery so that it could be corrected. We went to a cut doctor in Miami who used to do work for Muhammad Ali. He fixed it perfectly; you had to look really closely to see any kind of blemish on her face after he was done.

After our honeymoon, I had an intense argument with Robyn Crawford, who was Whitney's assistant and had been her best friend since they were teenagers together in New Jersey. Over the years there were numerous stories about their being lesbian lovers, which Whitney always denied in public. I think their relationship *had* become sexual at some point, but once I arrived on the scene, changes had to be made. They

couldn't be as close as they were before because Whitney now had me in her life, her husband. But Robyn wasn't accepting this new development gracefully; she was not happy about being pushed away.

One particular night, she had gotten so disrespectful and dismissive of our marriage that I couldn't take it anymore.

"You gotta get the fuck out," I said to her. "You gotta go. I can't take this no fuckin' more! This is my wife. You have to go."

Robyn looked over at Whitney with this incredulous look on her face.

"Are you going to take this shit?!" she asked Whitney. "Let him talk to me like that?"

"Yeah," Whitney said softly.

Robyn stormed out, and a permanent breach formed in their relationship. But I would like to say that I never thought Robyn was a bad person. Robyn was the perfect person in Whitney's life for the time she was in Whitney's life, because that's when Whitney was her happiest. I wished and prayed Whitney could be happy with me, and she was for a time, but it wasn't the same as when she was with Robyn. I needed for Robyn to understand that I was now Whitney's husband, so their relationship had to change, but I didn't want Robyn gone entirely.

Robyn had never been accepted by Whitney's family. Her mother didn't accept Robyn; her father didn't accept her. But Robyn was the best friend Whitney ever had; she was her con-

fidante. Whitney needed her. Robyn was the one who listened to her, who heard her, who was always there for her. I tried to be those things too, but it didn't last. I think if Robyn could have been accepted in Whitney's life and remained close to her, Whitney would still be alive today.

Something in Common

Soon after our wedding, I traveled down to Virginia Beach to work on some tracks with Teddy Riley for my next album, the follow-up to *Don't Be Cruel*, which would be called, simply, *Bobby*. Whitney didn't want me to be in Virginia Beach by myself—though I'm not sure why. It was early in the marriage, so I guess she still didn't completely trust me. So she came with me.

One day when I was in the studio with Teddy, laughing and joking around, Teddy thought it was funny that Whitney and I kept going outside to smoke a cigarette. It was a beautiful day and we loved getting outside, joking and cutting up. One particular time when we came back inside, Teddy said, "You two have too much in common."

When he said that, we all looked at each other. We knew we had something. Bernard Belle was there with us. So we started trying to figure it out. We all wrote the song "Something in Common" together—Teddy, Whitney, me, Bernard, plus two other guys, Mark Middleton and Alfred Rosemond. It was such a great time for us.

We did it all in one day. We finished writing the lyrics and started laying down the track together. That meant I had to sing opposite one of the greatest voices of all time. Was I intimidated? Hell yeah. I've never thought of myself as a singer's singer. I can hold a tune. I'm a singer. She's a *sanger*. I could sing. She could *sang*. But I learned a lot from her, just by watching her work and also by her offering suggestions. She taught me how to use my voice, how to bend my notes, how to chop my voice when I needed. She was a great teacher. First of all, just to be around her when she was singing, to watch how effortlessly she did it, made you want to be better as a singer. That's what she did for me. And if she saw me straining to do something, she would give me a different way to do it, another way of approaching the note that would be easier.

While she taught me how to sing, I taught her how to dance. At first, she was uncomfortable with dancing. Admittedly she didn't have much rhythm. But she had a certain flair. If we were dancing together, she could hold her own. And we did love dancing together. I even sent my girl dancers on tour with her. I had them working with her and she progressively got better and better. With the two of us working together, sharing our strengths, I think we made each other better entertainers.

When you watch the video for "Something in Common," you can see all of Whitney's cute little signature moves. She's not bouncing around as much as I am in the video, but she's

looking smooth and sexy as she dances in her own inimitable way. You can also see glimpses of our playfulness in the video. In one scene when I walk up behind her, she lunges back at me like she's going to backhand me in the face. That illustrated the constant play-wrestling and play-fighting we did in our relationship.

A month after our wedding, my third studio album, *Bobby,* was released by MCA. While the album didn't do the crazy numbers of *Don't Be Cruel,* it still did very well. It sold over two million units and reached number one on the *Billboard* R & B album chart and number two on the overall *Billboard* 200 chart. The singles "Humpin' Around" and "Good Enough" both made it into the top ten of the *Billboard* Hot 100 singles list. In addition, "Humpin' Around" was nominated for a Grammy for Best R & B Male Vocal Performance but lost to Al Jarreau's "Heaven and Earth." That was the category I had won three years earlier with "Every Little Step." We were happy, and our careers were still riding high.

Whitney and I spent a lot of time watching television, cracking on people. That was one of our favorite pastimes. Well, that and sex. We did a whole lot of lovemaking. Nearly every day—and often more than once a day. Throughout the first decade or so of our marriage, before things started turning sour, we were always hot for each other. If we weren't in a place where we could make it happen, sometimes we'd sneak off and fuck in a closet somewhere. We just turned each other on like that. Nip was an incredibly sexual, sensual being. For

me she was just like a sexual magnet. Whenever I saw her, I just wanted to touch her. I'm also a very sexual person, so we were an explosive combination. When you watch footage of us together back then and you see us hanging all over each other, that was real. We probably had just finished fucking or were about to slip away and get busy.

Not long after our wedding, we got some joyful news in the New Jersey mansion: Whitney was pregnant. In fact, she had been about a month or so pregnant on our wedding day. It was exciting news for me; I love kids so much that I was giddy about adding another one to my brood.

Whitney's pregnancy went smoothly, for the most part. She got real big real fast. It seemed like one second she was this svelte goddess and when I turned my head she ballooned into all belly. She craved hot dogs and pork and beans—not exactly the meal of multimillionaires. She also craved sandwiches from Blimpie, the subs she grew up eating in Jersey. I remember times when I was on tour when I'd have to leave the hotel in the middle of the night to find a Blimpie for my wife.

The day the baby came was joyous; it seemed like every member of her family was waiting in the hospital in the New Jersey suburbs for our new baby to emerge.

After Bobbi Kristina joined our household, there was nothing but love flowing through our family. We were so happy to have this little bundle of energy around us all the time. Whitney refused to go anywhere without her baby in her arms. It was so pleasing to see her as a mother, watching

her give so much of herself to this little person. After Bobbi Kristina started walking, the three of us would spend hours at a time playing her favorite game, hide-and-go-seek. She would squeeze her little body into all kinds of hidden corners in that huge house. But as soon as we started looking for her, loudly announcing that we were coming to get her, Krissi couldn't keep quiet and would start squealing in delight. What a beautiful sound that was.

I have such vivid memories of the three of us playing in bed together, romping around or just lying there with the TV on. We were so proud of our little girl. Whitney always claimed that Bobbi Kris looked just like her. I wouldn't say anything; I'd let her have that because I knew the truth. As soon as she opened her mouth and smiled, you knew exactly who her daddy was.

"That's the only thing you got! That damn gap!" Whitney would say.

Even before Bobbi Kris was born we always had a lot of staff in that New Jersey house. Whitney's aunt Bae, who wasn't really her aunt but who had grown up with Whitney's dad and had helped raise Whitney, came to live with us and help run the household. After the baby came, caring for her became one of Aunt Bae's primary responsibilities, assisted by her two grown daughters. I didn't have any of my family around me in the beginning. I felt like I needed to get away from my family at that point because all I did was spend money on them, take care of them. That had always been ex-

tremely important to me, so I'm not complaining. But I did need a break. When Bobbi Kris was a little older, eventually my sister Leolah came to stay with us to act as Whitney's assistant and help care for Bobbi Kris.

As a family, the three of us cooked together, we swam in the pool together. At a moment's notice we would decide to take a trip. We liked the Bahamas, so I'd call our money managers and tell them, "I need thirty thousand dollars and a plane."

Then Whitney's family would want to come with us—her brothers, Gary and Michael, and their wives and kids, Raya, Gary and Blair. Next thing I knew our spur-of-the-moment trip had turned into a major undertaking. But it did limit the amount of time the three of us—me, Whitney and Krissi—had to spend together as a family.

Our fame got especially hard for Krissi when she started school. We would make efforts to hide her identity from the other students, like registering her at the school under a different name. But then Whitney or I would drop her off or someone else would drive her and pull up in a Bentley, so it wouldn't take long for her cover to be blown. One of the only black children in the school and she's getting dropped off alternately by Whitney Houston and Bobby Brown? Hmmm—wonder who that little girl could be?

That's the cross Bobbi Kris had to bear from a young age. My other kids didn't really have to go through that because I spent so much time away from them.

———

A FEW WORDS FROM LANDON BROWN

People have been approaching me since I was a little boy, for as long as I can remember, telling me how great my father is. Teachers would be starstruck and give me special treatment. It was all very weird to me. At one point I went to school with Darryl Strawberry's son and he explained it to me: "Well, my dad is really good at baseball."

So in my mind I thought, *Oh, if your dad is really good at something then other people admire him for it. My dad is really good at performing!*

When I was in seventh grade I went to live with my dad and Whitney in New Jersey. At the time I called her "Mom." I figured it was okay since my mom made me call my stepdad, Carl Payne, "Dad." When I got to the house, even before I had a chance to call her "Mom," she said to me, "I'm your mom too, so call me 'Mom.'"

This was 1998, six years into their marriage. Bobbi Kristina was five at the time, so I was excited to spend time with my little sister. In the time I lived there, I got an interesting view of their relationship from up close. Everybody makes a big deal out of their arguments and bad times—like no one has bad times and arguments—but if you were in the room with Whitney and my dad and my dad left the room, you would still think he was in the room because she was like the exact same person as him. It was weird. They both had this awkward laugh, and they were both completely honest with the

things they thought. Neither one of them had a filter. They agreed on so many things and were so much alike that when they did disagree on something, it was bound to become a big deal. My dad would go from frustrated to happy, then right back to frustrated.

A few months after I got there, my dad had to spend time in jail because of a drunk-driving conviction from a few years earlier. He was upset a lot and you could tell that he was having a hard time. When he was in prison, I got a chance to talk to him on the phone.

"How are you doing, Dad?" I asked, excited to be talking to him.

"How the fuck you think I'm doing, I'm in jail!" he responded.

I was always very sensitive, so I started crying. Whitney had me lie down with her and she started rubbing my head.

"It's okay, baby," she said to me. "He's just frustrated."

She was pep-talking me out of my tears. That's when it hit me—with all the people talking in town, all the media and newspaper reports about my father's behavior, I understood. People don't get that he's human; he has to deal with human things. The world wants him to be crazy, they like when he acts that way, but at some point it's just too much for him to handle. It was the same with their relationship. Everybody wanted to know about their relationship, but with a lack of privacy and *way* too much attention, a relationship is stressful.

———

TROUBLE MAN

In September 1995, when I was twenty-six, I went up to Boston to visit family and friends. I stayed in a hotel near where Kim lived with LaPrincia and Bobby Jr. I spent as much time as I could with my kids. But at night I hung out with my boys, driving around town in my cream-colored Bentley Azure, which had been a gift from Whitney. One night we went to a little spot called the Biarritz that was owned by some police officers, so cops hung out there all the time. One of my dudes was Steven Sealy, who was actually engaged to marry my sister Carol.

We all walked into the joint and assumed that the whole group had made it inside. Little did we know that Sealy was being held outside because he didn't have the proper ID or something minor like that. Sealy reacted by beating up the cop who wouldn't let him in. *Boom boom boom,* he hit the guy

at the door and fucked him up. We heard the commotion and so we went back outside. Sealy was talking a gang of shit.

We grabbed our friend, got out of there in a hurry and went back to a friend's house, got high and drunk together, and all fell asleep.

I had been hearing about this nasty gang war that had been going on in Roxbury. Most disturbing, it was taking place between guys who were all from Orchard Park. That really upset me; these guys were not supposed to be fighting and killing each other. So I told my people to get them all together so that we could have a gang summit of sorts and try to bring an end to the bloodshed. A couple nights later we went back to that same cop club to hold our summit. It was a beautiful gathering. I gave them a little speech. Not exactly MLK, but it got the job done—or so I thought.

"This is Bean, nigga. Boston. We supposed to be together; we ain't supposed to be fighting each other. Y'all from OP? We used to fight other fuckin' projects. This is some bullshit—we can't kill each other, man."

Everybody agreed with me, we all toasted, everything was good. We commenced to partying in the spot and everybody had a great time. As we were leaving, my cousin started arguing with me because he wanted to sit in the passenger seat of the Azure, which I was about to settle into.

"Dude, really?" I said. "Just get in the back and let's go."

As I'm getting out of the car to let my cousin into the backseat, Sealy leaned over to me and handed me a gun.

"Hold on to this," he said. "Some shit might pop off."

"What?" I said as I took it from him.

As I got back into the car, I heard *pow pow pow*. Somebody had come up right next to the car and started shooting. I ducked down into the seat and realized that Sealy had been shot in the head. The gunshots were still slamming into the Bentley and my mind was in overdrive. I crawled into the area under the steering wheel next to the gas pedal and the brakes. *Pow pow.* More bullets hitting the car. I pulled Sealy down on top of me, out of the line of fire. But he was already gone. I moved up enough to see out of the windshield. I cocked the gun he had given me, looking out to see if I could find the shooter. I saw the shooter—he was an old friend of mine from OP! I could see him straining to figure out where I was. More bullets whizzed by the steering wheel. Clearly, I was the target.

I decided I needed to get out of the car. If he was gunning for me, I was too easy a target inside the vehicle. So I rolled out of the passenger door and crouched next to the car. My cousin and another friend were still hunched down in the backseat. I immediately felt pain. Turns out a bullet had just grazed me. I still have that scar.

I waited until I heard the guns click, meaning they were out of ammo. I took off running, turning and firing behind me as I ran to make sure they couldn't return fire. When I was convinced I was out of danger, I tossed the gun toward a fire station.

Sealy was brought to Boston City Hospital. He had been shot several times in the head. I stayed at his bedside the whole time, praying he would wake up. But he was gone. The newspaper stories reported that I stomped around after the shooting, punching walls and shouting, "They got my boy!" Police also said I talked to them right after the shooting, but I have no recollection of that conversation.

My sister Carol was devastated—and she blamed me. She didn't speak to me for many years after that. It was upsetting to me because we had always been so close. But at the same time, I knew his death wasn't my fault. I understood her pain, but I was trying to bring these guys together and stop the violence. I had great intentions, but the result was horrible. A dude named John Tibbs was eventually convicted for Sealy's murder. Carol only started talking to me again a few years ago; now we speak at least a few times a month.

Home Again

When the guys in New Edition started making noise in 1995 about having me rejoin the group for its next album and tour, I was ready to get out of the house. Krissi was about two and I had spent the last couple of years at home as a father and husband and also managing Whitney's affairs. I had gotten the break from performing and traveling that I had been looking for; now I was ready to get back out there.

It had been a decade since I walked away from New Edi-

tion. The only group member I'd kept in contact with over the ensuing years was Ralph Tresvant. He and I remained close as ever, but I didn't speak to Mike, Ronnie or Ricky for many years after the breakup. I admit that I still held on to quite a bit of animosity. After all, they had allowed management—in fact, the same people who were managing me for my solo career—to talk them into voting me out of my own group, the group I started. That didn't go down easy for me, so I was pissed off for a long time.

But over the years my bitterness had subsided. I started to ask myself, *What the fuck am I mad about?* I had gone on to a hugely successful, groundbreaking solo career. I was married to one of the most beautiful, talented artists in the world. I had an adorable baby girl and three other wonderful kids. Life was looking real good for me.

The members of New Edition couldn't deny my success, so they granted me the respect I hoped for when we came back together. So many years had passed that the tensions were mostly gone. We were grown men now, so we had developed maturity and perspective. As for me, I didn't need the reunion. I didn't need money, and I certainly didn't need any more fame or notoriety. I was happy to get back out on the road with my old friends.

Right away, when we started talking about money I was brought back to the early days of New Edition. The first thing I heard was that the tour would have thirty dates—but the group members weren't going to make any money. We

would have to do a second leg of the tour in order to clear any money. My brother, Tommy, and I thought that was absurd. This tour was going to be a major event, just like the album release. The *Home Again* album sold 441,000 copies in its first week, debuting at number one on the *Billboard* charts. It eventually would sell more than two million, demonstrating that there was tremendous fan interest in our reunion. But yet, the performers on the tour wouldn't make any money?

MCA kept pushing me and Tommy to sign with the group, claiming they needed me to be under the same liability. But I refused—I was a solo artist with no interest in being considered the same entity as New Edition, with the same contractual deals and obligations. New Edition was in the midst of a legal battle with MCA over the terms of their contracts, so I wanted no part of that.

I told my brother to inform Al Haymon, the tour promoter, that I needed a million dollars free and clear in order to agree to the tour. I felt it would be ridiculous for me to spend three months on a grueling tour and come back home empty-handed. When he agreed to that, I told him I had one more condition: he had to let me go back to the group members and inform them of my separate deal. The last thing I needed was for them to find out after we were out on the road and to think that I had set out to undermine them.

After one of our rehearsals, I sat the group down and told them about my separate deal. As you can expect, they all exploded in anger. I thought that if I informed them of

my deal, they couldn't hold it against me—but I was wrong. They were immediately angry and resentful of me when they should have directed their anger at their management.

Johnny Gill got it right away. "I *knew* we could have negotiated for more money!" he said, jumping up from the couch.

While I understood their disgust, it's not like there wasn't a music industry precedent for what I was doing. You think Mick Jagger gets the same amount as the other members of the Rolling Stones when they go out on tour? They couldn't have a real reunion tour without Bobby Brown, so I was just using the leverage I had to make sure I didn't get screwed.

Let me just say *Home Again* had to be the craziest tour in the history of music tours. I said up above that we were all older and more mature now, right? Well, let me amend that by saying we *should have* been more mature. Instead, all of us were fuckin' wild and crazy. Up to that point, I had never done so much dope in my life as I did on that tour. We insisted on each of us having our own separate bus. We each had our own entourage; we even gave them sinister-sounding names. Mine was the Mad Mob. We even had jackets made up with the name splashed across the back. I brought back the old crew that used to roll with me before I got married. In total I had about seven guys on my bus. And each of us had a collection of guns—handguns, machine guns, about three pieces each. That meant I had nearly two dozen guns on my bus alone. You might ask what in the world we were

thinking, packing like that when the bus could be searched at any time—especially considering how much the authorities always zeroed in on me. The answer would be, we weren't thinking at all. We thought we were gangsters, serious OGs. So we had to have the hardware to go along with it. When I look back at it, we're just fortunate that nobody got hurt or arrested. And we did come close a few times. My crew and Ronnie's crew got into it once and guns were drawn. Some of us were trying to make extra money on the side by selling drugs. There was some kind of conflict, a stupid mix-up involving somebody selling on someone else's turf, resulting in a few guys deciding that they needed to show their pieces.

Whitney wasn't eager for me to leave home to go on the tour, so she decided that she would come with me. This led to one particularly memorable scene out in the middle of nowhere, when the tour buses were barreling down the famous Route 66 somewhere in the Midwest. I was doing so much dope on this particular day that I was overtaken by paranoia; Whitney and I had been arguing and for some reason I seized upon the thought that Whitney was trying to kill me. In a serious panic, I ran up to the bus driver.

"Pull over—I want her off!" I screamed, pointing at my wife. "She's trying to kill me!"

The driver, seeing the crazed look in my eyes, obliged me and pulled the bus over to the side of the road. I jumped off the bus, scaled a fence, and started running toward a house I could see in the middle of a big field. I had at least

an ounce of cocaine in one pocket and a handgun in the other. Whitney was running behind me, yelling, joined by her friends.

"Bobby, come back here!" I could hear her behind me.

Because we each had our own bus, our tour consisted of a massive caravan. When the people in the other buses spotted me running like a madman through a field, they all started pulling over too. People streamed out of the buses, asking questions.

"What happened—what's going on?"

"Bobby's going nuts!" was the answer they got.

Finally I reached the house that somehow I saw as the solution to my problems. But it turned out I was very wrong. A man was stepping through the front door, an older white man.

"Excuse me, can you get me some help?" I said to him.

What I heard next was the distinctive sound of a shotgun being cocked. *Clack clack. Uh-oh,* I thought.

"If you don't get your ass off this property, I will blow your fuckin' head off!" the white man said with a snarl. I was still a distance from him, but I could see enough of his face to know that he probably meant it. I wasn't really that shaken though. My primary conclusion was that he was not interested in helping me. So I turned and started running in a different direction, where I came upon a street. At this point, I had at least a dozen people chasing me, including Whitney and her friends and several members of New Edition.

I got to another house before the group could catch me. I pounded on the door. This time I was ready when another white man came to the door: I pulled out my gun and pointed it at him.

"Excuse me, sir, I don't mean no harm," I said, though the gun probably told him something different.

"There's somebody down the street trying to kill me. And they're gonna be here any second."

Staring at the gun, the man was surprisingly calm. "Sir, you need to call the police," he said.

"Yeah, you're right," I said. "Call the police."

Mind you, I had a pocket full of drugs, I was high as fuck and I was holding an unregistered handgun that I had just pulled on a random white man. In my drug haze, calling the police seemed like a good idea. Luckily the crowd, which included the incredibly famous Whitney Houston, arrived a few seconds later and convinced me to leave the poor white man alone and come away with them. But I still was taken by the idea that my wife wanted to see me die.

"Get my wife and all the rest of them off my bus right now!" I yelled.

Whitney and her crew rode to the next tour stop on Ricky Bell's bus. By the time we got there, I was still high, but I had calmed down enough to talk to Whitney. We sat down and I just told her, "Baby, you gotta go." I booked her a flight and the next day she and her girls were gone.

New Edition did go out again for a second leg of the tour

to make money, but Michael Bivins—who had a lot of other business going on, including his discovery of Boyz II Men—and I sat that one out.

How High

Much of the attention paid to me and Whitney over the years focused on drug use. It was the subject of most of the attacks and media criticism we endured. Before we got married, we smoked weed together and that was the extent of it. Then after I saw her doing cocaine on our wedding day, eventually that was added to our repertoire.

"Michael, what's going on?" I said when I first asked her brother about the coke. "She shouldn't be doing that stuff. That's some bad shit."

"Nah, that shit will make you feel right," he said.

The next time she offered it to me, I did it with her. I'm not particularly proud of this, but my defenses weren't exactly strong at the time. I had been smoking weed now for several years, so it wasn't hard to justify a step up to cocaine. With coke, if you keep dabbling, you're going to get hooked. I didn't like it right away, but pretty soon I noticed that it made me feel extra sexual. It had the same effect on her. We would do it when we would go out to a party; soon we'd be all over each other, and by the time we got home it was a wrap. We would have some mind-blowing sex—which would only make us eager to do more of the drug. A little later,

Whitney's brother introduced us to smoking cocaine, which is called freebasing.

When I was about thirty, around seven years into our marriage, the drugs almost killed me. I had been doing way too much. It was a prime example of the damage that can be caused when drug addicts have millions of dollars at their disposal. This one particular day I was trying to come down off a three-day high. I still had maybe an ounce of crack and an ounce of heroin left. I was on my way to the kitchen to cook more of the stuff. I was smoking a crack-laced joint and sniffing heroin while preparing to cook more crack. I didn't want to be too high, just high enough. In addition I was drinking Courvoisier and beer. As I said, I was doing *too much*.

All of a sudden, as I was walking back toward my drug den, I lost all control of my limbs. Everything. I just fell out onto the floor. Whitney thought I was playing.

"Get the fuck up!" she barked in that snappy Whitney way. "Stop playin'!"

She bent over and took the drugs out of my hands and started using them herself, while I was still splayed on the floor. It was just a fucked-up scene. Later on that night, when it was clear I wasn't playing, they took me to the hospital, where they did some tests and determined that I had had a stroke. The doctors were amazed I wasn't dead. With all the bullshit I was putting in my body, I probably came close to dying four or five times.

Believe it or not, after I was released from the hospital

and it was clear I hadn't lost the use of my limbs, I went right back to the drugs. My motto at the time was, *Fuck it!* The drugs were living for me; I wasn't living for myself.

This is around the time when my jaw got all crooked and affected my entire mouth. At first we thought it was the drugs sending my mouth in opposite directions, but eventually we realized it was my wisdom teeth. I had two big-ass wisdom teeth that were fucking my whole face up. I couldn't chew right and kept biting on the inside of my jaw. But I was so high all the time that I didn't even realize what was happening.

For some reason Whitney's drug use got worse after Bobbi Kris was born. Maybe it was because she had to stop using all those months while she was pregnant, but she resumed with a vengeance. The way our house was built, we could stay in certain wings of the house far away from our daughter. We had a room that had an airtight lock on the door and we would lock ourselves away inside while the staff took care of Bobbi Kris. I was adamant that we never bring any of our shit anywhere near her. I was self-conscious about washing my hands all the time, all day long, washing my face, downing breath mints. I felt like it was my job to leave the room and go make sure Krissi was all right. I would try to keep Whitney locked in the room, telling her she shouldn't come in front of our daughter because of the way the drugs affected her. But I couldn't police Whitney; nobody could police Whitney. She did what she wanted.

While I often get the blame for introducing drugs into our lives, I was the one who decided I'd gone too far and went to rehab to get my life together. But the problem was, when I came back home, clean, Whitney was still using. That made me really angry. So she would hide it from me. She'd leave home for days at a time so she could do drugs. It was a terrible situation. Unfortunately I'd slip back into the habit, this time even harder than before, because I couldn't control her and I couldn't control myself.

Our daughter was growing up in the middle of all of this. She often saw her mother and father high, and was around the two of us when we were fucked up. We tried to keep it away from her, but it was hard for us to see her only when we were sober. How much quality time can you spend with your daughter when you're high all the time? I would get really mad at Whitney, scream and yell that I wanted a divorce. This went on for years and years. Our daughter saw it all. When I think about it now, I just feel enormous pain. We failed her.

When my son Landon lived with us for a while, I felt like I failed him too. He was there but I was a distant presence because of the traveling, the tours, the drugs. We had a second house on the property where my father and Landon stayed. That's where my studio was. So even when I would go there, it would be at night when Landon was asleep because he had to go to school the next day. I saw how it was affecting him spending all his time around rich white kids. The first

time I saw him play basketball, he was just terrible. I was like, "Dude, don't ever do that shit again." That hurts my heart right now to remember that. We have a closeness now, but at the same time I just wish that the drugs were never in my life and I could get back that time I missed with him, teach him how to play ball, talk to him about life. But instead Whitney and I would be locked in a room together for weeks, off in another world.

After I got stuck on the stuff, I was stuck. When you have the kind of money we had, you didn't even need to leave the house. I would call up one of my boys, a supplier, and I'd say, "Yo, put the shit in the mailbox. Put me three ounces in the mailbox, the money is in there." I had an incident at the House of Blues during this time that illustrated my complete lack of self-awareness when I was high. Whitney and I were in the audience enjoying the magic of Maze and Frankie Beverly, swaying to their blockbuster hits, like "Before I Let Go." Apparently word had gotten to Frankie that I was in the crowd, so they decided to call me up to the stage. This is an honor usually given to celebrities, so I wasn't surprised. But for some reason Frankie and his boys decided that they would ask me to sing along to one of their songs. I don't recall which song it was, but I do remember it was a ballad. However, it wasn't one of their signature songs. I had heard the song before, but I didn't know the words. I'm onstage in a packed nightclub and they gonna throw me a curveball like that, without checking with me first? I was pissed off.

So I started making up my own words as I sang along. This didn't please Frankie and the band; they decided to abruptly cut me off.

"Thank you, Bobby Brown!" Frankie said, stepping on top of me.

Even though I was high, I felt the sting of embarrassment. As I made my way offstage, I wanted to do something to get a quick bit of revenge: I walked past Frankie Beverly and snatched the baseball cap off his head. Frankie's baseball cap was his signature wardrobe accessory. Taking off his hat was a big-time no-no. And Frankie was not happy.

"Awww, man!" I heard him say off mic.

He had embarrassed me, so my response was to embarrass his ass. Frankie moved toward me and I handed the hat back to him. I could see the displeasure on his face. I knew I had done something silly, but at the time I didn't really care. I figured that's what he deserved for calling me onstage to sing some song that wasn't well known. It was presumptuous, and I didn't handle it well.

When I went to rehab the first time, I made an important discovery about myself: I have bipolar disorder. The counselors were listening to me talk about my mood swings and drug binges and told me they wanted to run some tests. Bipolar disorder, which is caused by brain imbalances, is characterized by unusually intense emotional states that are a drastic change from a person's usual mood and behavior. The moods can veer from an overly joyful or overexcited

state, called a manic episode, to an extremely sad or hopeless state, called a depressive episode. During an episode, people with bipolar disorder may be explosive and irritable or exhibit extreme changes in energy, activity, sleep, and behavior. I found out that substance abuse is very common among people with bipolar disorder because they try to manage their symptoms and find stability. I can definitely attest to that one. Even now, sometimes I forget to take my medicine and I'll end up in a depressed stupor, sleeping on the couch all day. When that used to happen to me before, I would resort to drugs to make me feel better. The diagnosis was an incredible relief to me, explaining so much about the mood swings I've experienced throughout my entire life. I had sensed that something was wrong with me; I just figured I was crazy. I never imagined that there would be a pill I could take to make it go away.

I saw just how disruptive Whitney's fame could be when Whitney and I desperately tried to help save my sister Elizabeth (Bethy) when she was dying from lung cancer. We had heard about the Black Israelites and the healing medicines and magic they possessed, so Whitney and I brought Bethy over to Israel in a last-ditch effort to help her heal.

But instead of focusing on my sister and her needs, these guys turned out to be charlatans who only seemed to care about spending time with the rich and famous Whitney Houston. They told us that a baptism in the Jordan River could be a powerful start to her healing. So Bethy and I held

hands and dunked ourselves in the dirty, murky Jordan for a good forty seconds. It was a beautiful, spiritual moment for us—until we emerged from the water and saw that Whitney had gone off with the Israelites, who no longer seemed to care anything about Bethy. Instead of giving her healing medicines, they told us to have her eat vegan food. That was about it. I was incensed. I was desperate for anything that I thought might save her, and it broke my heart to see these supposed healers playing the fame game. We lost Bethy on June 21, 2003.

———

A FEW WORDS FROM LEOLAH BROWN

Over time, Whitney and I became close confidants. We had plenty of secrets we shared. She told me many things that she'd never told anybody before, things she needed to get off her chest. Whitney was very private; she kept things very close to the vest. But I saw how the people around her sometimes did things that really hurt her.

There was one image that I'll never forget. It happened one day when I was working as her assistant and we were about to go shopping and get our nails done. Whitney needed some cash. I pulled the car into the parking lot of that bank on the corner of Piedmont and Peachtree in Atlanta—the one with all the windows. I even parked in a handicapped spot because she said it was only going to take a second. After a while, I wondered why it was taking her so long to come out. When I walked into the bank, I saw a scene that will stay with

me forever. Whitney was standing in the middle of the bank, talking real loud with her hands waving in the air. And people were staring at her with their mouths hanging open. Luckily we didn't have cell phone videos at the time.

I'm thinking, *What in the world is going on here?*

Then I heard what had happened: the tellers had just told Whitney she didn't have any money in her account. She was standing there, incredibly mad and embarrassed.

"What do you mean I can't get money out of my account?" she said loudly.

"Ma'am," one of the women behind the glass said calmly, "as we said, there's no money in that account."

I was so upset for her. Someone must have taken the money out of her account. It had to be an awful moment for her. The whole bank was in shock that this was happening to *the* Whitney Houston.

When I was there with Nippy and Bobby, my primary job was to take care of Krissi and do a lot of the day-to-day things that Nippy and Bobby needed done. Krissi was about eleven or so by this time and in my opinion she had a good life. I'd bring her to school every day and when she came home she would hang out with all of her friends in the neighborhood. She had a lot of family time with her parents, doing fun things like going to restaurants, movies, events that they were invited to. Sometimes they would do things without the rest of the family so that they could have quality time with just the three of them. Other times they would bring the whole family—nieces, nephews, etc.

They loved Krissi intensely. She was well cared for; she was protected. I read things where people were saying she was neglected and that couldn't be further from the truth. Even when they were caring for her themselves, they had a full staff of people on hand to take care of her every need. There was so much love between them that I didn't think their marriage would ever end. I never thought things were so bad that they couldn't work it out.

I was amazed by some of the incredible things I would see my brother do when I was around him. People really just don't understand how big his heart is. Bobby would walk around with a checkbook and write checks for anybody who was in need. There are many people who wouldn't have finished college without him. Young people, even strangers, would walk up to him sometimes with stories about how their parents didn't have the money this month for their tuition. Bobby would ask how much and write them a check. He's paid people's rent; he's paid for people's funerals. He would never ask questions or ask for proof. And the public would never hear about any of it. It didn't matter if you were white, black—he didn't care.

One time in Atlanta it was getting cold outside and we saw a homeless guy sitting there on the ground without any shoes on his feet. Bobby saw him and asked the driver to pull the car over. He literally took his sneakers off and gave them to the man. Then he went and bought him some food and gave him hundreds of dollars in cash.

I remember another time there was this bum we used

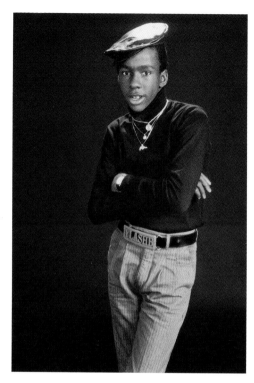

LEFT: Styling in the early eighties with my Flash B belt buckle. *Courtesy of the author.*

BELOW: New Edition when we performed at Jordan High School in 1986. *Back row:* Ralph Tresvant; the principal of J.H.S.; A & R executive at MCA Records, Louil Silas; radio rep, Maxia Barnett; a friend; and Michael Bivins. *Front row:* Ricky Bell; a fan; Bobby Brown; and Ronnie DeVoe. *Courtesy of the author.*

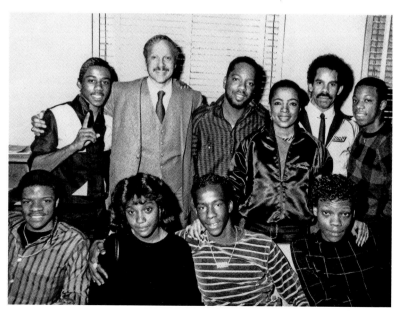

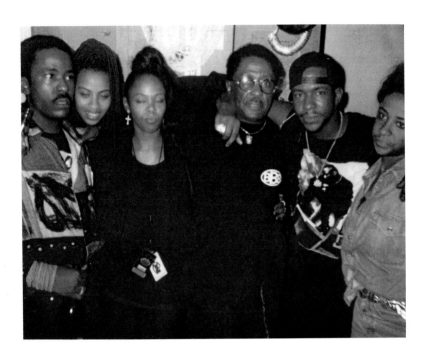

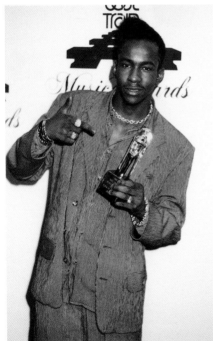

ABOVE: My brother, Tommy; my sister-in-law Carolyn; my sister Leolah; my dad; me; and my sister Carol; all of us backstage on the Humpin' Around tour in 1992. *Courtesy of the author.*

LEFT: At the Soul Train Music Awards in 1989, where I won Best R & B / Urban Contemporary Album for *Don't Be Cruel. Courtesy of the author.*

My amazing mom and me. *Courtesy of the author.*

My parents, Carole Elizabeth and Herbert James Brown; may they rest in peace.
Courtesy of the author.

LEFT: With my kids Bobbi Kristina, Bobby Jr., and LaPrincia back in the day. *Courtesy of the author.*

BELOW: Whitney Houston and me at the Soul Train Music Awards in 1990. We were the power couple. *Photo by Kevin Winter/ DMI/The LIFE Picture Collection/Getty Images.*

LEFT: At the 1998 Achievement Awards with Whitney and little Bobbi Kristina. Notice our color-coordinated outfits. *Photo by Jeff Kravitz/FilmMagic, Inc.*

BELOW: Mom, Bobbi Kristina, and my niece Amani. *Courtesy of the author.*

With LaPrincia at her high school graduation. I'm so proud of my girl. *Courtesy of the author.*

With my man Ralph Tresvant. Partner in crime. *Courtesy of the author.*

Me, Cassius, and Bobby Jr. at my and Alicia's wedding in Hawaii. *Courtesy of the author.*

Tearing up at our wedding while LaPrincia and Landon give a speech. *Courtesy of the author.*

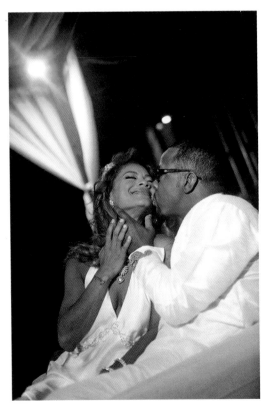

LEFT: So full of joy with my beautiful wife, Alicia. *Courtesy of the author.*

BELOW: At home with Cassius, Alicia, and Bodhi. I'm a happy family man. *Photo by Marselle Washington.*

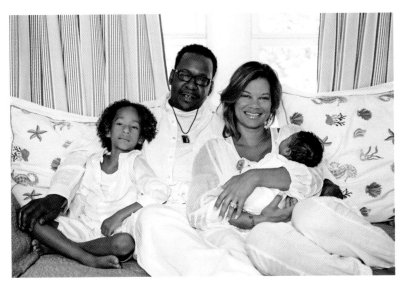

to see all the time when we went to downtown Atlanta. So Bobby had had enough. He went back home and got a bunch of clothes, stuffing them into bags. He brought the bags back to the man, along with some food. You should have seen the look on that man's face. He was so shocked and so happy.

One time Bobby, Whitney and I wanted a quick bite to eat, so we went to the Buckhead Diner on Piedmont, a longtime Atlanta institution. When we walked in, there were two white guys sitting at the bar. The guys immediately said hi to Whitney, but they didn't say anything to Bobby. As we sat down, they kept looking over at him and saying nasty things, like "Whitney shouldn't even be with you" and "Get out of here" and "She should leave you." Finally Bobby got up and walked over to them. I kind of held my breath because I didn't know what to expect. It had the potential to get bad in a hurry, depending on how Bobby handled it.

Bobby sat down at the bar next to them and said, "You know, I'm not a bad person. You're yelling and saying all this foul stuff to me, but I haven't done anything to you."

The guys at first stared at him without saying anything. Then they started talking to him and wound up having a great conversation. They eventually apologized to him, telling him he was really a nice guy. He could have handled it differently—he would have been justified in giving them the same kind of nastiness they were giving him. He could have said, "Fuck you, let's take this outside." Bobby is from OP— he's certainly capable of taking it there. But he didn't do that.

He sat down and calmly spoke to them with kindness, to the point where these two white men said, "Sorry." That's who Bobby really is.

––––––

Bars

In our society, stories about the horrible things that happen to men in prison are passed around so frequently that they have become almost a cultural cliché, particularly in the African-American community. So when a guy faces a prison sentence looming in front of him, he has to prepare himself for all varieties of hell that might be coming his way.

In the summer of 2000, I found myself being carted away to a Florida prison. My crime? A judge decided I had violated the conditions of my probation stemming from a DUI in 1996 in Hollywood, Florida. I believe our nation's probation system is a scam, giving the authorities complete discretion in deciding if and when you have violated your terms. A Florida judge decided that I hadn't completed the one hundred hours of community service that were a condition of my parole, and that I had violated my probation by attending the Grammy Awards in California and traveling to the Bahamas. Mind you, these trips were years after the actual DUI.

So one minute I'm enjoying a fabulous Bahamas vacation with my family, the next I'm being thrown into a jail cell in Broward County, Florida. The whole time I was out-

raged, feeling like I was being treated unfairly because of my name and reputation. I knew I was doomed when I watched my lawyer in action. This guy, who was retained by Whitney's people, was fine when we were consulting before we went into court. He sounded like a normal guy. But when he stepped into that damn courtroom, this dude turned into the stuttering lawyer from *My Cousin Vinny*. If you don't remember the scene I'm talking about, Google it to refresh your memory. And then imagine my fate in that guy's hands. In my defense he told the judge: Just because you hear that Bobby Brown beats his wife, that Bobby Brown does drugs, that Bobby Brown is a menace to society, we're not judging him on that.

I sat there absolutely stunned, thinking, *Are you out of your fuckin' mind?* His defense was to throw me so far under the bus that you couldn't even see me anymore. It was no surprise when the judge sentenced me to seventy-five days in jail. I had already done more than half of the time awaiting the hearing, so I had to do thirty-six more days.

I truly spent the next decade being punished for that 1996 DUI arrest. My cause wasn't helped by the fact that I had also gotten arrested in April 1995 at a Disney World nightclub after my boys beat up a guy who had spit on me. I tolerate a lot of crazy entreaties by fans and members of the public who are definitely *not* fans of mine, but the one thing I will not tolerate is somebody spitting on me. My boys jumped on him and really messed him up. I wound up having to pay the

guy about $30,000 in an out-of-court settlement. When the Orlando police carted me away in a squad car, I already had to go to the bathroom. I told them repeatedly from the back of the squad car that I had to go pretty bad, but they ignored me. So what did I do? I took my hands, which were in handcuffs, and managed to slip them underneath my legs—I was a lot skinnier and more limber then—so that I could reach my zipper. I unzipped my fly and proceeded to piss in the back of the police car, unbeknownst to the cops. They pulled me out of the car and carted me off to a cell, only discovering later that I had pissed in the car. Yeah, in retrospect it sounds quite crude and immature—I was twenty-six at the time—and I'm sure I wouldn't do something like that now. But hey, I *told* them I had to go.

When I was sent to jail, knowing all the stereotypes about what it was like, I walked in there preparing to fight. I didn't want to fight, but if it came to that I was mentally ready. But it turned out that my fears were unfounded; I never had to raise my hands to anybody. I think the most important thing for me was to stash away any sense of superiority, so that nobody—fellow inmates or corrections officers—got the impression I thought I was better or entitled to any kind of special treatment. I could sense instantly that the quickest path to trouble for me was to act like I expected special treatment because of who I am. My attitude was that I should keep my head down and get this time over with.

The biggest benefit I derived from those two and half

months in jail was that I got clean. I finally beat the dope I had been hitting hard for nearly a decade, out of necessity. I had spent time at a rehab facility in Minnesota, but it wasn't until I had to sit there in that fuckin' cell every day that I finally beat my addiction. It wasn't easy, it wasn't pretty, but after a couple of weeks I knew that I didn't crave it anymore. I had emerged on the other side.

I was my usual self while I was in there—the clown, always trying to keep people up. In that way, I made a ton of friends. Most of the other inmates were fans of mine, so they treated me with respect. We had just one television, which was often tuned to video shows, so whenever one of my videos came on there would be a loud uproar throughout the cell block. Guys would be yelling and talking shit to me and about me, but in a good-natured way. I would laugh and play along with them. I got even more popular when I used my money to make sure everybody in the block ate well on Fridays. If we had money in our kitty, the corrections officers (COs) would let us order food from the outside. So I would pay for the entire block to get food delivered from this barbecue joint. We'd be feasting on ribs and chicken and other delicious fare. That nearly made up for the rest of the week, when the food was warmed-over garbage—and sometimes not even warmed over—consisting of things like salami sandwiches and peanut butter and jelly. I went from a private chef preparing mind-blowing meals for me and Whitney to peanut-butter-and-jelly sandwiches. And I'm not sure who

their food supplier was but we're talking the cheapest kind of peanut butter and jelly you could imagine.

I should point out that my time wasn't spent in some low-security summer camp with white-collar criminals. No, my fellow inmates were dudes awaiting sentencing or trial for some hard-core crimes, like murder. I chose not to go into protective custody because PC wouldn't have given me the opportunity to reduce my sentence. I wound up getting out about two weeks early because I stayed in the general population, where I worked doing jobs like cleaning the showers and toilets and collecting the trash.

We had a condo in South Florida where Whitney stayed the entire time I was locked up. In 2000 we were both in a bad way, spending way too much time high. But there was still a lot of love between us. Whitney came to see me every week, but I never let her bring Krissi, who was only seven. We always had separate visitation from the other prisoners, so she never had to interact with everybody else. We would sit facing each other in the visitors' room with thick glass between us, so we never got a chance to touch. Whitney would talk about business, about Krissi, and constantly tell me how much she missed me. My brother came to see me once but I didn't get many other visitors. I didn't want my parents or other family members to visit me. It was just too painful when they walked out of the jail and I had to stay.

I had my only conflict with another inmate at the prison. I was on my bunk, lying back and reading, when a white inmate walked into the room and came close to my bed.

"Did you fuckin' tell the COs?!" he said, loudly and aggressively.

This guy was a member of the Aryan Nation, a gang of white supremacists with shaved heads and scary-looking tattoos all over their bodies. He had this look on his face like he was there to inflict some type of damage. I slowly rose up from my bed so that I was facing him. I knew that whatever was about to happen, lying on the bed while he stood over me was not the most optimal position.

"Nah, man, I don't know what you're talking about," I said to him, looking him in the eye. "I didn't say nothing to nobody."

He stared at me for a few more seconds, and I stared right back. He turned around and walked away. And that was that. I don't even remember what those Aryan guys were upset about, but they got the idea in their heads that I had snitched on them, which couldn't be further from the truth. I had no interest in getting in the middle of some white supremacist bullshit.

"You handled yourself really well," my cellmate said after the Aryan dude had left. "If you had stayed on your bed, he would have tried to kick you or something. You did the right thing."

My cellmate and I got to know each other fairly well. He had been charged with murder and was awaiting trial. He had been offered bail on a murder charge; I was denied bail on violating probation for a DUI. I couldn't believe the stupidity of that. The prosecutor had claimed that I had the

means to escape. My incompetent lawyer's counter? I wasn't a flight risk because I was such a "notorious individual" and therefore couldn't be incognito if I tried to disappear somewhere—as if the judge would be swayed by being told how bad I was.

"If you watch my back, I'll watch yours," I told my cellmate. "And I'll bail you out as soon as I finish my time."

I followed through on the promise, posting his $1,500 bail as soon as I was released.

I tried to attend a Bible class in prison, but the philosophy of the instructor was problematic to me. He was trying to tell me that I didn't know God when I was using drugs. But I disagreed. I told him that when I was high, trying to get closer to God was one of my primary preoccupations. That might sound crazy, but if you've ever gotten high you'll know exactly what I'm talking about. Drugs can give you a sense of serenity and peace that feels very spiritual. I would even take it a step further and sometimes read the Bible when I was high. But this guy told me I was a liar.

"You know what? I can't even be here," I said.

So I got up and walked out of the class.

I channeled my energies into trying to help the younger guys, the ones in their late teens and early twenties. I started the Young Guys Study Group, an informal gathering for the younger cats who were in there on drug charges. I would mentor them, talk to them about their lives, advise them about the moves they needed to make going forward to turn

around their trajectory. We related to each other because they knew I wasn't talking in the abstract; I had come from the same places, been on the same rough streets, as them, but I had gotten lucky and escaped because I could hold a note and move around a stage.

There is a mind-numbing monotony to jail, a daily battle against time, which turns out to be your greatest enemy. How do you fill up the twenty-four hours in a day without driving yourself crazy? In Broward County, the battle was made even more painful by a giant clock placed in the middle of the block. So, even if you tried to avoid clock watching, you couldn't; you'd look up and see that only five minutes had passed since the last time you looked. I spent as much time as possible reading—the Bible mainly, or books by old-school street-crime writers like Donald Goines.

When it was time for me to get out, I was amused by the hilarious antics of Chris Rock, who had launched a "Free Bobby Brown" campaign on his HBO show. Of course the humor came from the fact that he was making fun of me, comparing me to historic freedom fighters like Gandhi and Nelson Mandela. I was fully aware that all my scrapes with the law served as a punch line for his parody. But the one thing I've always been able to do is laugh at myself—and I had to admit that the segment was damn funny. He even had a little plane flying over the jail with the banner "Free Bobby Brown." He had the crowd sing an acoustic, country-western version of "Don't Be Cruel" while he interviewed a

whole bunch of folks and asked them if my imprisonment was racially motivated.

"Nah, he just fuck up," one lady said.

When I walked out of the jail, I wrapped Rock in a big hug.

Reporters asked Rock why he had decided to stage the protest. He said, "People ask me to get involved in causes all the time. I just felt I needed a cause I could believe in. So I sat down and really thought about it and I said to myself, 'Self, what can I believe in? Who never let you down?' And I came up with one person, Bobby Brown."

My next encounter with law enforcement came three years later, in an incident that still haunts me. Whitney and I had our share of arguments, sometimes really nasty, ugly stuff, lots of cursing, lots of name-calling. But up until a fateful night in 2003, I had never hit her—or any other woman. I adore women; I believe they are precious creatures who must be cherished and protected. The idea of some dude laying hands on one of my daughters drives me insane. So it will forever disturb me that one of my long-lasting legacies, one of the Bobby Brown tales that will exist forever on the Internet and in the public consciousness, is that I abused Whitney Elizabeth Houston.

On this particular night in early December 2003, we were both intoxicated. We weren't high, just drunk. Whitney thought I had left the house with my brother to take a flight, but I was still home. So she came back in the house and had

some guy with her. Even worse, it was her drug dealer, one of the people whose presence in her life was torturing me because I had been trying to push her to get clean. I couldn't believe she would bring this dude home with her. So I confronted her and things just exploded.

"Who the fuck is this and how you gonna come into my house with some other dude?" I screamed at her.

We started yelling back and forth, cursing. I put hands on the drug dealer, really roughed him up. I was in an unstoppable rage. Whitney tried to stop me from beating up the dealer, but I was not having it. I turned around to her, drew back my hand, and smacked her across the face. The moment it happened, I was stunned and full of regret. I knew I had stepped across some line, a step I would never be able to undo. The circumstances of the blow, how much she might have done to incite me, wouldn't matter. From that moment on, I would forever be a wife beater. At that moment, all I wanted to do was get out of the house. I went out and got into the car with Tommy and we drove off. After I left, someone in the house called 911 and reported a domestic disturbance at our home in Alpharetta.

Stories in the media said that Fulton County police officers came to our home at eight-thirty p.m. in response to the call. Whitney didn't identify herself on the phone call. When police arrived, Whitney calmly told them that we had been arguing and it escalated into a physical confrontation that ended with me hitting her on the left side of her face with an

open hand. The officer claimed that Whitney had a bruise on her cheek and a cut on the inside of her upper lip.

The news stories made it look like I hopped on a flight to escape arrest, when I had actually left for the trip that Tommy and I had planned weeks before.

In the end, as you saw if you watched our reality show, *Being Bobby Brown,* after Whitney refused to press charges, the matter was reduced down to a misdemeanor and a $2,000 fine. But the damage was already done; in the public's mind I was Bobby Brown, Wife Beater.

When I watched the interview Whitney later did with Oprah Winfrey, I was horrified. I felt like she threw me so far under the bus that I would never get out from under. She said I hit her and spit at her in front of Krissi, but that never happened. I never spit at her and my daughter was upstairs sleeping during the fight. But I sometimes wonder if the things that later happened to Krissi, the domestic abuse that she may have later suffered, perhaps was the universe in some way coming back to destroy me for raising my hand to her mother.

That drunk-driving arrest from 1996 continued to haunt me over the course of the next decade, as I kept getting thrown into jail because the system decided again and again that I hadn't abided by the terms of my probation. In 2004 I was sent to jail in DeKalb County, Georgia. I was especially hot over this one because I didn't understand why I was still paying for a DUI from nearly ten years ago.

My lawyer this time was a black woman named Phaedra Parks, who went on to become a reality television star on *The Real Housewives of Atlanta*. Her later television stardom didn't surprise me because she always seemed like she was craving attention and publicity. Every time I stepped into the courtroom when she was my lawyer, there would always be a host of television cameras. It was as if she had her own traveling media contingent. I even complained to her about it, telling her I didn't like having the press there every time I approached the courthouse. But it didn't seem to deter her.

I won't cast aspersions on her lawyering skills, but I will say that when she was my lawyer, I usually wound up going to jail. I haven't had much luck with my legal representation over the years.

When it was determined that I had to spend thirty days in a Georgia prison for yet another probation violation, I was so damn frustrated. I did not think I deserved to be there. I thought I might get some help or at least a little leniency from the Fulton County district attorney, Paul Howard, considering that Whitney and I threw a campaign fund-raiser for him at our house that raised more than a million dollars—with more than a half million coming from my own bank account. But Howard refused to pardon me or take any kind of special interest in my case whatsoever. So much for the legal system tilting in favor of the rich and famous.

From the second I walked into the prison in Decatur, the experience was different from Florida because I knew so

many of the guys locked away. These were guys I had run into in clubs and bars around the city of Atlanta over the years. There were more black guys in the Georgia prison—no Aryans to worry about there. I was also treated better by the COs in Georgia—at least by the black COs. They would do little things to help me out, like sneaking me a cigarette now and then and letting me smoke, even though there wasn't supposed to be smoking in the prison. The white COs were quite different; they had the attitude like the last thing in the world they would ever do is treat me better because I was Bobby Brown.

Over the month I spent there, I had a job that allowed me to go outside as part of a small crew and sweep. I relished this outside time and felt fortunate that I had been assigned to the crew. When I was inside, we spent a lot of time playing spades. We played just as loudly and aggressively as we did back home, talking a whole bunch of smack. I also played a considerable amount of basketball, putting me in the best shape I had been in years.

Whitney came to visit about three or four times over the month. As opposed to Florida, we were able to touch each other, though it couldn't go any further than hugs, kisses and caresses because there was a CO standing over us the whole time. The visits took place in the warden's conference room, which afforded us some privacy. I know the other inmates didn't get to visit with family in the warden's conference room, but it was much more for Whitney than me.

They wanted to keep her away from the prying eyes of the other visitors.

The food was the same nasty crap that I got in Florida, this time with no special deliveries on Friday. But we did get pizza on Friday, which wasn't bad. Wednesdays it was chicken cacciatore—I still have the schedule committed to memory all these years later. Because I had plenty of money in my commissary, I was able to gather the ingredients to make a special jail soup that I learned to love. You needed Slim Jims, cheese sticks, Cup-a-Soup, Doritos and some hot water. You would bite the Slim Jims and the cheese sticks into little pieces and put them inside the Cup-a-Soup. Then you'd crush up the Doritos and put them in the cup, along with some hot water. You put a book on top of the cup and let it sit for ten to fifteen minutes. Once it was done, it was this delicious mix of cheesy, crunchy pepperoni soup. I got so addicted to it that after I got out I continued to make it for about two weeks. Then one day in the middle of preparing my jail soup, I stopped.

"What the fuck am I doing?" I said out loud. There was no reason for me to eat jail soup, and I hoped I'd never have to again.

After I got out, strangely I didn't want anything to do with human contact. It's odd because at the same time I craved sex and intimacy, just like the stereotype of the just-released felon. But the dichotomy is that while you want sex, you don't want anybody to touch you. In jail, nobody

touches each other; you don't even shake hands. You come out in a weird state, both repelled by and drawn to touch. I would take long drives in the car with the sunroof open and all of the windows rolled down, staring at the trees and feeling the strong breeze on my face. I just wanted fresh air.

Starting the Reality Show Wave:
Being Bobby Brown

When I was about to get out of prison, my family members started urging me to do a reality show. My kids had seen Flavor Flav's show, so they thought it would be fun for me to do my own. My brother, Tommy, also thought it would be a great way for me to show the public what I'm really like. When he first proposed the idea to me, while I was still behind bars in Georgia, I was reluctant. Why would I want to let the world into my private life when we had spent so many years trying to keep the world out? It didn't sound right to me. But then I started thinking about my desire to clear my name, to show the public that they were wrong about me.

I was also thinking about my future. I was clean and free, pleased to be moving forward with the rest of my life, with fresh eyes. I was happy to be going home, happy to be with my beautiful wife again, happy to be with my kids.

"Why don't we just film it?" Tommy said. "You're being real about everything in your life. Let the public see the real you."

We hooked up with Tracey Baker-Simmons, who became an executive producer, and we started filming. Eventually we sold the show to Bravo, who quickly jumped on it. My thinking was, let's just film everything, so that nothing could be misconstrued or taken out of context. I wanted to be out in the open about everything.

I had read so many articles that made me look like this beast, this asshole, this person who didn't respect anyone or anything. I had even seen people calling me a pimp. I thought it was outrageous, crazy. I was just a loving husband and loving father. My life wasn't perfect, I wasn't perfect, but I wanted the public to see who I really was.

Originally my wife was not even supposed to be a part of the show. I know she told Oprah that she appeared on the show because I asked her, but that wasn't true. When we first started planning it, the cameras were just going to follow *me* around. But after I got out of jail, Whitney didn't want to leave my side. Every time I planned to film, she wanted to be there. So even though it wasn't planned as an examination of our marriage, that's what the show became. When we went out to dinner together, or traveled to the Bahamas or London, it became a show about our zany relationship.

Though a lot of the television critics blasted the show, the ratings were huge when it first aired in the summer of 2005. Whitney and I had been public figures for a long time and our marriage, thirteen years old at this point, had become a permanent fixture in American pop culture—but for all the

wrong reasons. It was clear that the public was eager to see what it looked like on the inside, since for so many years the view they got of us was provided by gossip columnists and tabloid magazines. One of Whitney's favorite expressions, "Hell to the no," even entered the public consciousness and became a permanent part of American pop culture.

People wondered whether we were embarrassed by our depiction on the show, but we laughed our ass off throughout the whole thing. Not only was it fun to do, it was therapy for us. We had a chance to see how we acted around each other, how we responded to situations, the mistakes we made. But all along, we were just being ourselves. If people thought Whitney was something different, they got a clear glimpse of who my ex-wife was through that show. She was a down-ass, horny chick. She was the woman I loved; I was the man she loved. That's what the show was about—not drugs or anything else. We basically loved, lusted after and adored each other for real, in so many ways. We enjoyed each other's company tremendously. We laughed, we talked, we screwed, we did everything together. And it was beautiful. Everybody else tried to make it into something strange or laughable or ridiculous, but it wasn't. Whitney later told Oprah Winfrey that I was her drug. And I can honestly say the same was true of me—she was my drug. When you watch the show closely, you see that at its base the show is about how difficult it can be to be in love and be famous.

As far as how the show affected her "image," I don't really think Whitney saw her image of being America's

sweetheart as something different from her true self. If any-body knew her, they knew Whitney was for real, straight up and to the point with anything she talked about, any-thing she had to say. There was no biting her tongue for anybody. That's who she was. She wasn't going to pretend to be something different or put on any airs. The way she thought was, *As long as I'm sharp, as long as I look good when I walk out of this motherfuckin' room, then we're good.* That's how we both felt—as long as we took care of our business, noth-ing else mattered.

In one telling sequence, she revealed her thoughts about what the public was watching:

"He's a nut," she said to viewers during the show after I did something silly. "But nobody knew that *she* was, so it's exciting to see."

It was never my plan for the show to make people think I'm a better person than I really am. No, the goal was just to show *who* I am.

————

A FEW WORDS FROM TOMMY BROWN

In the years leading up to the taping of the show, my relation-ship with Bobby changed considerably from what it had been when we were younger. He was married and focusing his en-ergies on Whitney and his family. He didn't need me as a man-ager anymore because I didn't have anything to manage. He just stopped working. I thought it was a mistake at the time, but I couldn't fault him for wanting to take care of his family.

He saw the way Whitney's affairs were being mishandled, how people were taking advantage of her, and he wanted to fix all of that. She was his wife—how can you argue with that? I thought he could have continued working on some of his own stuff too, but I respected his choices.

And if her business affairs were going to be fixed, he was the right person to do it. One thing I always felt Bobby didn't get any credit for was his business smarts. He might not have graduated from high school, but from the beginning Bobby was always extremely shrewd and visionary when it came to his business affairs. He's brilliant. There are a lot of things he's influenced in this industry that people just aren't aware of— like moving to Atlanta more than twenty years ago and starting a label and a studio in the South because he saw that's where the growth in the industry was going to take place.

In the beginning I didn't see the shrewdness. He would tell me to go and ask for this and this and this when I was negotiating for him, and I wouldn't always do it because I thought he was asking for too much. And then I would look back a year or two later and see that I should have done what he told me to do. He'd say, "Man, didn't I tell you to ask for this?" So I learned to carry out his wishes because he might be seeing something that no one else could see yet. As he would always say, "You're not going to get it if you don't ask."

The purpose of the show was to reveal another side of my brother, so I didn't go into it thinking about how it was going to make Whitney look because I didn't even think she was

going to be involved. Of course they're a married couple so I knew she would be some kind of presence in the show, but I thought it would be very limited. I never expected her to be in almost every scene. When she kept showing up during the taping and not always presenting herself in the best light, I called her people and asked them if they perhaps wanted to become more involved. I was thinking, *Who's in charge of her side of the fence—can you give me a little help?*

Anybody who knew Whitney was aware of the fact that you weren't going to control her. I couldn't tell her what to do. But when I called her agent about what was going on, there wasn't much of a change. They asked for right of refusal for the editing of the show, which we gave them. So what you saw on that show had been approved by Whitney's team. They signed off on everything that was aired. In the few instances where we had a disagreement, it was usually about something that we thought should stay in because it presented Whitney in a more positive light.

When it was clear that Whitney's side wasn't going to get very involved, we took it upon ourselves to make sure her makeup looked right and to try to make her look as good as we could. There were things we edited out ourselves to try to make her look better. But if her people were really concerned about her and her image, it seems like they would have had somebody there on set representing their client. We didn't do anything sneaky or exploitative. We were just rolling the camera. I've heard people say the show ruined her career. While

I don't agree with that, I will say her management made no effort to stop it or to help her. And one thing everyone took away from the show was the love between Bobby and Whitney. People saw genuine love, even if many of them wound up picking a side and saying, "Wow, she needs more help than he does."

I think what happened was Whitney was yearning to express her natural self to the world. That's why she was so eager to be a part of *Being Bobby Brown*. She was itching for the world to know she wasn't fitting inside the body that they had molded for her. It was like her declaration—"I'm tired of Miss Prissy. That's not who I really am." She no longer wanted to be trapped by her image.

A FEW WORDS FROM LaPRINCIA BROWN

I hated *Being Bobby Brown.* Everybody said it was so good, so funny. To me, it was so embarrassing. I was only on two episodes because a lot of it was filmed during the school year and I couldn't miss that time from school. But the show didn't give the best impression of my siblings either; it didn't tell people who they really were. It also came at a bad time for me to have my family on a TV show—I was fourteen when it started filming, but I was almost sixteen by the time the show finally aired.

That's when I started getting more snappy with my father.

We had always been so close; I could tell him something and he would listen to me. Even when I was really young, when the bill would come and my dad would pay for everybody—he *always* pays for everything for everybody—I would say, "All of these are adults. How come they can't pay for themselves?" I would say this out loud, to a table filled with family members and friends, when I was about eleven or so. I just feel like everyone leeched off him for so long. He's your little brother—he shouldn't have to be taking care of you and all your children. That's a lot of pressure to be under when you're dealing with your own stuff.

I think I was the only one who would say stuff like that to him. Nobody else would tell him these things. I was very protective of him. And when I said them, nobody would tell me, "Hey, you're a child. You shouldn't be saying that—stay in your lane." I guess you could say I was a brat, but I feel like it was in the best way possible. I've learned to filter it now that I'm older; I know I can't go around saying things like that out loud. But at the same time I feel like too many people are walking on eggshells around my dad. I feel like over time, if you become this really famous person when you're fourteen and you're supporting everyone and paying everyone's bills, they rely on you for all of that. So they're not going to be honest with you all the time. He needed more honesty in his life. You don't need somebody sitting there and just saying, "Yeah, Bobby!" You need somebody saying, "No!" That's how we end up in bad situations.

At a summer camp before I was about to go into fifth grade was the first time I heard anyone say anything about my dad and drugs. Some kid called me a "crack baby." I was nine, so I had no idea what he was talking about. I remember thinking, *What's a crack baby?* I figured it out later on when I started reading the tabloids and going on the Internet. When I saw all the stuff about my dad and Whitney doing drugs, I remembered what that kid had called me. *Ooohhh, that's what he was talking about.*

When I was about eleven, we went to Disney World in Florida and I got a taste of how funny and crazy my dad and Whitney could be together. One of the rides we went on was called Tower of Terror. After we got off the ride and were walking through the park, Whitney pointed to this guy who was on a different ride and said he was making a demon face. Later that day I was talking to them and said something about the Tower of Terror ride we had gone on.

"We never got on that ride," Whitney said.

"Yeah, we would never get on that," said my dad, who used to be afraid of rides—though he's not anymore.

"Yes you did!" I said to them. "Dad, you were in the middle."

They looked at me like I was crazy.

"He's afraid of rides," Whitney said.

So then they proceeded to convince me that it was a demon that was on the ride with me. I started to believe them, so much that I started crying. They laughed really hard and told me they were just kidding.

It wasn't until maybe eighth grade, after *Being Bobby Brown*, when I started to realize what was happening with the drugs. Everything was so obvious to me by that point. I think before that, when I was in elementary school, my mom hid a lot of it from me. Now I became very sensitive and outspoken. If you said anything to me about them, I'd flip out. This was about when my dad's song with Ja Rule, "Thug Lovin'," came out. I started going on the Internet and reading stuff and feeling really hurt by it.

When you get to that age, you don't want to be bothered with your parents anyway. I stopped wanting to visit for the summers. By the time they moved to Atlanta, I was in high school, I was cheerleading, so that changed my summers anyway. They were even further away from Massachusetts, where I lived with my mom, so they were a lot less accessible. I saw them a lot less.

I started having a lot of anger and resentment toward my father. I would get mad at him and ask him whether he was on drugs. People would tell me he was doing drugs, but he would say he wasn't doing any, or maybe he would say he was just smoking weed. But if I was with him and I saw him around certain people and he was acting a certain way, I would get really frustrated. I would feel he was doing something he shouldn't have been doing. So I wouldn't talk to him.

I remember one time he was in Boston and he was supposed to take me and Bobby Jr. to the movies, along with my mom's friend's son. But when we were at his hotel, I didn't like

the way he was acting and I didn't like the people who were there with him. I told him he needed to get himself together and I got Bobby and the other little kid in the car and left him. I think he was there for two or three days and I wouldn't answer any of his phone calls. I don't know if he was high or drunk that day because it was kind of early in the day, but if you say you're going to the movies with your kids, I shouldn't get there and find random people there with you drinking.

During this time, as I dealt with my anger, the only thing that kept me positive was knowing that my dad was a good person, above everything else. I knew he loved his kids over everything. I kept feeling like there was a way I could get through to him. I took it upon myself to fix this, to fix him. And everyone else started depending on me to fix every situation too.

After my father got clean when he went to jail, everything changed. He became a different person with us. For the last decade or so he's been a much better father—he started reaching out to us more, spending more quality time with us. He wouldn't just come to visit and be gone the whole time; he'd come here and do things with us, bring us places.

———

HATING BOBBY BROWN

BREAKING UP

One of the things that bothered me most when I was married to Whitney was the constant depiction of me as being out for Whitney's money. In subtle little ways or in big obvious ways, the media and the public would make comments or write pieces that made me look like a money-grubbing, freeloading loser who was only interested in his woman's cash. I was consistently outraged by this portrayal. Once when I got into a car accident, the headlines were quick to say, "Bobby Brown crashes wife's car." It made me look like some irresponsible leech, despite the fact that I had been in an accident, and as any married couple knows, whose name the car is registered under has no connection to who actually owns the car or who pays for it. I actually went into our marriage with more money than Whitney. I wasn't wealthy; I was rich. It was often my money taking care of her, rather than the other way

around. But I knew the intent of these portrayals—they were a way to emasculate me, to further break me down as a black man, make me look like I was dependent on my woman.

At the beginning of our marriage, I had more than $50 million in the bank. Two years before we were married, I had the biggest album in the country. I then spent two years on the road, on a record-breaking world tour playing to sold-out stadiums. Why would I need Whitney Houston's money? As a matter of fact, I couldn't believe how little Whitney had in the bank, considering her massive success in her own right. That's one of the reasons I was so compelled to take over her affairs, because I knew the people around her had to be taking advantage of her. There's footage of her publicly declaring that her husband was now managing her career; I was able to show her the evidence of what was happening to her money, how she was being screwed. And I never took a dime from her—not one red fuckin' cent. We were married. Our finances were bound together, like every couple in the world. All I ever wanted was the best for my wife.

One of my major moves was to get rid of her managers. Whitney was making money through various streams that she wasn't even aware of. After reviewing the books, I concluded she wasn't getting all the money she was entitled to. I even approached Clive Davis about her finances. I had some issues with the way Clive's label was handling Whitney's money. Ultimately, we worked it out and Whitney got what she deserved.

One of the biggest mistakes I made was allowing all of my stuff, my finances, my royalties, to get commingled with hers and to be taken care of by her financial people. When you have as much money as we did, you have money managers set up to pay all your bills. Instead of keeping the team I already had, I let my finances be handled by the same people who were handling hers. That's how I ran into trouble with things like child support, because I assumed they were writing my child support checks regularly, only to find out they weren't. Next thing I knew, Kim was having me arrested for falling behind.

That emasculating image of me as the leech continued throughout our marriage. When our marriage ended, it only intensified. That's one of the main reasons why I walked away from my marriage without asking for a dime—even though I came into the marriage with tens of millions of dollars. I wanted Nippy to see that our union was never about money. She was listening to people, her family, her management, saying these things about me in her ear, and she started to believe them. They even floated a story in the press that I was suing her for spousal support, but that was just another ploy to make me look bad.

Things were wonderful between us for the first seven years or so of our marriage, but eventually the fighting, the drug use, the tabloids, the distrust, wore away at us until we didn't have enough left to keep it going. Though I was repeatedly labeled in the tabloids as the cheater, let me say

that Whitney did her share of cheating too. In fact, she cheated before I did. She slept with quite a few of the producers and artists that she worked with or associated with over the years. I won't drop names here because they're still around and a few view me as a friend. When I found out about the first one, I was blown away. I thought, *Okay, okay, you gonna play me like that? I'm not that type of dude, but if you can do it, I can do it too.*

I'm sure there will be people who will read this and think it's easy for me to throw out such an explosive accusation about my ex-wife as she's no longer here to defend herself, but I have no interest in slandering Whitney without cause. My intent in discussing what happened between us is not for the sake of salacious smearing; it's more about trying to paint the most accurate picture of what went on inside our marriage.

One of her affairs that I am willing to mention is the one she had with Tupac. This occurred in the first few years of our marriage, during a time when I thought we were in a good place. I will admit it here that the news of the affair really fucked me up. I could not believe that Whitney was willing to jeopardize what we had, which I knew was hot, heavy, and unique, for some fling.

We fought long and hard about the cheating, lobbing hurtful accusations back and forth. We were together in September 1996 when we found out that Tupac had been killed. Whitney bawled her eyes out, crying for days over his

death. Her tears were painful for me because I knew what they meant—my wife was mourning the passing of a lover. Of course, I was really sorry Tupac was gone too. He was a talented artist gone too soon. He and I had talked about my signing to a label he wanted to form called Makaveli Records, which sadly he never was able to get off the ground.

When our marriage reached the end of the line, there was a lot of conflict, a lot of arguing, a lot of sadness and unhappiness. One of us would decide to run away, but a week or two later we'd be back in each other's arms—until the next explosive conflict. There were separations of a few days or a few months. During one of our longer splits, I even lived with another woman, Louanna Rawls, the daughter of legendary singer Lou Rawls. I lived with her in Los Angeles during this emotionally tumultuous time. Louanna soon started getting threatening phone calls telling her to stay away from me. After a couple of months I broke it off with her and went back to Whitney.

Eventually you reach a place where you ask yourself whether there's enough left to be worth all the tension and heartache. Finally, I got to the point where I thought, *If you don't want to be with me, then let's end this.* And I walked away forever. You have to understand that I was only twenty-three when we got married. By the time we were having our serious problems, I was thirty-seven—a grown-ass man. My tolerance for bullshit and craziness was lower than it had been in the beginning. I wanted some peace. We were still in love, but

we couldn't fight all the other shit that we dealt with on a constant basis.

When Whitney went to rehab, the counselors began to convince her that I was the source of her problems, the trigger for her drug use. So when she came back home, she began to treat me like I was the enemy. That wasn't something we were going to be able to recover from. It eventually became clear that her drug habit had nothing to do with me. I got clean in jail and never used again except for one two-week slip during our separation when I couldn't beat back the depression over missing Whitney and Krissi. I emerged from that and I've been clean now for nearly a decade. But even after I was gone from her life, Whitney was still using.

When I look back on the evolution of my bad-boy reputation, I realize that it was only after I got together with Whitney that I really became the bad boy, at least in the eyes of the media. Before Whitney, it wasn't open season on my personal life. I wasn't treated like some kind of criminal degenerate. Yeah, I got arrested for lewdness during that early concert, but that was my only brush with the law—and that was all about my stage performance. When the media began to write about me and Whitney together, they questioned everything about my character. It hurt me to my core. I felt like it was destroying what I had created as an entertainer.

There's this story line about the end of our marriage that presents Whitney as fleeing me, like I was some kind of monster. But the reality is that I walked away. I walked away with

about $1,000 and a one-way plane ticket to Los Angeles. I left my cars, my houses, my jewelry, everything I had, with her. I didn't ask for anything to be sent to me. I didn't have credit cards; I didn't even have ID. I was going to move to Los Angeles, make some music, rebuild myself and my career. I wasn't even sure where Whitney was staying when I left. It was several months before I saw her and Krissi again. The breakup triggered a spate of press reports that left me feeling suffocated and enraged—all with the narrative that the beauty had finally been freed from the beast.

Instead of returning all of my belongings, the Houston family got rid of all my stuff—my Grammy, my American Music Awards, my People's Choice Award. Those are my accomplishments, my career, and all of it is gone, scattered in the wind. I have no idea where they are. I think they might have sold it. I had at least two million dollars' worth of jewelry—gone. I was so focused on getting myself together at the time that it didn't occur to me until later how thoroughly I had been disrespected by these actions. It also took me a long time to have my royalties from all my publishing redirected to me. They had been going to Nippy Inc., Whitney's company in Newark, for the longest time and being absorbed into our joint finances. When I split, it took me far too long to have the bimonthly checks sent to me once again.

When I moved to LA, I didn't have a place to stay, so I hooked up with a friend who was going to help me restart my career. My brother and my father decided to stay with

me, to help me deal with the pain and get me pointed in the right direction. Eventually I ran into my old friend Alicia Etheredge, who just happened to own a house right down the street from where I was staying with my brother and father. It was so good to see her—she was a connection to a better time in my life, when the world was so full of possibilities and I was just about to rocket into the stratosphere. Alicia was a huge help to me at this point in my journey, helping me to rent a car, even helping me try to reconnect with my wife so that I could see my daughter. Although I had always been extremely attracted to Alicia, it still would be a long while before she would even entertain the idea of some kind of romantic or intimate connection between us. She's always been a very practical girl, and my life was far too messy for her at that point to consider going down that road. She had developed a very successful career in artist management, so she was all too familiar with the dramas of messy artists and their messy lives.

The breakup was incredibly hard on Krissi. Sadly, I can now see that it was the event that began her downward spiral. After I moved to LA, I found out that she and Whitney were also in LA, staying at some rehab center where Whitney was trying to get clean. She had Krissi there with her. I borrowed Alicia's car and went to see them. At the time I told Alicia that I was trying to put my family back together, that I desperately needed to see my daughter.

Whenever I did see Nippy and Krissi, it was difficult

because Nippy was always trying to entice me, trying to switch the purpose of the meeting from seeing my daughter to talking to her about our getting back together. My sister Leolah told me she had pledged to my family that she was going to get me back and she wanted the family's help. But when I was around Whitney, I knew it wasn't going to work; I needed to get away from the drama and conflict that life with Whitney entailed. I wanted to try to find some normalcy, a life that wasn't lived in the headlines and tabloid front pages.

It all must have been terribly confusing for Krissi, the back-and-forth between me and her mom, the uncertainty about our status and the future. I was extremely alarmed when I spent time with them and I saw Krissi pull out a cigarette. I exploded, but Nippy started screaming at me.

"What the fuck are you talking about, Bobby, she can smoke a cigarette!" Whitney said.

But my teenage daughter pulling out a cigarette right there in front of me wasn't okay with me. I started to worry about what was going on in their household in my absence. But I began to feel increasingly helpless about what kind of impact I could have because Whitney would try to keep Krissi away from me as much as possible. She didn't give me a chance to be a father to her anymore. Anytime I wanted to see Krissi, I had to see Whitney. And when I saw Whitney, it would become about something else, our relationship, not about my seeing my daughter.

Even worse, Whitney was making Krissi think that I didn't care for her or for Whitney, that I had abandoned both of them. It was such bullshit, but as an absentee father, there was nothing I could do to fight against it. Any dad whose marriage falls apart knows what I'm talking about, the incredible frustration and helplessness you feel in trying to reach out and parent your child and getting pushed away each time—particularly if the mother is badmouthing you to the child. Things got to the point where Whitney would insist on having security present when I saw Krissi, just to be spiteful, in my opinion, because I was not threatening to her and certainly not to my daughter. But what all of this did was create the impression in Krissi's mind that I was poison, that she was supposed to stay away from me—while she was being given the freedom when she was with her mom to do God only knows what.

———

A FEW WORDS FROM LaPRINCIA BROWN

With my little sister Krissi, there was a three-year age difference, so I was always her big sister, her protector. The two of us were very close. We used to spend a lot of time playing with dolls when we were very little. When I was about seven and she was four, we were obsessed with these sing-along kid videos that we used to watch all the time and sing along to. We had this thing we called Sis Stars, where we did a lot of skits and plays. We would perform them for the rest of the family. She was so much fun—super bubbly and happy.

She started changing when she was a teenager, after her mom and my dad split up. I hadn't seen her for quite a while and she came up to Massachusetts to stay at my mom's house for a month around Christmas. I was eighteen and she was fifteen. It was awesome having her there, but I realized after the fact that I probably did a lot of things I shouldn't have when she was there. I brought her with me when I went out drinking with my friends. I feel bad about it now. But I think she was already drinking at home. She brought Everclear with her to my house, which is this really high grade of grain alcohol, basically like moonshine. She pulled it out of her bag to show to me, like "Look what I have!" I didn't tell my mom or my dad. Maybe I should have. We tried to drink some of it; we poured a capful into a big jug of orange juice. It tasted terrible; we didn't even consider trying to drink more of it. I should have thought more about the stuff I did with her.

After she went to California with her mother, I went out there to spend time with her. My dad was with Alicia at this point, so Alicia was the one who dropped me off at the hotel where Krissi was with Whitney. That's when I met Nick Gordon for the first time. He was there with Krissi, Whitney and one of Krissi's friends. They introduced him to me as one of Krissi's friends. He looked a lot older than Krissi; I asked her how old he was. She replied that he was older than me, which I thought was strange. I remember wondering why she was hanging out with a guy with a mustache and beard who looked like a grown man. At some point we went shopping at a boutique, but Whitney didn't go with us. When we returned to the

hotel, things got real strange. They all started smoking pot together—Nick, Krissi, the other teenager and Whitney. Yes, she was smoking with them. I started to feel super uncomfortable, so I called Alicia to come get me. When she picked me up and I got in the car, I started bawling my eyes out. I don't even think I was very close with Alicia yet, but I told her what I saw there. She was trying to console me. I never told my dad about what I saw that day.

———

As I tried to communicate with Krissi about what was going on with Whitney, at one point I realized Krissi was being told that I was out there cheating on her mother and that's why we broke up. In trying to defend myself, I told her about the relationship her mother was having with Ray J, the younger brother of the singer Brandy who became famous from his sex tape with Kim Kardashian.

"Your mother is cheating on me with Ray J actually," I told her. "If you think I'm doing something wrong, I'm not."

"No, he's her friend," Krissi said back to me. "He's just her friend."

It might have been wrong to throw something like that in the face of a fourteen-year-old, but I was desperate to defend myself and redeem my standing in my daughter's eyes. I couldn't have my daughter looking at me like I had been the one who destroyed her family, when I knew the truth.

When things began to heat up with Alicia, my meetings

with Whitney got even weirder. I think she was still intent on our getting back together, but I knew I had moved on. I was just focused on my daughter. I was feeling like I was missing some of the most crucial years of her upbringing, when she was becoming a teenager, with her own views of the world and a growing sense of her independence. As it turns out, I was missing a whole lot because this is when that guy Nick Gordon started coming around, though I knew nothing about him. But I'll get into him more later.

I can't say enough about how thankful I am for the role that Alicia played during this time in my life. She was extremely understanding about what was happening with Whitney and Krissi and she continued to encourage me to stay as close to Krissi as I could. Her own parents had gotten divorced when she was a teenager, so she was sensitive to how difficult the ordeal was for Krissi.

We started out with my sleeping in a rental car in Alicia's driveway, then she let me come into the house. At some point, but not right away, sparks began to fly. After all, it had been the clichéd love at first sight for me when I first saw her nearly fifteen years earlier when she was a teenager, but she didn't like me in the same way back then. She was just seventeen and not ready for the big celebrity trip. Now I had gotten another chance.

Eventually it occurred to me: I was in love again. It was so very special between us. Alicia had become my best friend, my rock. She understood exactly what I had gone through,

saw me pick myself up from the dirt—when I had no reason to be in the dirt in the first place. I was down because I felt I had lost the love of my life. Eventually I realized I was meant to lose that in order to gain what I have now: love, respect and honor from a woman.

———

A FEW WORDS FROM ALICIA ETHEREDGE BROWN

Over the years after he got married to Whitney, I ran into Bobby on a few occasions and I usually came away pretty worried about him. The first time was when I was still studying at Howard University. I was at a club in DC called the Ritz with a friend. The club was packed, sweaty. Bobby was up on the stage with the DJ and they acknowledged that he was there. He wasn't with his wife. My friend knew I was friends with Bobby, so she suggested I go say hi to him. My friend took me back to where Bobby was. He didn't see us come up, so I touched him from behind. When he turned around, I said, "Bobby!"

He looked at me in a fog, obviously high out of his mind. I had never really seen him look like this. He stared at me with no idea who I was, like I was a ghost. I tried again.

"Hi!" I said.

I really was happy to see him. I hadn't seen him since his wedding and I considered him to be a good friend. But I was kind of in shock from what I saw. That's when I knew he wasn't doing well. It took him a minute, but he eventually recognized

me. When he wasn't reacting to me, I was like, *Are you kidding me?* But when he realized who it was, his demeanor changed right away.

"Oh my God, Alicia!" he said, giving me a hug. But I was very sad. This was in 1996, about three years into his marriage.

In 2000, my friend Tiffany Washington suddenly passed away at the young age of twenty-five. In the midst of my extreme grief, I tried to track down Bobby to let him know, since Tiffany had been his friend too. She was the one who stole her parents' invitation to Bobby and Whitney's wedding and took me with her. But Bobby was in jail at the time so I couldn't reach him.

I remember watching Michael Jackson's thirtieth-anniversary special at Madison Square Garden in 2001 and being stunned when I saw Whitney and Bobby. She looked so bad, so skinny. I thought, *Oh my God, what are they doing?*

One night a few years later I was at the bar at the Mondrian hotel on Sunset Boulevard having drinks with some friends. Sunset was an infamous spot for me when I was younger. For Bobby too. We would hang out at the clubs and bars all up and down the strip back then. One of my friends, Carrie, said she heard Frankie Beverly and Maze were playing at the House of Blues, which was right across the street. We both decided we would like to go over there and see if we could get a glimpse of anything. I'm sure at the time we were pretty tipsy. So we ran across the street to peek in, see if we could get into the Foundation Room, a more intimate bar/

lounge inside the venue. There was a side door in the back of the club that someone had cracked open. We walked over to the door.

"Are you going in?" I asked.

The woman at the door turned around and it happened to be Louanna Rawls, Lou Rawls's daughter. When she turned around to look at me, she had tears in her eyes.

"What's going on? Are you okay, Louanna?" I asked. I was thinking maybe she was a little drunk, but quickly I realized it was more than that. She was staring through the door. Bobby and Whitney were inside, apparently looking extremely high.

"Bobby's in there with his wife," she said.

"Who?"

"Bobby," she repeated. "Bobby and Whitney."

"Oh, are they?" I said. "But what's wrong?"

"He's a fuckin' asshole!" she said. Now she was bawling as she walked off.

"Okay, honey, get home safe," I said as I watched her walk away. But in my head I was thinking, *What the fuck was that?* I found out from Bobby later on that he had stayed with Louanna for a while in LA during one of the times when he and Whitney were fighting. It probably had happened not very long before that night. It was all very weird and disconcerting for me. He later told me that was the night when he took off Frankie Beverly's hat. All I could say was, "You took off his hat? Who does that?"

I watched him on the TV show *Being Bobby Brown,* and

I really enjoyed it because it was like I was seeing my funny, crazy old friend on the screen. I would watch it sometimes when I was around other people and I would hear their negative comments, mostly blaming him, saying he had made Whitney the way she appeared on the show. But I would tell them he was just being himself. I didn't know her at all, but as I was watching him do things like not being able to get his shoe off his foot because the laces were stuck, I felt like I was seeing my old friend again and it was good—because the last time I had seen him he'd looked really bad. Now he seemed like his old self.

The next time I saw him was a few years after the House of Blues, when he performed at the Greek in 2006. It was a summer concert series so there were a bunch of different acts performing, including Bobby and Damian Marley. They had just recorded a song together, "Beautiful." When he came out to perform that song, he looked great onstage with Damian. I was jumping up and down so hard when Damian was waving the Jamaican flag that the heel on my stiletto broke. After the show we were hoping to see him, so my friend and I went backstage. Guy also performed, so Teddy Riley was down the hall in another room. I went to see him, his girlfriend and their new son. We were waiting in Teddy's room when finally Bobby opened the door. Superhead— a.k.a. Karrine Steffans—was with him in the dressing room. I was taken aback. Luckily I held in the gasp that must have been close to my lips.

My first reaction was to apologize for disturbing them, but I truly was happy to see Bobby. When we went into his dressing room, he called me "Britney," teasing me about my shoes and how ridiculous I looked barefoot. A bunch of other people came in the dressing room. We told him we had to leave because we had other friends waiting for us.

"Hey, give me your number," he said.

"Where are you now?" I asked him.

"I'm out here in the Valley," he said.

"No way! I just bought a house in the Valley," I said.

"Yeah, I live right up White Oak," he said.

"No way—my house is right up White Oak!" I said. When I told him my address, he said, "Yep, I'm two blocks down. That's crazy! It's so good to see you."

A few days later, Bobby called me. And that's when this thing officially began. He said he was living in LA with his brother and Pops and he wanted to hang out with me. So I went up the street to where he was staying at this big house on the hill owned by a guy named Sal Vincent, a music industry type. We all went out to eat—his brother, his dad, Bobby and me.

At that time in my life I had just bought a house, where I lived with my dog, and I was doing artist management, traveling quite a bit working with artists like Macy Gray. I had worked for several labels earlier in my career, but I decided I liked the artist management side. It's way more personal and a natural fit for me: I can talk to people, they trust me, I have

a little bit of sense, and I also like to collaborate on the music side of things.

At first it was just me and Bobby working together. He was asking me to help him out, which was natural. I thought he was an unbelievable artist. If I could help him in any way do what he needed to do to get back, I would. What I love about what I do is being passionate about the artists I work with. I need that if I'm going to spend all my hours with them.

I was in my early thirties and had traveled the world and done a lot of crazy things, sown my wild oats, so to speak. So I was coming into that phase of my life where I was definitely thinking about being in a long-term relationship. I was think-ing about kids more and starting to consider maybe doing it by myself. By this time most of my friends had been married or had kids.

I started looking into Bobby's situation and saw he and his family were living in this house up the hill with this guy be-cause he had a recording studio. The whole idea was that Sal Vincent had Bobby come out here to record some music. So I came around and started asking questions, trying to protect my brother. That's how I've always been with Bobby. Bobby was also shooting this movie, playing an old man. I can't even remember the name of the film now, but Bobby was un-comfortable with the terms and wanted me to take a look. He hadn't yet signed anything, but he desperately needed to make some paper.

He told me he had left Whitney and moved to LA. But I

knew Whitney was also in LA. I was trying to figure out what was really going on. They were all just squatting in this house. They gave Pops the bedroom and Bobby and his brother were sleeping on the couch. All of Bobby's clothes were in black trash bags. This was not a good situation at all. He was trying to do his best, but he was really sad, really depressed. He explained to me he hadn't been doing anything for a very long time, but he was ready to get on again.

During this time, I felt like I wanted to be there for my friend. I still didn't know the full story yet of what had happened between him and Whitney, but I was feeling protective and hopeful about getting him to a better place. Over the next several months Bobby was trying to see me and stay at my place as much as possible. I understood that he was trying to escape his situation, but I had to tell him, "This is where I live. When I go to work, you have to go home."

During this whole time Bobby, his brother and Pops were going house hunting almost daily because the guy they were staying with said he would help them find their own place. But it was taking way too long. I started getting suspicious.

I loaned him my car a couple times to go see his daughter Krissi. He was always talking about going to see them. Early on, things were very pleasant between him and Krissi; she would be happy to see him. I got the sense that he was unsure what he wanted to do. I told him, "Listen, if you have an ounce of wanting to fight for this situation, if you want to be with her, it's worth it."

He hadn't yet told me of all the horrors in his marriage, but he was miserable without his daughter. Having been a daughter whose parents went through a difficult divorce, I was telling him, "No matter what you and Whitney are going through, just show up for her." There were days when he was a sobbing mess, talking about how much he missed his child. You never want to see your friend go through that.

I introduced him to this guy who rented him a Benz for thirty days, so he had this little Benz he was driving around in and that's the car he slept in in my driveway. There was still nothing going on between us, but I was starting to ask, *Why is he back in my life?* Let me just say this was not a man who was in an attractive situation for me. He wasn't in any shape to be in a relationship with me. And I wasn't interested in that from him.

It took maybe a year of being around each other, him sleeping on my couch, going through his divorce, actually moving into my house, before anything happened between us. How did the romance start? It was just a process of us growing closer, sharing intimate things. I just realized I loved him and adored him. It grew on me. There was a point where we asked ourselves, "Are we really going to do this?"

He's very charming and very sweet; he's always been that way. I think I put Bobby in the "brother" box early on. It's not that I didn't like him. Even though I've said he wasn't my type, it was more that I didn't think he was ready for me. But watching Bobby go through the process of ending his relationship

with Whitney, and his fighting to be a better person, I grew to love him again and in a different way. He makes you feel like you're the only person who matters. And he was willing to do anything to get himself to a place where I would consider being with him. It's like being open to a new level with an old friend you always loved. It was magical.

That's not to say it was easy. There was a whole lot of baggage there—the drugs, the drinking, the tabloids. We went through quite a lot of struggle. It was scary too. But at a certain point it didn't matter because I was in love.

When you're with Bobby, you're never going to get *stable*. I was never convinced things would be stable. I was never thinking, *Yeah I'm going to settle down and have kids with Bobby*. He's always been exactly who he is: crazy, loving, persistent, passionate. Never boring. I realize now that was what was attractive to me. I wanted him to be in a better place and I was willing to take care of him. At some point it was like I got swept off my feet. He worked really hard to show me he wanted to be with me, wanted to be better. He was constantly working on himself. That was interesting to me.

One day in the middle of all this, my phone rang. It was a girl named DeeDee on the other line. She was an old friend of mine who also was friends with Bobby. She started in with what sounded like small talk, but then she started asking me about Bobby.

"Have you seen him?"

"When have you seen him?"

"Where is he staying?"

I was taken aback by all the questions.

"Wait, why are you asking me these questions?" I asked her.

But then I heard Whitney's unmistakable voice. "Does she know I'm on the phone?"

I realized that DeeDee had called me to ask questions about Bobby while she had Whitney listening in on a three-way call, like seventh grade. It was so bizarre. Then DeeDee said, "Nippy, calm down. So, Alicia, listen, Whitney's on the phone."

I had a few things to say to Whitney: "First of all, you're here questioning me. I don't want to be rude, but I don't know you. You don't know me. Your husband and I are friends. But I don't have any information to give you about him."

Whitney kept talking like she couldn't hear me but she could hear the other girl. So I tried again: "DeeDee, I can't believe you called me with her on the phone."

Then to Whitney: "I know your husband. He's just a friend, and I'm just trying to help my friend out. If you want to talk to him, you guys need to have your conversation. I'm out of this."

All things considered, I believe I was pretty polite. I immediately called Bobby, going off on him.

"I fuckin' can't believe this! Your ex-wife was just on the phone calling me. I don't want a part in any of this shit!"

Bobby was stunned.

So I slowed down and explained to him what had just happened. "This is too weird. You gotta handle your shit," I said.

At first when Bobby finally got the divorce papers, he said, "I just need to fight so I can see my daughter."

I noticed that things seemed like they had started to change with him and Krissi around this time. Whenever he went to see her he always came home very distraught. Or he'd tell me there was a fight, there was a scene. I would tell him that wasn't good, that when his daughter was there he and Whitney needed to keep it together.

"I can't do it anymore," he said. "It's just not worth it. Whitney's messed up. I can't help her anymore. I need my daughter out of that scenario. I want to see her regularly."

In February my friend Djata and I went with Bobby to Boston. We were all excited because we were going to his daughter LaPrincia's cheerleading competition. We drove to Kim's house, and when we got there, Kim gave us the address. LaPrincia had already left, but Kim told us, "She knows you're coming."

So we drove way out somewhere in Massachusetts. It was freezing, icy, and pitch-black. When we got out of the car, Bobby was elated to see LaPrincia. But as we were about to walk into the place, up rolled undercover officers and they arrested him right there on the spot for child support. Was it a Kim setup? Absolutely. It just seemed so cruel. That was so spooky for me. He was obviously upset. I was frightened, freaked out, panicked. I stayed there in Boston until he got out, maybe three or four days later. Most of that time I was on the phone with his lawyer. I didn't understand. *You owe her*

money, but how can they just arrest you like that? I was not used to this weird relationship Bobby and Kim have. This was jail we're talking about, which to me was traumatizing. I was really shaken up. That was a big wake-up for me—*What the hell am I in for?*

But we stayed the course. Bobby began working more. After we got home, I took over sending out the child support payments. I started to manage his life in the way that I did for all my clients. It had been a long time since he had that because in his marriage everything was focused on Whitney. Artists are very interesting people in what they decide to take care of and what they don't. They do expect somebody to take care of a lot of the mundane details. If you're a good manager, you build the teams around the artists that will help them manage their lives. It definitely helped with Bobby that I understood the mind-set of the artist. With a lot of this stuff, a regular wife would be like, *Oh hell no*. But I think this is defi-nitely a part of why it works between us. It's an incredible help to us that I've worked with artists all these years. I accept that part of him and understand who he is.

———

STAYING BOBBY BROWN

MOM AND DAD GET THEIR WINGS

One of the most enjoyable developments in my life after I moved back to Los Angeles was the opportunity to grow extremely close to my father. Over the years our relationship had changed dramatically as I got older. We began to understand each other and see how much we were actually alike.

Admittedly things were a bit rough between us when I was younger. By the age of fourteen I had become the family's main breadwinner, in a sense displacing my father before I was even old enough to shave. He didn't look on this development with fondness. He was a proud man with very strong ideas about how a family is supposed to work. A teenager being the family's main financial benefactor was not the proper order of things to my dad. I think he carried a grudge against me for quite a few years after my career took off and the big dough was rolling in.

For my part, somewhere in the back of my mind I think I still blamed my father for allowing me to get molested by the priest back in Boston. Not to get all Freudian, but I suppose I saw it as a father's job to prevent that sort of thing from happening to a young child; they're supposed to protect us, aren't they?

I was raised in a household surrounded by a multitude of women; it always seemed like they were the ones who loomed large and in charge in my mind. When a male authority figure finally did step into my life in a meaningful way, it was my brother, Tommy, not my dad.

Somewhere along the way, time gave my father the opportunity to understand that my career was a profound blessing for the entire family, not some sort of judgment on his masculinity. Considering the plight of so many of my male contemporaries in Orchard Park—in prison or in a grave—it was clear that I was lucky to have made it out in one piece. In fact, my success allowed all of us to make it out.

So when I got the news that my father had been struck by the big C—lung cancer—I was devastated. He had stopped smoking more than thirty years earlier—how could this happen? Just as we were becoming best friends, I was faced with the possibility that he could now be taken away. He was a strong mule of a man, a former construction worker who wasn't afraid of anything. But now we would have to step into that world of hospitals, doctors and debilitating health issues. In what seemed like a cruel act of fate, in the same

week I found out about my father's cancer, Alicia discovered that her father, Henry, also had cancer—his of the prostate. We were fortunate that we were there to comfort each other, but I was not looking forward to the coming months and sitting by my father's side as he fought off this horrible disease. While Alicia's father was lucky the prostate cancer was caught early, in stage 1, my father was already at stage 3.

I knew my family had some unpleasant months ahead of us—but I had no idea how truly horrible it would all turn out to be.

Alicia was helping me get more gigs now, so I was pleased to be working regularly, bringing in some cash. I realized how much I'd missed the stage. I had spent my whole life training to conquer that stage, to stalk it like a beast—and then I had just walked away from it for the better part of a decade. When I was back up there performing, it was like I had flipped a switch and reignited an essential part of myself. I realized I wasn't whole, I could never be totally happy, if music and performing weren't in some way closely connected to my life.

Whenever I got some cash in my pocket, the first thing I thought about was the well-being of my father. I was able to get an apartment for him and Tommy. I needed to make sure his apartment was well stocked with food, that his medicine was right, that he had everything he needed. Luckily he was a vet, so his medical needs were taken care of through the VA.

After Alicia and I got together, I had already started hear-

ing rumblings from my mother in Atlanta that she wanted to relocate to Los Angeles. With me, Tommy and my father in LA full-time, I think she was feeling like she was too far away from the action. But when she heard about Pop's cancer, it was set: Ma was moving back to LA.

"I'm coming out to be with him," Ma told me over the phone. I wasn't even sure I had heard her correctly. After all, it had been years since they had lived in the same house, even though they had never divorced.

"I need to get there," she said.

When Carole Brown made such a declaration, the matter was done. I told Alicia the news. She had never seen my parents living under the same roof, so she was a bit confused.

"Wait, your mom is actually moving out here?" she asked me.

"Yeah, we have to move her out here," I said.

I got back a puzzled look.

Even though the two of them had been living apart for many years, there was still a great deal of affection between them. So, we got my dad a two-bedroom house so that he would have room for his wife; Carole Brown moved across the continent, back to a place she had moved away from more than fifteen years earlier when we all went to Atlanta.

My mother was still a strong woman, but she had also started to slow down and experience health issues at this point. Because of chronic obstructive pulmonary disease (COPD), she now required an oxygen tank to help her

breathe. All those years of smoking had caught up to her too. And she was moving a lot slower. But she was ready to help care for her husband, despite her own challenges.

I was happy that my mother was in Los Angeles when my son Cassius was born. She was a strong presence for Alicia when she went to a doctor's appointment on a Friday and was shocked to learn that she had to have an emergency C-section that day instead of waiting until the following Tuesday, when they had planned to induce labor. The doctors told Alicia they were bringing her across the street to take the baby out of her belly in forty-five minutes. It was the first doctor's appointment during her entire pregnancy that I had missed and it turned out to be the most important. I was out with my brother when Alicia got that news and for some reason I didn't have my phone with me. So she started calling everybody. My mom was there to help her, as well as Alicia's sister, Kim. My mother finally reached Tommy and me and we hauled ass to the hospital. I was walking into the hospital just as Cassius was being born. Everybody was there with us—my mom and dad; Alicia's mom and dad; my sister Carol and brother, Tommy; Alicia's sister, Kim. It was a glorious day for both the Brown and Etheredge families.

Over the next year or so, my dad was getting progressively worse. He was in and out of the hospital, slowing down, getting weaker. I was still convinced he was going to beat the disease. I mean, this was Pops, one of the strongest cats I knew. How could he not beat cancer? He was still en-

tertaining us with his sense of humor, always quick to crack a joke to keep everybody in stitches. As long as he kept us laughing, I was convinced everything would be fine.

But Mom was showing some signs that had me concerned. She was less interested in going out, being social. She even stopped going to church, which was not a positive sign at all. Alicia would bring her clothes and try to get her out of the house, but my mom would be content to stay inside, staring at the television. I think she was also depressed about my father's deteriorating health. She came to Cashy's first birthday party in May 2010 and she was in good spirits that day. She was happy, beaming, enjoying the antics of her hilarious one-year-old grandson. It's the last visual image I have of her being out in public and enjoying herself.

Later that year we bought her a set of fancy cooking pots because she said she wanted Tommy to cook some fancy dishes for her and my dad in the house where the three of them were living together. She was even teaching Alicia how to make her famous mac and cheese—one of the delicious dishes that used to bring a steady stream of neighbors to our door back in Orchard Park. I was feeling that vague sense of dread that you constantly carry around with you deep down in the pit of your stomach when your parents are starting to get sickly. It means that your world is never perfect; there's always something amiss in your spirit. But I was trying to stay hopeful. While my mother's decline was a bit unsettling, it was my father who drew nearly all of our concern. He was not

getting better; he was not beating it. He had too many stays in the hospital. A part of me knew it was just a matter of time, but I didn't want to face that reality. So I kept telling myself and everybody else that he was going to be fine.

Then one night at about ten, I got a call from Tommy. He told me I needed to come to the hospital, quickly. He wouldn't give me any more news, but he sounded upset.

"We have to go to the hospital," I told Alicia when I hung up the phone.

I saw the stricken look on her face. "Oh my God, Pops?" she asked.

I shrugged, trying to fight off the dread that was threatening to wash over me.

We got in the car and rushed to a hospital in the Valley that was nearby. There wasn't much traffic so luckily it didn't take long. I was desperately trying to hold it together, but as we got closer I was getting increasingly more frantic. Alicia was driving, since I didn't have a license. Because I had struggled with DUIs, I was no longer allowed to drive.

"My brother didn't sound good," I said to her. "I can't believe this is happening to my dad. It's so fuckin' crazy."

When we arrived, we saw Tommy waiting for us in the parking lot. My sister Carol was with him, as well as Tommy's son, Tommy Jr. We got out of the car and rushed over to them. Tommy motioned for me to follow him as he walked away from the hospital, which I thought was odd.

"Bobby, she's gone," he said. "She's gone."

I thought I had misheard him. Did he say "*She's* gone"?

"What do you mean, *she's* gone?" I said. "Who the hell is *she*? Where's Pops?"

Tommy turned to me with an incredibly sad look on his face, like he was fighting back tears.

"Ma's gone," he said.

It hit me like a fuckin' horse kicking me in the head. I felt myself drowning, grasping. I think I fell into Tommy's arms, sobbing. It was a total shock to my system. I had just assumed I was rushing to the hospital to see my dad. Now he was telling me that my mother was dead. Gone.

Tommy and I stood there in the parking lot holding on to each other tightly, crying, unable to come to terms with the unbelievable, unexpected loss. His son Tommy Jr. started explaining to Alicia what had happened. Through my grief, I was able to follow along: Tommy had made dinner for her earlier that night, something fancy that he had gotten her excited about trying. He brought it to her in the bedroom, setting her up in front of the television. She took her medicine and started eating as she stared at the television, watching one of her favorite shows. Tommy went back into the living room, where he was watching television with Pops. A few minutes later he heard Ma start coughing, almost like she was choking on something. When Tommy ran back into the bedroom, she was keeled over, facedown in her food. She had had a massive heart attack. She died on January 20, 2011, at age sixty-nine.

Anyone who has lost a mother knows how massive the

pain is, the hole that is torn in your heart. My mother was my rock, the dominant presence I knew was always out there somewhere thinking about me, caring for me, watching over me no matter what craziness was going on in my life. No one's love is as perfect, as unconditional, as all-consuming, as a mother's. Carole Brown made it her job in life to do all she could to make sure everything was all right in Bobby Brown's world. She was a strong presence there at the start of my career, and she was an important adviser to me even after I had grown so big that I needed a whole team to watch over my interests. I had no idea how I would be able to even function without knowing she was within reach.

After I got Tommy's news, I had to see my mom myself, to touch her, to say good-bye. We walked into the hospital and they led us to her room. She had a peaceful look on her face, like she was sleeping. Her lovely hair was down, her graying waves spread out around her head. I went up and took hold of her hand. I bent over and kissed her face, her cheeks, her forehead. I reached down and rubbed her head, stroking her hair, trying to store as many memories as I could of these last moments, wanting to remember everything. I was crying the whole time, but I don't even remember that. I felt like I was floating in some horrible dream, aware of being in the room and having people around me, but not totally conscious either.

We stayed in that room with her for at least forty-five minutes, not wanting to let go. Her body was still warm to the touch, tricking us into entertaining the thought that

maybe she wasn't gone. Carole's children sobbed for her—me, Tommy and Carol—refusing to accept the monumental loss. Pops had stayed home when the ambulance came to get her. He didn't want to be there to participate in the mourning. He stayed home and mourned on his own.

The next few weeks were a dizzying procession of painful decisions and heart-wrenching memorials. We planned a viewing for her in Los Angeles, then wanted to have her funeral and burial in Boston. We had to pick a casket, arrange travel for the body, choose the clothes she would wear, put together a program, write an obituary, plus handle a million other tiny details. If you've planned a funeral, you know what I'm talking about. I was so fortunate to have Alicia by my side, taking care of everything I couldn't. She and my sister Carol actually consulted with a stylist to choose Ma's outfit and they collaborated on creating the program. In addition, we had relatives calling from all over, looking for me to help them travel to Boston and put them up in a hotel. My sister Carol was in communication with Whitney, who said she wanted to attend the funeral. At first she said she would like to sing, then she told Carol she'd changed her mind. We weren't sure whether we should include her on the program. It went back and forth several times and I grew frustrated. "Listen, none of this is necessary," I told Carol. "Just her being there is fine. It's enough."

I was still outraged by some of the things Whitney had said to Oprah on national television a year or so earlier. She had painted a picture of me as this mean, nasty, spiteful guy

who abused and terrorized her, while she was a fragile, innocent victim. I was amazed at how I became the aggressive wild-eyed drug abuser in every one of her stories, spending her money on other women, cheating and spitting on her in front of my daughter. I had stopped using drugs years before we split up while she was still heavy into the drug use. As for the cheating, as I've noted, she was just as guilty as I was. And though she portrayed me as neglecting our daughter by continually failing to visit her, the reality was that she constantly acted to keep Krissi away from me. She kept telling Oprah that some of the things she was saying were going to make me mad—well, hell yeah, because she wasn't telling the truth.

So with all of that still bouncing around in my head, I wasn't that concerned about whether my ex was going to sing at my mom's funeral. I just hoped she was going to bring my daughter with her. It all was a lot to deal with in the middle of my grieving.

After the viewing in Los Angeles, which was rough for me, we left our son with Alicia's sister, Kim, and traveled back to Boston. The funeral took place at Twelfth Baptist Church, the Roxbury church that had been our home for years when we were growing up. My family and I were honored and humbled by how many of our friends from home and from the entertainment world came to my mother's funeral. The church was overflowing, teeming with people, probably way more than any fire department would have authorized.

I entered the church along with Alicia, LaPrincia, Bobby Jr. and Landon. We went to the second row on the right side of

the church. The first row, right in front of the open casket, would have been too much for me. I felt more comfortable in the second row. A steady stream of friends and acquaintances came over to pay their respects as music filled the church. I could feel the eyes of the church fixed on me. Of course I'm used to being watched by the public everywhere I go, but this was different. I was trying hard to keep it together, and I felt that at any moment my emotions might start spilling out in front of the world, captured by camera phones and shared over the Internet. I felt like I was on display. I just wanted the ceremony to end as quickly as possible so I could get out of that church, almost like I was holding my breath the whole time. I would have preferred to be back home with my dad, who had decided he wasn't making the trip back east for the funeral. But I knew I was expected to be present and be strong, so that's what I promised myself I would do—even though I felt so sick to my stomach that I was afraid I might vomit or worse. I remember rocking back and forth, slowly, while standing in the pew and clutching Alicia's left hand with my right. I'm sure she probably felt like I was going to squeeze the blood out of her fingers.

Suddenly there was a burst of murmuring in the church, as if everyone had started whispering at the same time. I turned around and saw what the commotion was: Whitney. She walked toward me wearing a long fur coat. Bobbi Kristina was trailing behind her. She walked right up and gave me a big hug. As we were hugging, she was looking at Alicia over

my shoulder and quietly mouthed the word "hi" to Alicia. I wrapped my daughter in a big embrace, so happy to see her. Whitney then went and sat in the front pew with Krissi at her side. That was fine—she had been Carole Brown's daughter-in-law for fifteen years so she definitely could sit with family if she wanted. But then she started behaving strangely: she kept turning around to look at Alicia and me. And not just a couple of times. Over the course of the service, she must have done this more than a dozen times. Because she was sitting directly in front of us, it was incredibly conspicuous, embarrassingly so.

At one point I leaned over to Alicia and whispered, "Oh my God, if she doesn't stop staring at you . . ."

"I think she's staring at *you*," Alicia said back to me.

Every time she turned around, Alicia's aunt, who was sitting behind her and had accompanied us from the West Coast, pinched Alicia on the arm, while Alicia lowered her head just a bit so that her large church-lady hat could shield her face. I didn't have anything to shield me, so the frown on my face was clear. Krissi turned around a couple of times too, but it was probably because she kept seeing her mother do it. She was almost eighteen—old and savvy enough to wonder about her mother's curious behavior.

Alicia told me later that it was a clear indication that Whitney still wasn't over me. After all, she had told Oprah that she was waiting for me to come back. But I had not one ounce of desire to return to that crazy life. I was more con-

tent with Alicia and my son Cashy than I had ever been in my adult life. No way was I giving all of that up. For the first time in my life, I actually understood what domestic bliss was. (That is not to say that I wasn't still a knucklehead at times, endangering all I had.)

In the midst of the service, the guys from New Edition went up to the microphone to talk about my mother and about me. Johnny Gill showed his church roots, launching into what sounded like a short impassioned sermon about how we all needed to overcome the work of the devil. I rose up from my seat and decided to join them. So did Whitney. Johnny started singing "Never Would Have Made It," thrilling the church with his deep, unmistakable voice.

After Johnny was done, Whitney *did* decide to sing, a tender version of "Precious Lord, Take My Hand." But before her song, she had some words she wanted to share with the congregation.

"First of all, I want to say, this is *my* mother-in-law. That is *my* mother-in-law there!"

Then she went on to talk a bit about my mom and about growing up in the church. Clearly she was directing her comments at Alicia, alluding to her own feelings about who was *really* my wife and partner. I found it strange and off-putting, but I didn't want to dwell on it. Her voice was a little hoarse, which she apologized for, but when she launched into the song it was touching and heartfelt, pure Whitney.

At the burial site, when they lowered my mother into the ground next to my sister Bethy, I finally lost it. I cried loud

and long for my mom and for myself, knowing how much I was going to miss her. That was the final act of a brutal week, bidding my last farewell. It wasn't easy.

When the burial was done, we had to make our way over to Orchard Park—now called Orchard Gardens to reflect the significant money that had been spent to upgrade the place—to attend the repast that was being served for my mother at the Boys and Girls Club gym. It was the same club where I played basketball as a little boy with several of the guys from New Edition and where my mother used to work. I was happy to see so many of my old friends there and to be back home in a place that had been so important to my development. They showed a video montage of my mother, which was amazing and unexpected. The gym was filled with tables and chairs and the place was laid out with tons of good food. I was pleased that I got a chance to introduce Alicia to a lot of my old friends. But for the most part, my overriding thought was that I wanted to get out of there, to slip away from all the prying eyes requiring me to hold in my emotions.

Alicia and I were making our way toward the exit, wading through the crowd, when the doors of the gym swung open. Once again, we all looked over and saw what the commotion was: Whitney. Apparently she had gone back to the hotel to change into jeans and a sweater. She was accompanied by my older sister Tina. There was some type of R & B playing throughout the gym, which up until that point I hadn't even really noticed. Whitney and Tina entered the gym dancing to the music, extra hard, like they were up in the club or

something. Right away I could tell that they were high. I was embarrassed for my sister and especially for my ex-wife, that she still didn't have the self-control to keep it together on a solemn day like this one. Whitney was automatically going to be the center of attention in any room, in any situation, so the dancing only added fuel to the gossip fire.

Whitney's brother Gary and his wife, Pat, came over to say hello and introduce themselves to Alicia. I saw Whitney eyeing us across the gym. I didn't want any part of that. I grabbed Alicia's hand and we escaped as quickly as we could before we found ourselves in the middle of an unfortunate scene.

We went back to the W Hotel, where we were staying, and spent some time with my kids. We all got a little jolt when Krissi called and said she wanted to come over. She told me she and her mom had been fighting and she needed to get away. So she came to hang out with all of us. We really enjoyed seeing her; it had been so long, particularly for my kids. In fact Krissi went out with her siblings that night—it was the first time in years that they all had the chance to spend quality time together. I can vividly remember the big smile on her face as she interacted with her sister and brothers. At the time I thought, *This is the way it was supposed to be*. Little did I know it was the last time that I would have the chance to see this happy scene. Later that night when Alicia and I were trying to sleep, my cell phone kept ringing. It was a call from a California area code, a number I didn't recognize, coming through over and over. When I refused to an-

swer it, Alicia finally picked it up and said, "Hello?" Turned out it was from DeeDee, Alicia and Whitney's mutual friend who had called Alicia several years earlier with Whitney on the sneaky three-way.

"Alicia? Hi, it's DeeDee," she said. Alicia put it on speaker so I could hear. "How are you, honey?" she continued. "I'm just calling to check on you and Bob and to let him know I'm sending my regards, see how he's holding up."

Alicia said, "He's hanging in there, handling it the best way we can." I shook my head. I didn't want to become a part of the drama.

There was a bit more small talk, then DeeDee lowered the boom.

"So, where are you guys staying?"

Immediately we suspected what was going on—DeeDee was again an emissary for Whitney, checking in on me, hoping to feed her information. If she were just sending her regards, she could have left a message rather than blowing up my phone. We hung up, infuriated.

As if my year couldn't get any worse, soon after we got back to LA, Alicia threw me out of the apartment. She said my drinking was getting to be too much for her to handle. This couldn't have come at a more untimely moment for me; I knew I needed Alicia to help me get through the pain. But I also leaned far too much on alcohol to dull the hurt. With the logic of an addict, I rationalized that alcohol was a much better option than narcotics. I thought at least I could control the alcohol, could function out in the world with it in my sys-

tem, that a slightly drunk Bobby Brown was much preferable to a strung-out Bobby Brown. Of course this is exactly the opposite of the thinking that counselors and therapists tried to instill in addiction treatment. Alicia had sat with me when I went through one stint in alcohol rehab, so she knew all the protocols. Clearly I wasn't supposed to be drinking. Not even a drop. But after Ma left us, I didn't know how else to cope.

Alicia moved out of our apartment and into a friend's house with my son. The friend had a five-bedroom house; Alicia rented two rooms on the top floor. I promised her that I would get it together, that I was capable of doing whatever she needed me to do. But she said she needed to see some evidence. In other words, talk is cheap and easy. With my head spinning, I moved my stuff into my sickly father's house, which was now empty without my mother. I was spending a lot of time on the road performing, so my precarious living conditions weren't a constant worry, but the sorry state of my life was always there, sitting in the back of my head. I knew I couldn't fuck this up again, not when I was just learning what domestic bliss was supposed to feel like.

Meanwhile, my father's condition was growing progressively worse. I had an up-close view, now that we were living in the same place. I was depressed watching him slowly wither away, while also fighting the depression of being away from the woman I loved and my baby boy, in addition to feeling completely helpless about not being able to see my daughter Krissi. The year 2011 was turning out to be a major nightmare.

It's not uncommon for a spouse to pass away soon after their longtime partner dies, so we were worried that Pop would stop fighting now that Ma was gone. We even joked about it, wondering how long Ma would let him stay down here without her, saying that she would soon be coming to get him. We got him a hospital bed to try to make him more comfortable, but we knew it was just a matter of time—particularly when he stopped talking. This big, funny, outgoing man who had always been the life of the party, an essential part of the family, didn't want to talk anymore? It was painful to watch.

In his last days we were all gathered at the hospital, waiting for the inevitable. He was clearly tired, weak, ready to go. When he stopped eating, it was just a matter of days. I was dumbfounded, in a state of shock that I could actually lose both of my parents in the same year. I was glad that my father and I had the chance to really bond in his later years, to the point where we could laugh and talk for hours. Our connection had become so tight that we would finish each other's sentences. He was my best friend. While my mother was the strong, commanding brains of the family, my father was the family's heart and soul.

Herbert Brown died on December 10, 2011, at the age of eighty-two. It was less than eleven months after we lost my mom.

We brought him back to Boston for another memorial service. Pop had requested that we cremate him, so that's what we did. There was another big turnout for him, an-

other powerful, emotional day in Roxbury. My ex-wife didn't come to his service; nor did my daughter Krissi. But the rest of my family and children were there except for Cashy, the littlest one. Alicia also stayed home in California—but I was convinced that when I returned home I could win her back. With my parents gone, I desperately needed to fix that part of my life, to make things right with her. I needed her now more than ever, and I knew how much I loved her.

I visited Alicia and Cashy as often as I could—every day if she let me. I needed to show her exactly how remorseful I was, how committed I was to finding some way to act like a man who deserved to be with her. Finally, my persistence paid off. New Edition was just about to embark on a major tour, celebrating the thirtieth anniversary of the release of "Candy Girl." By the time I left for our first date in Louisville, Kentucky, on February 10, 2012, we were back together.

But my peace of mind didn't last long at all. On February 11, when we were in Southaven, Mississippi, preparing for our next performance, I got a call on my cell from Ralph Tresvant. What he told me was so unbelievable, so unconscionable, that I couldn't even process the words. Whitney was dead.

NIPPY IS GONE

Whitney's death came just two months after my father succumbed to cancer; I was in a tailspin. The news not only changed my life but shook the entire world to its core. The princess was gone. I was numb, in disbelief. It seemed so cruel, to take such a beautiful soul away from us. Whitney and I were not on the best terms at this point in our relationship, because I felt she was trying to keep my daughter away from me and poison her mind against me, but I still cared for her deeply. I never could have foreseen this happening. I was in shock.

Whitney had been found unconscious in suite 434 at the Beverly Hilton hotel, her body submerged in the bathtub. Paramedics tried to revive her, but she was pronounced dead at 3:55 P.M. Local police claimed there were "no obvious signs of criminal intent." (The Los Angeles County coro-

ner reported a month later that the cause of her death was drowning and the "effects of atherosclerotic heart disease and cocaine use.")

Because it was coming so close behind the deaths of my parents, Whitney's death sent me into another head-spinning spiral. I felt like I was trapped in a particularly vicious place in hell. But through my intense grief, my first thought was that I needed to reach out to my daughter. She was only eighteen—how in the world would she be able to deal with the death of her mother without me there to hold her and assure her that the Earth would keep rotating? I prayed that she would be strong enough to fight her way through the dark places that I knew would threaten to subsume her. I had just lost my own mother; I understood very clearly exactly what she would be feeling. I knew that, more than anybody, I was the one who could help her make it through. I just needed some time with her. I tried to talk to Krissi, but she was so out of it when she answered the phone that I was even more disturbed. I desperately needed to make sure my daughter was all right. I knew that Tommy was in Los Angeles, so I called him and told him to get to the hotel as soon as possible and scoop up his niece.

A FEW WORDS FROM TOMMY BROWN

After Bobby and Whitney divorced, it was really difficult for Krissi. She was hurt and she didn't really understand what

had happened. In addition, Whitney and her family were putting wedges between Krissi and Bobby's family, telling her everything that happened was his fault. So I can imagine she started to believe that he was the cause of her unhappiness. With any divorce, a kid is invariably going to wind up on one side or the other. Since Whitney had custody, that meant she was with Krissi day-to-day and had the opportunity to plant these negative seeds about Bobby. The Houstons and their personnel did everything they could to make sure Krissi never reestablished a bond with her father, even at the expense of that child. I thought it was so tragic because they had been so close when Bobby was still with Whitney.

I had a chance to talk about it with Krissi after her parents separated and I could see the hurt she was feeling. Like any child, I think she might have held out hope that her parents might get back together. But when Bobby got with Alicia and they had a child, it dawned on her that her parents were never getting back together. Then things really changed. Every time I had a cell phone number for Krissi and got a chance to talk to her, the number would be different the next time I tried to reach her. This happened at least four times.

When Bobby called me after hearing that Whitney had died, he told me to get to the hotel right away. So I got in the car with my nephew, Bobby's son Landon, and my son Tommy Jr., and flew over to the Beverly Hills Hotel. That's where I knew Whitney liked to stay when she was in town. But when I got there I saw no police cars, no media hoopla,

no excitement. It couldn't be the right place. But I got out of the car and started looking around, trying to figure out what was going on. That's when somebody told me she had died at the Beverly Hilton. Then we raced down Sunset Boulevard to the Hilton, which was only about five minutes away. As soon as I turned the corner onto Wilshire, I saw the media mob and knew this was where we needed to be. The police let me through, but they wouldn't let Landon and my son up with me.

When I got to the hallway upstairs, I saw mayhem, people everywhere. I finally located Krissi outside of one of the rooms packed with people. It was a suite near the room where Whitney's body was still lying. I saw Krissi falling out in that hallway, wailing loudly as she leaned against the wall. I saw Pat and Gary Houston, Whitney's sister-in-law and brother, but they weren't paying Krissi any mind. They were too busy grabbing Whitney's belongings out of the room. At that moment they seemed oblivious to Krissi's anguish, this little girl who had just lost the most important person in her life.

I got Krissi into a room and tried to console her. Bobby told me that he would be in LA as soon as possible, but he said I couldn't let her out of my sight. I cleared everyone out of the room, including Ray J and a bunch of other celebrities, so Krissi wouldn't be surrounded by chaos. A few of them, like the singer Monica, were very sweet and helpful, truly concerned about Krissi. This was right before the Grammys, so music celebrities were everywhere.

Krissi kept telling me, "I gotta get my brother."

I was thinking she was talking about her brother Landon, since we were in LA, where Landon lives. So I thought I needed to figure out how to get Landon up to the room.

"I don't know where Landon is, but I will reach him," I said.

"I'm not talking about Landon," Krissi said.

"Well, what brother are you talking about?"

"My brother Nick," she said.

At this point I was really alarmed. She didn't have a brother named Nick, so I thought she was hallucinating.

"Baby, you don't have a brother named Nick," I said. "You all right?"

Maybe I should take her temperature or something?

"Nick stays with us," she said.

This was the first time I ever heard his name. Apparently he had been there for a couple of years at this point, but I had no clue that a young man was staying there with them and I was pretty sure Bobby didn't either because he would have told me. I was blown away by this news. But a part of me was still thinking that she had taken something and was in the throes of some kind of drug-induced hallucination. She was drifting off, like she was in a haze. I called Bobby and handed her the phone, thinking that maybe her father's voice would pull her out of it. But she was barely lucid when he was trying to talk to her. She was still focused on seeing Nick.

"Okay, we'll find out where Nick is," I told her.

I had kicked everybody out of the room, so I wasn't sure if this Nick character was one of the people who had just left.

But I started asking around and didn't find anybody named Nick on the floor.

After a little while Nick showed up.

"Uncle, I just want to talk to him," she said.

"Okay, baby, I'll give you five minutes," I said.

I was really uncomfortable because I didn't know this kid. I told her I would be right outside in the living room area of the suite. Krissi came out of the suite with Nick, who quickly slipped away. She was acting extremely lackadaisical; I was immediately alarmed.

"Krissi!" I said. But she wasn't responding.

"Baby, come on, you gotta respond!"

She was still not responding to me, despite the volume of my voice. I saw her eyes roll back into her head and nearly lost it. I decided to call 911.

"I need you now!" I yelled into my phone.

I don't tend to push the button too soon, but it was clear to me that she needed some medical assistance. I don't know if this guy gave her something, but I later found an empty Xanax bottle in the room. There was also a bottle of wine.

When we got to the hospital, I explained to the doctors why we were there. They started checking her out. I was expecting somebody from the Houston family to show up, but instead I was greeted by this white guy who turned out to be Whitney's rehab treatment counselor. His name was Warren Boyd and apparently he's the treatment counselor to the stars. The doctor told me Krissi had been evaluated and seemed to be

fine. Krissi was telling me she wanted to go back to the hotel, but that was the last place I wanted to take her. I had to keep her safe until Bobby arrived; I didn't think that chaotic hotel was the right place to do that. But then I thought about the fact that she had just lost her mother in that hotel, so maybe I should let her stay there as long as she wanted.

As soon we got back to the hotel I regretted the decision. There were a bunch of music industry celebs, including Ray J, in the suite popping bottles and drinking like they were turned up at the party—all while Whitney's body was still nearby, with that area of the hallway cut off by police tape. It looked crazy to me. I wanted Krissi to get some sleep, so I cleared the room out once again. I told them that they were serving no purpose upstairs—they needed to go downstairs and continue their party. I had Krissi lie down on the bed.

"Even if you don't go to sleep, just relax," I told her.

I called Warren Boyd back and told him that I needed to get her out of the hotel. He said he would come and bring her to one of his facilities in Huntington Beach.

While I was in the hall waiting for him, I saw Whitney's longtime agent, Nicole David.

"What's going on here? This is crazy," I said. "No one is attending to her."

Nicole shook her head. "I know, I know. It's unbelievable."

"I'm getting her out of here," I said.

"That's what you need to do, get her somewhere away from here," Nicole responded.

As I headed back to Krissi's room to check on her, I saw Nick leave the room. *When did he go in there?*

When I walked back in the room, Krissi was even more lethargic than before. I panicked again.

"Krissi! What did you take?" But there was no response from her. So I called 911 yet again. I told them, "Get here now!"

I shook Krissi again, trying to wake her up.

"Krissi, don't play no games with me," I said.

But she never really came around. So when the emergency technicians arrived, they put her back on the cart and we took the ambulance back to the hospital. She was barely conscious the whole time. At the hospital, I was prepared to sign whatever forms I needed to in order to have her stay there and be observed. The doctors determined that she hadn't overdosed. Warren arrived, along with several members of Whitney's security detail. They convinced me that Krissi would be safe if we brought her to Huntington Beach, the place where Whitney and Krissi had been staying. I called my niece LaPrincia, Krissi's big sister, who happened to be in LA, and told her to meet us there.

When we got to Huntington Beach, I felt confident that Krissi was in good hands because she was with her big sister. LaPrincia would take good care of her. In addition to LaPrincia, my niece Mimi was also there. She's the daughter of my late sister, Bethy, and she was also very close to Krissi. Warren put me up in a room nearby in the same facility. I talked to Bobby and updated him on the situation before he got on

the plane to fly to LA. I had a hard time sleeping that night because my brain was still in overdrive from all the craziness. I couldn't believe Whitney was gone. But our priority now was to make sure her daughter made it through.

The next morning Bobby and Alicia picked me up and I showed them where Krissi, LaPrincia and Mimi were staying. We walked into the suite and saw LaPrincia crying. We asked her where her sister was and she told us Krissi was "gone." She was hysterical now, saying Krissi had been taken away. Apparently when LaPrincia thought her sister was in the shower, somebody had entered the room where Krissi was staying, which had a door leading outside, and whisked her away.

There was pandemonium as we realized what had happened. Clearly it was the work of the Houstons, probably assisted by Warren Boyd, the rehab guy. Bobby was incredibly outraged. When I went into Krissi's bathroom, I saw that the rug leading to the bathroom was soaking wet. I wondered what the hell had happened there. When I found out, I was seriously shaken. Nicole David told me that the night before Whitney was found dead in the bathtub, Krissi had almost drowned in the bathtub. She had been submerged under the water and had to be pulled out. And then the next day her mother died the same way? And then ultimately the same thing happened to Krissi again? I was told that Whitney and Krissi had had some type of fight the night before and that Krissi was mad at her mother.

It's all too much for me to comprehend. How could this all be a massive coincidence?

Bobby turned his anger on me, saying he had told me to not let her out of my sight and now she had been taken away. I felt like it was unfair to blame me, but I also understood why my brother was angry. I was so upset, I had to get away from there, my mind still reeling from the sadness of the whole scene.

———

A FEW WORDS FROM LaPRINCIA BROWN

There was this guy named Warren who was supposed to be helping Krissi the day her mother died, but he kept telling her, "If you don't want to see your dad, you don't have to." I was so upset when I heard that. Who are you to know what she needs right now, to tell her she doesn't have to see her father? That seemed to me to be the opposite of what somebody should really say in that situation. But I thought they were building a suspicion of our father in Krissi's mind. I felt like it was really controlling. When I heard her saying, "I don't want to see my dad," I didn't take it as her being mad at Dad, I took it as her saying it was going to hurt to see him. She didn't want to have to deal with the hurt.

I think if I were to tell my boyfriend or my best friend after my mother had passed away that I didn't want to see my dad, they'd be like, "Okay," but still make sure my dad got to me. They would tell me that I needed to see my father, not take it upon themselves to make the decision for me.

When we were waiting for my dad the morning after her mom died, Krissi was supposed to be taking a shower. I asked my cousin Mimi, "Where's Krissi?" But she sat there ignoring me, looking off into space. At this point my dad pulled up and I started freaking out. There was a door connected to the outside in her room and someone had taken her away. I started crying hysterically because I didn't know what to do. I couldn't believe they had taken her away.

It was so crazy that Krissi had just had an incident in the bathtub before her mom died. They said she had fallen asleep in the tub and somebody had to pull her up. I never got a chance to ask Krissi about this. She kept changing her phone number and I could never get through to her. The few times I did talk to her, I could tell she wasn't really talking to me. It was like she was just telling me whatever I wanted to hear. I think Nick convinced her we couldn't be trusted—her siblings, her father—that we were terrible people. But he didn't even know us. My dad didn't even know who he was.

I think there's this idea out there that my dad is a bad father, and that somehow what happened to Krissi is partly his fault. But once your child turns eighteen and you have no say over what they're doing, you can't *make* them see you, you can't *make* them tell you where they are. You can't call the police because they won't talk to you. There's only so much you can do. When you have everyone else covering for you, when you can change your number every two seconds, when you have all this power to make somebody leave you alone,

then what are your parents supposed to do? I want to know. What do all these other parents do when their kids run away and never talk to them again?

———

Reaching Krissi

After Whitney died, Alicia and I stayed in a hotel in Huntington Beach for four days, dodging paparazzi, trying to connect with Krissi. The Houstons and Whitney's team kept blaming it on Krissi, telling me she didn't want to see me. But I wasn't buying that—suddenly we're acting like Krissi is making wise choices? They knew damn well she needed to be with her father. My other kids were on the verge of breakdowns because they couldn't reach her either. I was drifting between fear and outrage, worrying about my daughter's emotional and mental state while being exceedingly upset about what I saw as a concerted effort to keep my child away from her dad in this time of extreme need. Who did these people think they were, to keep a daughter from her father? And from the things Tommy was telling me about the inattention he witnessed the night Whitney died, it's not like I could believe she was in the best of hands with them.

I often worried about the kind of care Krissi was getting in her mother's household after I left, based on the things I saw with my own eyes and the things I was hearing from other people, such as my daughter LaPrincia. But at least I

knew her mother loved her and wanted the best for her, even if she was sometimes in too altered a state to know how to provide that for her. But I had no assurances that the rest of the Houston family was putting the care of Krissi at the top of their priority list. I mean, on the day her mother died, my brother saw her dealing with her grief alone in the midst of a roomful of clowns like Ray J partying and popping bottles.

Their lack of concern for my child was confirmed when I heard about a reality show they were producing called *The Houstons: On Our Own*. Not long after Whitney was put in the ground, Pat Houston started making plans to parade Krissi's grief on-screen for the whole world to see in a reality show. How do you do that to a baby who just lost her mother? Are you kidding me? Nobody ever came to me to ask my opinion about whether this was a good idea—because they knew I would have said, "Hell no!" I was incredulous when I heard. And might I point out that Krissi wasn't a Houston, she was a Brown. (Ironically, Pat Houston wasn't really a Houston either. Her husband, Gary's, last name was actually Garland, not Houston, because he and Whitney had different fathers. Gary's father was Freddie Garland, to whom Cissy was married in the mid-1950s. When Gary played in the NBA, his name was Gary Garland. That was still his name when he married Pat. They were Gary and Pat Garland. But somewhere along the way they became Gary and Pat Houston.)

With Krissi, I saw the family repeating some of the same patterns that I had seen with Whitney: making her feel in-

adequate as a means of controlling her. That's exactly what they did to my ex-wife. They couldn't let Whitney live the life she wanted to live; they insisted that she be perfect, that she be someone she wasn't. That's why they wanted Robyn out of Whitney's life. That's why they never thought I was good enough for her. People want to attack me for my involvement with Whitney, but at least I gave her the space to be herself. Hell, if it would have made things better for Whitney, we could have been just friends and she could have kept Robyn in her life. In retrospect, I could have lived with that. But the people around her, like Clive Davis and her family, wouldn't let that happen. And now they were orchestrating Krissi's separation from her dad and, at the same time, broadcasting Krissi's pain on a television reality show? I felt like it was a nasty, unconscionable form of child abuse.

My brother, Tommy, actually agreed to appear on the show as a way to see Krissi face-to-face, but at the last minute they told him Krissi wouldn't be appearing on the set.

I've always felt a big part of a father's job is to protect his children, particularly his daughters. But the people around Krissi were denying me the chance to protect and care for my little girl and it was driving me crazy. Of course Krissi wasn't making it easy for me either. She was still mad at me for my relationship with Alicia, thinking it somehow meant a rejection of her and her mother. When Alicia and I had Cassius, she wanted to hold that against me as well. I had another child with somebody else and I was happy, so she took it

personally. And I was not given the chance to make it right, to get her to look at the situation with mature, grown-up eyes. She was still seeing the situation as a child would—the same way she saw it when her mother was around to tell her I didn't love them because I had moved on. But I needed her to develop the mind-set of the young woman that she was. And I wanted to help her.

Whitney's funeral was yet another nightmare for me, stage-directed by the Houston family. Tommy and my lawyer Chris Brown (no relation) had several days of discussions about my attending, when I was arriving, who was coming with me. They were well aware that I planned on coming to New Jersey with my family in tow—my three children who had also been Whitney's stepchildren. She had helped to raise them, had been a key, loving figure in the lives of Landon, LaPrincia and Bobby Jr. Of course they would be there right alongside me as we said good-bye to this woman they loved and who loved them. Chris was given the instructions on when we should arrive, where our car should drop us off, etc.

The morning was busy with tense activity as we all got dressed. Alicia was a big help in making sure things ran smoothly. My old friends from New Edition all wanted to come to the funeral with me. In a major coincidence, the group was performing the next day on our tour in Newark, where the funeral was being held. But I told them that while they were free to attend, I just wanted to roll with my family.

We arrived on time to New Hope Baptist Church in Newark. Alicia and Cashy were back at the hotel; she thought it would be best if she stayed away. The crowd was teeming with celebrities, many of them old friends of mine. But I wasn't in the mind-set to be social. I felt like I had been to an endless parade of funerals by this point. I was tired of the black suits, the tears, the emotional turmoil. And most of all, I wanted to see Krissi. This was the one place where I was certain we would be together.

From the moment we walked into the church, things went bad quickly. We were escorted to the second row of pews, behind where Krissi would be sitting in the first row, in front of Whitney's casket. We sat for a short while, waiting for the services to start, watching the celebrities stream into the church. While we were waiting, one of the security guys came up to us and told us we had to move.

"Excuse me? I don't understand," I said to him.

"Sir, you have to move," he repeated in the even, hushed tone that ushers take at funeral services.

"But we're supposed to be sitting here," I said, growing angrier. "We're not moving."

The guy paused, then he said, "You can stay, but your kids have to move to the back."

"Sir, we're not moving from this spot," I said. "You're gonna have to move us."

But then I glanced at my kids, who looked like they were in shock, and I knew instantly that getting into some type of

loud scene with these people was not the right move. I saw Brandy and Ray J sitting in the row behind me, watching. *So they're trying to move my family behind Ray J?*

I leaned over to my kids.

"Let's go," I said.

But before I left the church, I had one thing I needed to do: I walked up to the casket, kissed it, and said good-bye to my ex-wife. Then I turned around and led my children out of the church. Since the primary purpose of my attendance at the service was to pay my last respects to this woman whom I had loved for all of my adult life, my mission there had been accomplished. I know many have tried to criticize me for leaving Whitney's funeral under those circumstances. But I'm fine with my decision that day. It was about bringing my family to the church and saying good-bye to Whitney. That was all. I was not going to stay there and let us once again become pawns in a game being orchestrated by the Houston family. They had days to figure out where to seat us and to acknowledge that my children, once a big part of Whitney's life, should be sitting with their little sister. Anything else would be cruel and callous treatment. And now suddenly there was confusion about where the Browns would be sitting? As a long line of celebrities breezed into the church and were led to their seats up front? No, I wasn't there for that—and wouldn't subject my children to it.

Besides, I knew the rest of the day was going to be the show anyway. I didn't need to be there for the show.

When we emerged from the church, we saw Krissi in the back of a black Town Car outside of the church. My kids were excited; getting to spend time with her would easily make up for the ridiculousness in the church. We immediately rushed toward the car so we could greet her. But right away, four security guards appeared and got in front of me. They told me to stay back. It was another punch to the gut for the entire family. My kids were incredulous; all three of them started crying. I was incensed that the Houstons could treat my family with such disregard, especially my children, who were Krissi's siblings. They had brought my three grown children to tears. LaPrincia had already tearfully called Alicia on the phone and told her to send the car for us because we had left the church.

Just put yourself in my shoes here for a moment: You spend a decade and a half raising a child along with the woman of your dreams, both of you loving this child so much that at times it takes your breath away. Angels come down and take this woman away from both of you, tearing a huge hole in your hearts. And then, inexplicably, some outside force steps in and tells you that you are such a pariah, such an evil person, that not only are you not allowed to hold your child in your arms on the day her mother is being buried, you can't even see her. And if you object too loudly, it is you who will look like the irrational fool.

Here we are, years later, and the thought of those moments still knocks me into a deep funk.

The rest of that day was surreal for us all. I was still numb from coming so close to embracing my baby girl and being rudely dismissed. Alicia was fielding phone calls from people like Reverend Jesse Jackson and Reverend Al Sharpton, trying to get me to return to the service. We had the television on and watched some of those folks outside the church, talking about my exit. But I didn't have any regrets about what I did. Essentially I was trying to protect my children. I would have been tortured by the idea that I was sitting in the front of the church while they were separated from me, mourning without their father. The memory of that would have haunted me much more than leaving the church before the singing and preaching started. My only regret was not being there to console Krissi.

――――

A FEW WORDS FROM LANDON BROWN

My mom was mad at me all the time because she said I loved my dad's kids—Bobby, Krissi and LaPrincia—more than I loved my siblings in California. I didn't get that. She and Carl had had two sons by the time I went to live with my dad; eventually she had a third. She said I loved my dad's kids more because I talked about them all the time, always saying they need me, they need me.

She said, "But your brothers need you too."

"Yeah, but they have me," I said. "They see me all the time. The others need me."

As the oldest, I felt protective of all my siblings. I still do. Even if sometimes I say they make me so mad, and I turn my head away from them, that same night I feel like such a jerk for feeling that way for even five seconds. Bobby and Princie were with their mother all the time in Boston, and I don't think their mother liked my mother very much, so I didn't really get to see them very often. LaPrincia is so independent; she never needed my help. Trying your hardest to help someone who never needs you is really frustrating. Listen, everyone needs someone. Talk to me. I'm here for this specific purpose of you being able to use me for comfort. That's my job. Little Bobby used to walk on his toes all the time. That would make my dad so mad. It was so funny. I just want to see how he's growing up. I want to see how all of this, life, is working for him. I hear he's playing hockey. I love hockey. I want to watch him play hockey. But he's in Boston and I'm in Cali.

When I stayed with my dad and Whitney and they weren't around, which was often, the people around Krissi wouldn't let me talk to her, wouldn't let me see her, wouldn't let me hug her. They would say she needed room to breathe. I'd be very disappointed by that. Whitney's nephew, little Gary, her brother Michael's older son, would wait until they weren't looking and then walk her over. "Landon, she's here," he'd say. He would bring her to me so I could play with her.

As she got older, I think she was just looking for an idea of what a man was supposed to be like. My dad was all over the place, on the road. He didn't really have much time to show her exactly what a man is supposed to be like. She

would call me, talk to me about boys, talk to me about Dad. She was really caring too. She would completely stop thinking about herself and would say, "How are you? Tell me about what's going on with you. What's going on there?"

That was new to me because everybody always wants to know about my dad, everyone wants to get their questions out of the way. Nobody really cares what's going on with you. But here she was, a little kid, like eleven, maybe twelve, asking what was going on with me.

Her personality went through big changes as she got older. When she was little, she was innocent, silly, playful. Then she jumped to being very spoiled—very mean and spoiled. Then all of a sudden she was serene, just awesome, silly, caring. She was way deep into what was important to you and would mold her conversation around it, gear it to what was important to you. "Oh, you like soccer? I've never really liked soccer, but I know this person . . ."

She would always find a way to connect to you.

———

Wedding Day

As June 2012 approached, Alicia and I prepared for our destination wedding in Hawaii. I was hoping that I would have all my kids there to share the special moment with us, but Krissi's presence was looking doubtful. She wasn't speaking to me at the time; I couldn't even get her on the phone to

invite her to the wedding. I knew she was still dealing with the pain of her mother's passing, so I didn't press the issue too much.

I had proposed to Alicia in 2010, when our son, Cassius, was eleven months old. I did it at a show in Florida, on tour with Heads of State. That was another combination of New Edition, when Johnny, Ralph and I went out on the road as the lead singers. I had planned on proposing in Los Angeles, so Alicia would be around her friends and family when it happened, but the LA show got canceled. So I decided on Jacksonville, Florida, because I just wanted it to be done. I was out shopping with Ralph in Jacksonville and when we came upon a jewelry store, on a whim I decided to go inside.

"You know what? I'm just going to do it," I said as I pushed open the door to the store.

"What?" Ralph said.

"I'm about to get married, man."

So I picked out the ring that I wanted with Ralph by my side. When I pointed to it, I said, "Let me marry this girl before she leaves my black ass!"

Let me say, I was no longer balling like I was in the nineties when I proposed to Whitney and got Joe the Jeweler to whip up something magical. I was on a radically different budget now. I had walked away from Whitney with no money, and I had been absent from performing for years, so it was going to take me a while to build up another nest egg. Alicia and I had spent many nights eating McDonald's

chicken sandwiches for dinner, literally stashing our nickels and dimes, keeping on top of my child support payments, living check to check.

I had spent so many years in mansions and Bentleys, not ever thinking about money. Now that I had to think about it on a daily basis, I must say I preferred things back in the day. Alicia lost her house because we couldn't stay on top of the payments. I felt bad that I had pulled her down into this sinkhole, and I vowed that we wouldn't be there for long. I wanted to marry her and take care of her as best I could.

Just as I asked Whitney's dad for his daughter's hand in marriage, I also asked Alicia's dad, Henry Etheredge. It was a bit awkward for Alicia because she was on the phone with him when we were out to dinner and I asked her if she could hand me her phone. She looked at me with a frown, wondering what I was up to. I walked away from the table so we could talk privately.

When I told Mr. Etheredge my plans, he said he was fine with my proposing to her, as long as she said yes. I wasn't an easy partner, I knew that, but I was certain she wouldn't turn me down.

So that night at the show in Jacksonville, I had Alicia come out on the stage with Cassius. They had been sitting at the side of the stage as usual, watching the show. As my manager, Alicia traveled with me for nearly all of my shows. We usually brought the baby with us.

I told the crowd, "I want you to see my girl and my baby boy." They responded with robust cheers.

Because I often had her come out onstage with the baby, Alicia still didn't suspect anything. Ralph and Johnny were onstage with me, so they watched it all wearing big smiles, knowing what was coming. I got down on one knee and asked if she would marry me while the crowd roared. A tearful Alicia said yes and gave me a big kiss as little Cassius watched from her arms. I told the crowd, "I'm going to work harder on this one than I did on the last one."

That got another round of cheers.

When we looked at my shows scheduled for 2012, Alicia and I were excited to see that New Edition would be stopping in Hawaii on a major tour. Bingo! Right away we knew that would be the perfect location for our wedding. We had taken a trip there with my kids Landon, LaPrincia and Bobby Jr.; Tommy; and my dad before he died, and we'd had such a great time. We scheduled a three-day-weekend party for all of our invited guests, including a big brunch, beach parties, a boat ride—not to mention a New Edition concert. The entire weekend was the picture of the kind of people we are—outgoing, welcoming folks who love to be around others and always want to make sure everybody is having a great time. It was such a fun party, we never wanted it to end.

The incredibly talented Lalah Hathaway made the trip to sing at our ceremony. She serenaded us with her powerfully moving song "I'm Coming Back." We also asked Charlie

Wilson, but he had a prior engagement that weekend and couldn't come. When Alicia and I first called Lalah to ask her, she shocked us by saying she'd had a dream that she would sing at our wedding. When she told us about her dream, she had us all blubbering on the phone.

"I wouldn't miss it for the world," she said. "I already felt this. I already knew it."

We were so blown away by how magical that was. But that was nothing compared to her tearing that song up on our special day. It was such an awesome moment; Lalah is a beast.

We were married by Reverend Michael Beckwith, the pastor of our church in LA, Agape. Beckwith typically doesn't fly for anybody's wedding, but he agreed to get on a plane for ours. We were moved that he would do that for us. Alicia wore white, while I wore a red suit and Adidas sneakers, matching Cassius, our ring bearer.

The only note of sadness was the ones who were missing. We were all pained by the absence of my mom and dad. Krissi was also conspicuously missing. She was still making me pay for moving on, for falling in love again. Every time I thought about my child, I felt pangs of regret, confusion, anger. There were many adults in her life who were helping her keep her distance from me and I didn't understand why.

Krissi did call me the day after the wedding to congratulate me. It was great to hear her voice after so many months without any contact. I could tell she was still hurting.

I was further enraged to hear allegations that I was trying to get my hands on the money Krissi was due from her mother's estate. Krissi was getting a monthly allowance determined by Pat Houston, as executor of Whitney's estate. If I didn't take any money from her mother, I certainly wouldn't take it from my daughter. Krissi did have a lawyer— a lawyer who was provided by the Houston family. When she turned twenty-one in March 2014, she was supposed to get $10 million, but that never happened. She later told me the only reason she agreed to do the television show was because she felt she didn't have any money.

I flew to Atlanta several times to try to track my daughter down, but she was avoiding me. I would find out later the reason why—she was scared I would see what was going on with Nick. I'm pretty sure she knew what I would have done to him if I had discovered it. But soon enough I started hearing from some of my security guys in Atlanta, who were telling me that I needed to get her away from him. I told them they needed to bring her out to LA to be with me, but they said she refused.

I had first heard the name "Nick" several years earlier, when Krissi was in her early teens and she and Whitney told me he was living in the house with them. It didn't make any sense to me why my ex-wife would let some nearly grown-ass man live in the house with my thirteen- or fourteen-year-old daughter. I heard stories from some of my friends in Atlanta that he used to hang around Krissi's middle

school, which was extremely suspicious to me because he was at least five years older than the middle schoolers. What would a seventeen- or eighteen-year-old want with middle schoolers?

When I'd call the house to talk to her, Whitney would tell me she had gone somewhere with Nick and that he was like her chaperone.

"He's okay, Bobby, he's fine," Whitney said to me.

But I didn't have enough information about him to be comfortable with the arrangement. I started to suspect that his presence was more about Whitney than Krissi—I began to believe he was providing my ex-wife with drugs.

Krissi had been calling Nick her "brother" all along. After Whitney died suddenly she started referring to him as her "boyfriend." I was extremely alarmed by that development.

"We're in love," she said to me dreamily over the phone when I finally got a chance to ask her about this.

"Little girl, you don't even know what love is," I said back to her.

Then we saw on Instagram that she claimed they had gotten married. She displayed a picture of what was supposed to be her wedding ring. But I recognized it right away—it was the huge diamond ring I had given to Whitney when I proposed to her twenty-five years earlier. In my mind, the sight of that ring cast instant doubt on her marriage claims. I got her on the phone again to question her. She admitted to me that they weren't really married. While some of my family

members were doubtful that she had told me the truth, I had a strong feeling that she had.

Over the course of many phone conversations with my daughter, I tried to befriend Nick. My plan was to get my daughter to LA; once she was with me, I'd cut him off like a bad habit. He would say all the right things to me on the phone, but when I'd come to Atlanta to see her, he'd figure out a way to make her unavailable. One time when they were supposedly in LA, I went to the Beverly Wilshire, thinking I was about to see my daughter. I called her and he answered the phone, claiming they were on their way downstairs as I waited in the lobby. Nobody ever showed up. I found out that they weren't even staying there. Whatever game he was playing, I had a growing sense of dread about what was happening to my daughter. I wasn't even sure where they lived; they had moved out of Whitney's condo in Atlanta. Apparently the Houstons were funding their game of musical chairs.

I finally got a chance to spend time with my daughter on Father's Day 2014. She came to my hotel in Atlanta and we had lunch at the Palm restaurant in Buckhead. I was in town for several weeks with New Edition to rehearse for our upcoming tour. She even had a lengthy conversation with Alicia before our meeting. She told my wife that she was excited to come out to LA to spend time with Alicia and Cashy, to establish a relationship with both of them. Alicia was thrilled, since she had been feeling for so long like she was possibly

some sort of impediment, in Krissi's mind, to Krissi and I reestablishing our bond.

Krissi talked to Cashy on the phone. He called her "sister," which is what he called LaPrincia. She told him she was going to come to LA and hang out with him and have a bunch of fun.

When we saw each other, we ran to each other and hugged, like a scene from a Hollywood movie. I lifted her in my arms and twirled her around. My heart was so full as we sat in the restaurant, laughing and acting up like we used to do. It was the first time we had spent any substantial time together in several years, which looks outrageous just seeing it written down. She was in a great mood, smiling and happy. You can see the pictures of us together that Krissi posted on Instagram that day to confirm that. I felt some of the anxiety I had been feeling for such a long time start to slip away.

Over the next several months we stayed in steady phone contact. We had many conversations that ended with a heartfelt "I love you." We would talk to each other on FaceTime, make video recordings for each other. And we would keep up our communication with a steady stream of texts, filling each other in on our days and our lives. She came to see me perform in Atlanta, but for some reason she told me she couldn't stay to visit with me backstage. I was disappointed but was glad to get her text that she loved the show.

"Oh my God, Dad, the concert was so good!" she wrote in the text. "You were jamming! I was singing so loud!"

When Krissi found out that Alicia was pregnant again and that we were having a girl, she sounded excited on the phone.

"Oh my God, I have a sister coming!" she said.

Then she quieted for a second and asked, "Dad, she's not coming to replace me, is she?"

I couldn't believe she would ask me that.

"Krissi, how the hell can anybody replace you?" I said.

I felt that she was finally growing up, maturing. She was realizing that she needed to have a relationship with her father. She was actually telling me her feelings, her fears, in a way she never had before. As part of this new maturity, I also got the sense that she was breaking away from Nick, trying to create some distance from him. She had gotten over this childhood infatuation she had with him. But it appears that perhaps Nick didn't want to let her go.

We started making plans for her to come out to LA for my birthday on February 5. Everybody in the family was giddy about the prospect. We missed her so much.

But on January 31, I got yet another heartbreaking phone call. Somehow, my baby girl was in a coma.

———

A FEW WORDS FROM BOBBY BROWN JR.

Believe it or not, after my father and Whitney split, I went more than seven years without ever really seeing my little sister Krissi. The more I think about it, the crazier it sounds to me. I

don't even count the time I saw her at my grandmother's funeral in 2011 because I didn't spend much time with her that day, and she was acting like a totally different person.

I know there's a perception in the public that the Brown family was not there for my sister, but the thing is we weren't allowed to be there for my sister. I would try and try, but I'd be unable to get in contact with her. I almost felt like since my father and Whitney weren't together, everyone around her would make her feel like she didn't have to have a relationship with us. Maybe it grew into a false hate for us. Or maybe she wanted to talk to us, but nobody let her. I wasn't there with her, I'm not a witness, so I can't say. But it was clear something was going on with her—she was going through a lot and she had the wrong people around her. And the people who were around her were not trying to let her talk to the people who would steer her in the right direction and get her out of that bad situation. It was tragic and painful for us to watch.

Krissi and I had a great relationship growing up. We were only a year apart, but she was my little sister. She was always hilarious, always a goofball. Sometimes I felt she had a jealousy issue with Princie. Sometimes she'd get mad because Princie wasn't giving her enough attention. She was the silver-spoon child of the family. She grew up spoiled and she could do anything she wanted. She was definitely disciplined way less than we were. The way my sister and I were raised was very different from the way Krissi was. We were raised by my mom. I'm not trying to throw any shade, but two celebrities

going through what my dad and Whitney were going through and having to raise a child, it's going to be hard for them to be in the child's life consistently and be in the proper mind-set to teach the child right from wrong, be a role model, be around all the time.

Even though my mom had some financial struggles at times, I was never jealous of Krissi's life. I never thought, *I wish I had it like that*. Because even when I was young, I didn't think the way she was raised was fun. I thought the way I lived with my mom was fun. I went to public school; I had friends and they weren't people I could boss around. Krissi had a rough life. Maybe from the outside it didn't look rough, but looking back it definitely wasn't ideal. I mean, she didn't have to do anything she didn't want to do, so if she didn't want to go to school, she wouldn't have to go to school. As she got older and my dad wasn't in the picture, she just stopped going to school altogether. She was in a bad environment and nobody around her was trying to help. Everybody on the Houston side said they were trying to help, but if that was the case none of this would have happened.

After my little sister lost her mother, everybody who was allowed to be around my sister should have been there for her. After Whitney passed, everything should have gone into lockdown mode. That's how the Browns would have treated it.

Every time I spoke to my sister she told me she was coming to see me. She'd say, "I'm coming up, I'm gonna be there, I can't wait to see you." But then she'd never show. She did

that with everybody. I don't think it was all her, because she was around Nick; she was around people who were very manipulative. And the way she grew up, she didn't learn real from fake. When you don't know real from fake, you're going to be easily manipulated and you're not going to know who's really in your corner. She wasn't given the tools to understand how things work, how people are—to know that when you see people do something wrong, you're supposed to learn from that.

When I would stay with my dad and Whitney during the summers, I started to feel like Whitney didn't like me. I found out that my dad was messing around with my mom while he was talking to Whitney and she got pregnant with me. It started to affect me as I got older, especially when I was told Whitney made my dad take a paternity test to make sure I was his. That messed me up a lot. And then I started thinking about their naming my little sister Bobbi, which is my name. I grew up thinking they were trying to replace me with her. It didn't result in my having any animosity or hate toward my sister, since she didn't have anything to do with it, but I did have pain from that. Sometimes they would send for LaPrincia to come visit them and not for me. And when I was there, LaPrincia would stay in the big house, but I'd get sent to stay in Crossways, which was another house where the studio was that was across from the big house. I would be sent over there with my boy cousins. Since I grew up with my older sister, I would want to stay with her and with my father in the big house.

I would notice that Whitney called me Robert instead of Bobby, which made me feel like they were trying to replace me. Everybody always called me Bobby. The only time I'd be called Robert was if my parents were mad at me. But when I went to New Jersey, suddenly I'm Robert because my sister's name is Bobbi? I'd be thinking, *Shouldn't you guys be calling her Krissi, since I'm older? After all, I was Bobby before her.* It was mainly Whitney doing it. She would call me Robert all the time. My dad would call me Little B, Bob, Bobbo. He would never call me Robert unless he was mad, though sometimes he would do it when he was with Whitney. I'm not sure how my mom found out about that. Maybe my sister told her. She would call and complain and that would create conflict, with me in the middle. I didn't want him to be mad at me. But I always felt that Whitney didn't like me, that her entire family didn't like the Browns.

When we were at Whitney's funeral, we saw her family at work again. I think the Houstons set my father up. They knew all of my father's children were going to be there, that we deserved to be there. That was my father's wife for a very long time. Everybody with him was in Whitney's life for a long time. Yet the Houston family treated us like that, told my father's children we couldn't sit down in the front with my father, where my sister would be sitting. We got called his "entourage" when everybody knew we were her stepchildren.

After we walked out of the church, as we were leaving, Krissi's limo was pulling up. We all got excited because we hadn't seen her in so long and we would have a chance to

make sure she was okay. As we were about to go up to her car, a bodyguard stepped to my father, with his hand on his gun. He said, "Sorry, we've been told not to let you near the car." My father wasn't even allowed to say hello to his own daughter. Everybody in my family and the Houston family knows my father has a good heart and would want to make sure his daughter is okay. If he's not being allowed to do that, someone is stopping him. I think it was Pat Houston or Cissy. I'm not the type of Brown to broadcast my opinion all over the national news, but I have my suspicions.

I've used my music as a way to stay sane through all the craziness and tragedy that's gone on in my family. Having the same name as my father has been both a help and a hindrance. When it's a hindrance I realize it's all in my head. Everything is in my head. The way I look at it, my father built his legacy, now I'm building mine. People can say I have big shoes to fill but I have my own shoes to fill; I'm building my own legacy. His legacy is great; mine will be great too. I won't allow myself to make the mistakes my father made because I learned from them. I thank him for that, being able to learn from him in more than just a positive way. Every time I do music, every day I wake up, I want to better myself as an artist and a man. I don't look at it as a competition between me and my father, I see it as a competition between me and myself as an artist. Of course my father is one of my biggest inspirations; I want to be like him. But I also want to be better than him because I want to be the best.

———

LOSING MY BABY

Raising sons is hard enough, but it's especially hard when you've achieved a certain amount of success in your life and you want your children to hunger for achievements in their own right. For those reasons, I suppose I did treat my daughters differently than my sons. I always felt like the girls needed more attention, more watching over. I was raised by women, so I've always given them more of my time. I was on my own at the age of fourteen, out there in the world, so I guess a part of me felt like my boys should do the same, like throwing the young out of the nest so they can take flight alone.

It's very tricky when you raise children with lots of money around. Coming from the projects, to me money *did* mean everything—it was always a major motivating force in my life. But what happens when that motivator is taken away?

What's going to drive you if you were raised in the suburbs and didn't want for anything? Money can make you soft, entitled, lazy. I wanted to make sure that didn't happen with my boys. I wanted money to make them confident, protective of their family, their sisters. I wanted them to be kings of their castles.

If my son tells me he doesn't want to go to school, he doesn't want to go out and get a job, then at some point that's on him. I'm going to have to take a step back and let him be a man. Before stepping back in, I want to give him a chance to see how a man lives, what a man does.

I still want and need to be in their lives; that's extremely important to me. But at the same time I want to give them the space to explore what it means to be a man. I understand that there may be some hurt feelings from things that happened when they were younger, when perhaps I wasn't paying as much attention as I should have. But what are we going to do now, moving forward? We can't change the past; we can't have a do-over. It's behind us. But how do we move on from there?

I gave my daughters more attention, because I purposely didn't want the boys to be lacking in the toughness I had growing up. I wanted the boys to have some grit, some resiliency. I needed for them to be hungry. Maybe I should have explained it to them a bit more, the method to my madness. Maybe I should have acknowledged the pain that some of this may have been causing. But it was all done for a reason,

a purpose. I didn't want them to feel neglected, but I didn't want them to be too entitled either. All we had to do was look at Krissi to see the dangers of a child being given too much, having too much handed to them.

I am still trying to process the incredible pain I have endured over the past year of my life, from the very moment I got the phone call on January 31, 2015, telling me my daughter was in a coma. Alicia and I were working with a group we had signed, a talented R & B duo named Paul Campbell. We were in the midst of a photo shoot when we found out what had happened to my little girl. Any parents who are reading this who have experienced profound tragedy with their children know the impossible emptiness that you have to fight on a daily basis, the enormous energy it takes just to get out of bed every day.

After I got the news that my daughter had been found unresponsive and submerged in a bathtub in her Roswell, Georgia, town house, I went into a state of paralysis. It was like my body shut down along with Krissi's. I was forcing myself into movement, but at nearly all times my mind was in that Atlanta hospital with my daughter. Tyler Perry was incredibly gracious in offering me and Alicia a ride from Los Angeles to Atlanta in his private jet so that we could get to her as soon as possible. During the trip, he filled us in on his efforts to help get Krissi under control after her mother died. He said he just felt like he had to do something and she was responsive to him, so that led to his offering her an acting

job on his sitcom *For Better or Worse*. He said he was trying to keep her close. Tyler gave Krissi a handful of basic requirements that she had to follow, such as showing up to work on time and being prepared. But she failed to fulfill every single one of his requirements and eventually just drifted away.

When I walked into her room at North Fulton Hospital and saw my baby lying there with tubes and machines connected to her body, I was devastated. At that moment, it all became tragically real to me. My first order of business was to make sure everyone understood that as her father, I would be the one making all the decisions regarding her care. The doctors and staff were all looking to Pat Houston as the official voice of the family, but I had to make sure they knew Pat was just the executor of Whitney Houston's estate. I was the girl's father, her next of kin.

Over the course of several hours we met with doctors, with security, with law enforcement, but there were still a ton of questions about what had happened to my daughter. She was found face down in a bathtub, but they didn't know how long she had been underwater, how long she went without getting oxygen to her brain. We didn't yet know anything about the drugs in her system or the abuse that she had endured. We needed to know who was there with her when this happened—who witnessed all of this? Right away, I made it clear that no matter what, Nick Gordon couldn't be allowed anywhere near my daughter. We said she was to have no more visitors at that time.

When we got a free moment, Alicia and I decided to run over to the hotel and drop off our bags and take showers. We were gone no more than two hours, but when we returned we were shocked to discover that Nick had been let into her room to see her. I was outraged at the lack of respect for my position as her father that had been shown by the Houston family. When I pressed them on it, the lawyer for the Whitney Houston estate explained that Nick had been calling Pat, so they figured if they let him in the room while the lawyer was there, perhaps they could get him to provide more details on what had happened. But that sounded crazy to me. If we suspected that he was somehow to blame for her predicament, then the details were to be gleaned by law enforcement—and the last place he should have been was in her hospital room. How dare the Houstons place their suspect judgment over the wishes of her father? I had to set the tone right away, to let them know that it was their supervision of Krissi and management of her life that had gotten us to this hospital in the first place. This all had happened on their watch. I told Pat, Gary and Donna that now we would be making a huge pivot, changing to my way of doing things. Under the father's watch, Nick Gordon was to be kept far away.

It was the beginning of an extremely difficult six months, having to fight with them on every tiny decision regarding my daughter.

Not long after we arrived, we sat down and talked to the neurologist. He told us that in his medical opinion, North

Fulton Hospital didn't have the necessary equipment to assess and treat Krissi properly. He suggested that we move her to Emory University Hospital, which was more advanced in this particular area. We told him we sincerely appreciated his honesty. But then we were shocked when the Houston family fought us on moving Krissi to Emory. They said it would be tough on security and mentioned all the news media outside the hospital. I was incredulous. I didn't care how many news vans were parked outside—if the doctors said my daughter needed to be moved to get the proper care, why the fuck wouldn't we want to move her?

Things *were* much better at Emory—we could tell that the medical team was more advanced, more knowledgeable about brain injuries. We all became students in Brain Medicine 101, spending many, many hours talking to specialists, reading as much as we could find, researching the latest medical advances.

During those months, we all first stayed in the Atlanta home of Alicia's sister, Kim, who is the founder of the Mixed Chicks hair products company. Then we moved into an apartment in downtown Atlanta. Tyler Perry helped us secure the apartment; he was constantly making sure we weren't in need of anything. He truly was like an angel to our family during this ordeal. He was also an important support for me—a fellow father who could understand what I was feeling and serve as a confidant. I was in such a constant state of dehydration, my body rebelling against the never-

ending tears, the lack of appetite, the depression. I actually had to go to the hospital several times myself so that I could have fluids pumped into my body.

I would sometimes sit very still in the apartment, look out over the city and think about my life, all the twists, turns and traumas that had gotten me to this point. What had I done wrong, what moves did I make, that had put this hex on me, cast my baby into this vegetative state? How much did our behavior—the drugs, the time I spent locked away from her—contribute to what she had become? It was a tough internal dialogue, coming to grips with my own responsibility for how my daughter had turned out. Were there things that she saw in the way I treated her mother that made her more likely to stay in what I knew had to be an abusive relationship? I was wracked with very tough, painful questions.

I tried to remain hopeful, to grab on to the little things that told me there was a chance Krissi could make it out alive. I didn't really care what state she would be in, as long as she was still with me. I was committed to rolling her around in a wheelchair for the rest of her life, sitting down and feeding her every day, by myself, if that's what was necessary. If that's what would keep her in my life. After all the years, this is what it finally took for me to have her around me? That was some cruel stuff.

As I was grappling with my grief, I was also dealing with an incredible amount of anger. The more I found out what

kind of life she was living with Nick Gordon, the things that young man had done to my baby girl, the more I felt like I was on the verge of exploding. We were meeting on a regular basis with the police to get updates on what they had learned. When our lawyer Chris Brown came into town, he began to make inquiries on our behalf. One day he told us he had found out that Pat Houston had taken out a restraining order against Nick.

I was like, *Wait, say that again? What the hell are you telling me?*

So we had a meeting with law enforcement and one of the detectives asked Pat about the restraining order. We were sitting around a table in a conference room—Pat, Gary, Donna, and Pat's brother Ray, who used to do security for Whitney and then had been in charge of Krissi's security. All of them were on the payroll of the Whitney Houston estate and were charged with caring for my child when her mother died. But now Pat recounted a story that I found hard to fathom.

She said that at a birthday party for Krissi, Nick got into it with Gary and Ray, aggressively getting up in their faces in an extremely disrespectful way. Out of respect for Krissi, they tried to play nice and let him leave the house with all his limbs intact. But according to court papers, Nick made threatening comments and posted pictures of guns intended to make Pat fearful for her personal safety. She said that's when her relationship with Krissi became strained, because she told Krissi she couldn't be with the family when

Nick was with her. So she said Krissi stopped communicating with her. And Pat took out the restraining order.

I was outraged and dumbfounded. Crazy thoughts were flying through my head: *Wait, you had a restraining order against Nick and you didn't think it was dangerous for my child to be living with him? And you continued to pay the rent on a condo where he is living with her? And nobody thought it was a good idea to pick up a phone and tell her father?* I had to stop myself from flying across the table and strangling somebody.

It got even worse. At the hospital it was discovered that she had bruises all over her body. And then there were the missing teeth. We saw that she had a couple of front teeth missing. We were told that a tooth had fallen out when they were putting the breathing tube down her throat. But there was a second missing tooth. Pat told the detective that she had received a call from someone telling her that Krissi was missing a tooth. She said she confronted Krissi, who claimed she had fallen in the kitchen.

While we weren't discounting the possibility that Nick had something to do with Krissi's incident in the bathtub, we also wondered whether the car accident she had been involved in just four days before she was found in the bathtub might have had something to do with her brain injuries. Bobbi Kristina lost control of her Jeep one afternoon while driving in Roswell with a female friend and it swerved into oncoming traffic, hitting a Ford Taurus. Even though the driver of the Taurus sustained serious injuries and Krissi's

friend Danyela Da Silva Bradley was hospitalized, Krissi was checked at the scene and sent on her way. We asked the doctors whether she could have suffered some type of brain trauma or hemorrhage that didn't present itself until four days later, resulting in the bathtub incident. But the doctors couldn't really give us definitive answers. They couldn't rule out the possibility that the accident was related but they couldn't say it was, either.

At one point, a doctor at Emory told us that if she were his daughter, he wouldn't continue Krissi's life. We thanked him for his honesty but kindly told him it was our decision and we chose to fight until we had exhausted every single possibility. But it wasn't easy, particularly since we were getting so much negativity from the Houston clan about our decision. I'm not saying they didn't want Krissi to recover, but they were bombarding us with a steady stream of doubt about whether she would ever come out of her coma and suggesting that we should just give up.

I must add that we were seeing what appeared to be steady improvement. After Emory, we moved her to DeKalb Medical, where we hoped she would learn to breathe on her own rather than through the machine. And she would breathe on her own for an extended period, like twenty-four hours, but then she'd start struggling and they'd put her back on the machine. She also was getting physical therapy at DeKalb, where she would sit up in a chair with her eyes open and track my movements around the room with her eyes. We all

would do therapy with her—me, Alicia, Landon, Bobby Jr., Tommy. We would stretch her legs, move her hands, touch her tongue, have her track us with her eyes. For the most part she was responding, exhibiting little movements from time to time that we saw as huge leaps in her development. This is when I announced during one of my shows that she was awake and responding. While these changes might not have been as medically significant as we prayed for, to us they were positive signs that she was on the road to some sort of recovery—certainly better than the alternative. We chose to use these small improvements as a reason to remain hopeful. And her cells were still alive, which was great news after she had suffered such a severe injury, when brain cells will often wither away. We knew her brain had gone quite a long time without oxygen, but we didn't know how long. And we didn't know exactly why it had been deprived of oxygen. Though she was found face down in the tub, there wasn't water in her lungs, meaning she didn't drown. There wasn't blunt-force trauma to her head. There wasn't any indication that she had been choked. So we still had too many questions.

In June, we decided to bring Krissi to Chicago to be evaluated by some of the top neuroscience specialists in the country at Northwestern University. The hope was that they might be able to figure out how to repair the part of her brain that hadn't been responding. We had done quite a bit of research that brought us to the conclusion that Chicago was one of our last hopes for a recovery. My brother,

Tommy, flew with her from Atlanta to Chicago; Pat and I flew to Chicago on different flights. But things didn't go as we had hoped in Chicago. They were much more aggressive in their treatment than we had been led to believe they would be. Krissi had a really bad seizure while she was there. We hadn't seen her responding to treatment so violently up to that point. Before, if her brain was having seizures, we would reduce the treatment levels. But in Chicago the treatment felt much more invasive. Tommy and Pat wanted to stop it and bring her back to Atlanta. I wanted to keep her there and wean her off the medicine at a slower pace. But the doctors in Chicago didn't see it my way, so we brought her back to Atlanta.

After Chicago, things began to move swiftly downhill with Krissi's prognosis. Her body began to shut down and for the first time things were looking grim instead of hopeful. There were far fewer signs of progress for us to hang on to. We had been intent on getting her weaned off the breathing machine, hoping that might eventually lead to our being able to bring her to Los Angeles and ultimately to our home, where we were committed to caring for her around the clock.

During this time I also went to the courts to file all the necessary paperwork so that my status as her guardian couldn't be challenged. This was made much easier by the fact that she had not married Nick; if they had married, I would have had to fight him for control over the decision-making, which likely would have driven me crazy.

Alicia and Cassius were spending so much time in Atlanta that we withdrew him from his school in LA and homeschooled him, with Alicia taking over the responsibility for his kindergarten lessons every day.

Krissi couldn't stay at DeKalb any longer after the Chicago intervention because she was no longer responsive enough to meet their stringent requirements. So we then had to move her to the Peachtree Christian Hospice in Duluth. Because hospices tend to be the end stage, we had to tell them to continue feeding her. To not do so in my mind would have been like pulling the plug. But at some point after she moved to Peachtree, a change occurred in my mental state. After fighting for more than five months, I allowed myself to come to peace with the probability that we would soon be losing my daughter.

At the same time, I was also dealing with the imminent arrival of another child—my daughter, who was inside Alicia's belly, growing bigger every day. In fact, Alicia was so far along in the pregnancy that she went back to LA when we brought Krissi to Chicago and she didn't return to Atlanta when we brought Krissi back because she was no longer allowed to fly. I had a private conversation with Krissi, sitting next to her bed in the hospice, moving my face very close to hers.

"It's okay for you to let go now, baby," I told her. "You've been fighting for a long time. It's all right. You can let go."

I got on a flight to head back to Los Angeles so that I

could accompany Alicia to her final doctor's appointment on a Friday before the C-section birth that was scheduled for the following week on Tuesday. While we were waiting at her doctor's office, Alicia told me she was hungry, so I headed downstairs to get her a sandwich. By the time I had gotten back upstairs with her food, she had been given monumental news: her doctor didn't want to wait until Tuesday to deliver the baby. Rather than wait any longer, the doctor wanted to go ahead and do it. That night.

We went to the hospital, where we were soon joined by Alicia's family. Several hours later, on July 9, 2015, at 8:24 P.M., we welcomed Bodhi Jameson Rein Brown into the crazy Brown clan. I was able to feel moments of pure joy—the first I had felt in a long time—when I held this precious baby in my arms. We had prepared ourselves for the rollercoaster ride that we might be facing, dealing with a new life and a death at the same time. And damn it, my joy turned out to be short-lived. On the third day after Bodhi's birth, the day before Alicia was going to be able to come home with the baby, I got a phone call from the hospice while Alicia was struggling through a shower in the bathroom. It was a nurse, regretfully informing me that Krissi had taken her last breath.

I thought I had prepared myself, but it still felt like my heart had been torn from my chest. I leaned into the bathroom and called to my wife.

"Alicia? She passed," I said.

Alicia came out and hugged me. We sat there on the edge of her hospital bed, sobbing for my daughter, for the unrelenting tragedies of the previous four years, for the cruel sequence of events that had finally brought her back into our lives. Alicia's sister picked me up and drove me to the airport. It was back to Atlanta on a painful, emotional red-eye flight across the darkened skies of America, tripping through memories of my years with Krissi—and the anguish of feeling for so long that she was just beyond my reach.

When I arrived at the hospice, I got another jolt of mind-boggling news: Krissi wasn't dead. The nurse had made an unbelievable mistake. I thought about the nurse's call a few months later when we discovered that one of the "nurses" caring for Krissi wasn't really a nurse at all. Taiwo Sobam-owo, thirty-two, was arrested for fraud, for stealing the identity of another nurse in order to get the job at Peachtree Christian Hospice. At one point she was one of the staff in charge of Krissi's care, but I don't know if she's the nurse who called me.

During the hospital ordeal, there were some crazy things being written in the media and charges being lobbed back and forth. Some of it was led by my sisters, particularly Leo-lah. I come from a large, passionate family and we wear our emotions on our sleeves. Leolah can be loud and brash and I don't always like her timing. And while the Houstons plant stories in the media hiding behind anonymous sources, LeeLee doesn't hide. When she says something, she's going

to put her name on it. Some may want to dismiss her claims as outlandish or extreme, but the substance of her claims shouldn't be dismissed. Some unbelievably ugly, suspicious stuff had gone down over the last few years. I think the Houston family has stayed on the offensive, pointing fingers at us, to keep suspicion and scrutiny away from them. After all, though they continued to try to give the media the impression I was some kind of nefarious character, both Whitney and Krissi had been tragically lost on their watch, not mine.

When I got back to Krissi's side after the birth of Bodhi, I knew that it was just a matter of time before she left us. Her organs were failing and the doctors were telling us she had just a few more days. But she actually hung on for two more weeks. The night she passed, I had another little talk with her.

"I love you, baby girl. And I just want you to know it's okay for you to rest now."

I kissed her, got up and walked out of the room. Within an hour, I got a phone call from another nurse. This time she really was gone. My baby had packed a lot of living into her twenty-two years. As the daughter of two very famous people, it wasn't always easy for her. I just wish I had been there with her and for her in the last few years to help ease her transition to adulthood. Such thoughts will undoubtedly pain me for the rest of my life.

Alicia got on a flight the next day with Cashy and our newborn to join me in Atlanta. Time to plan yet another funeral.

A FEW WORDS FROM LaPRINCIA BROWN

The time we spent in Atlanta with my sister was like going through a long, drawn-out nightmare. Everything was so hard and painful. Not only was it hard to be there because my sister was in the hospital, but it was also hard because I felt certain people were playing politics with my sister. Some of the people on the Houston side were making me uncomfortable. It's almost like they were making the whole ordeal theatrical or something, calling attention to themselves, asking the wrong questions.

My father was distraught, as you can imagine. I felt so bad for him. It seemed like year after year after year, he had something terrible happen. Most people don't go through that much pain in a lifetime. And it was all happening within a few years of his being off narcotics. Sometimes I'd worry that he might revert. But also sometimes I would forget about what he was going through. I'd be thinking, *He needs to do this,* and not understand that he was still struggling with so much. I'd then remember that I needed to take a step back and consider how good he *was* doing.

He and I got a lot of time to talk in those months, since we had to find things to pass the hours and days while we waited. Other than talking, there was TV and there was eating. The Browns are big foodies, so going out as a family to get food would be a big event. But it was all very mentally exhausting. We were all in and out: Bobby Jr. was there, Landon

was there. Alicia and Cassius were there. I went back home to Massachusetts for a week or so and then I'd go back to Atlanta for another couple of weeks. Uncle Tommy was there the whole time.

When Krissi's grandmother Cissy saw my father, she seemed very happy. If there was animosity between them in the past, I feel like she was at peace with it now. There were far more important things for them to worry about. When Krissi finally passed, I was in shock—though we were all preparing ourselves and my father had told us there was nothing else that could be done. Sometimes I wonder if the reality of it all has really hit me yet.

———

I let the Houstons take over most of the planning for the funeral. I was still too distraught to get into the details anyway. The conversations about laying her to rest were unbearable for me, so Donna would communicate primarily with Alicia when she had questions. At the wake, the night before the funeral, I broke down when I saw her body lying there in the casket. It was the first time I had seen her since I walked out of her room at the hospice. She looked so beautiful, so young, so precious. I couldn't believe I would never hear her voice again.

The funeral service was lovely, a fitting memorial for my baby. Even Cissy sang for her. The only sour note was provided by Leolah, who made a scene when Pat went to the mic to talk about Krissi.

"Uh-uh, no, I'm sorry, but I cannot sit here and listen to all these lies!" Leolah cried out. The Houston side all stood up to object, but we handled it right away. I told Leolah that she was out of line and she walked out of the church on her own. The drama was over quickly, so I don't think it marred the service.

Krissi's body was flown from Atlanta to New Jersey, where she was buried in a grave next to her mother. I still haven't been able to visit the grave site. I'm not yet ready to stand there, alive and functioning, knowing my baby's body is under a pile of dirt. Lifeless. Gone.

Maybe one day I will muster the strength to do it.

The administrator for Bobbi Kristina's estate filed a wrongful-death lawsuit against Nick Gordon, alleging that Bobbi Kristina died after he injected her with a toxic mixture and placed her unconscious in a bathtub. The suit was originally filed in June and amended in August after Krissi died. It accuses Gordon of assault, battery, intentional infliction of emotional distress, and transferring $11,000 from her account into his own without authorization. The suit alleges Krissi "died following a particularly violent altercation with [Gordon] that left her battered and bruised, with a tooth knocked out." It alleges Krissi confided to a friend that Gordon "was not the man she thought he was" and made plans to meet on January 31 to discuss the situation further.

Gordon has responded to the lawsuit by denying the allegations, calling them "scandalous" and "improper." But he did admit that he went out partying the night she was found

in the bathtub and that he got into an argument with her after reviewing video footage. He admitted that he changed his clothes after the argument. But he didn't say why he did that.

As of February 2016, there have not been any criminal charges filed against Nick Gordon.

I'm a Brown and the one thing we believe in is family. My entire adult life, my kids have always been a big part of everything, there with me every step of the way. I've tried my hardest to never let anything get in the way of my taking care of and being with my children. That's why it was so hard for me when I felt that people were purposely denying me that relationship with Krissi.

I had Landon when I was just seventeen. That was my exit from New Edition, my point of no return. I was going to move to Los Angeles and I was going to take care of my son; I was going to be there for him no matter what. And that's what I did. My whole life has been based on family. I come from a big, raucous family. We're Browns until the end. We take care of each other, we stand for each other and we protect each other as much as we possibly can. That's what the Browns do. Sometimes we may open our mouths and say dumb shit that doesn't make any sense, sometimes we may speak when we're not being spoken to, but through it all we always have love for each other.

All my kids appreciate that about our family and they all have my back in every way. And they know I have theirs.

That's the one thing that keeps me going, no matter what. My kids. My family. By myself, I'm so fuckin' scared. I'm still this little kid in this big bubble who had a dream of becoming an entertainer and having success and bedding the most beautiful women in the world. And I've done all of that. Losing the love of my life was the hardest thing, but I was able to find someone who gave me the strength to pick myself back up and keep moving on. Then I had to find a way to get through the loss of my child. But I take one day at a time, keep putting one foot in front of the other—and continue to be a strong, loving presence for Landon, LaPrincia, Bobby Jr., Cassius and Bodhi. Not to mention Alicia. That defines me, more than anything else you might have ever heard or read about me.

THE LEGACY OF BOBBY BROWN

There's no doubt that I've had my share of personal trauma in recent years. But through it all, I have retained my desire to entertain. When I'm out in the world, I get such love from my fans that I know I will never be able to walk away from performing. It's my lifeblood; it's what I was born to do.

When I look at the music industry now, compared to where it was when I started, I think I created a style—a fun, energetic, aggressive style that didn't take itself too seriously, a style that definitely influenced male entertainers who came after me. Where I come from, the show was always the most important thing. In New Edition, we didn't bullshit when it came to performing. We started out as young boys and we always knew the recording, awards and money didn't mean a thing if we couldn't perform in front of a crowd. So that was always the top priority. I would hope I've shown entertainers

that they need to have respect for performing live to a crowd and giving them their money's worth.

I've had some health scares, I may not be in the same shape I was when I was twenty, but I'm still the same motherfucker who will give you everything he has, will leave everything out on that stage. I may not be the best singer in the world, I'm not the best dancer in the world, but when I'm up on that stage you're gonna know it is Bobby Brown. They called me the Bad Boy of R & B and I still think that name was accurate. I am that motherfucker who will get up on that stage, who will pull his ass out, who will tell all his critics to kiss it.

After I stopped using drugs, I started to put on weight. When I look in the mirror, I see the belly sitting there, staring back at me. It can be painful when I look back at the videos, watching my skinny self fly around the stage, twisting and grinding at the age of twenty. I hear people calling me names, saying I look like Cedric the Entertainer or Busta Rhymes now. I admit, the talk about my weight does bother me. As I close in on fifty years old, I start telling myself it's too late to get back to the slim, trim Bobby Brown. But I know that's not true. I just have to make the commitment and push myself. When my wife tells me, "Come on, Bobby, you're not old!" I want to respond, "Shiiiit, yes I am." But she's right. I can still do it. One of these days, I'm going to go to the gym, push myself away from the table. One of these days . . .

People need to understand that I love this industry with all my being. Entertainment is what I was bred for, what I was born to do. I don't think there's any entertainer out there who wants this as much as I do, who appreciates entertainment as much as I do and who has the heart and integrity to be genuine with his fans as much as I do. Yes, I might fall short sometimes, and I've gotten mixed up in drugs and alcohol and all of that, but that comes with show business. It comes with the territory. I want people to understand that when I hit that stage, if I'm a beast, then that's my truth. That's what Bobby Brown is. Were you entertained? If you were, that's what matters. Don't keep fucking with me and coming at me with bullshit, just poking at me, because it hurts. I'm still a human being.

In this day and age, the media dissects every inch of your life, everything that has nothing to do with the entertaining. And critics and journalists write all these ridiculous things about me but have no idea of the craziness I went through before I even got into the industry, all the people I've lost—my grandmothers, my friends, my mother, my father, my sister, my ex-wife, my daughter. No one knows what that much tragedy felt like to me. Drugs were a crutch to deal with early pain, and I know now that the pain has to be dealt with in other ways in order for me to be the best I can possibly be. And I'm working on that, on a daily basis.

I've flushed all that bad stuff out of my life now and I'm trying to be better. But the only way I can do that is for

people to leave me alone for a minute. Let me perform. Let me get my shit together on my time, and just support me. Just show up for me and support me, because all I have is my kids, my wife, my family, and entertainment. That's all I got. Peace, I'm outta here. Ghost!

OTHER VOICES

Ralph Tresvant, close friend and New Edition bandmate (pages 58 and 132)

Tommy Brown, older brother and longtime manager (pages 61, 204 and 262)

Kenneth "Babyface" Edmonds, songwriter and producer, *Don't Be Cruel* (page 75)

Marvin "Marvelous" McIntyre, tour manager, *Don't Be Cruel* (page 79)

Malika (Williams) Payne, mother of Bobby's son Landon (page 89)

Leolah Brown, Bobby's sister (pages 151 and 182)

Landon Brown, Bobby's son (pages 162 and 279)

LaPrincia Brown, Bobby's daughter (pages 206, 222, 270 and 313)

Alicia Etheredge Brown, Bobby's wife (page 226)

Bobby Jr., Bobby's son (page 290)

ACKNOWLEDGMENTS

I'd like to thank:

Nick Chiles, my biographer and friend. Without your persistent support this would not have been possible.

HarperCollins and Dey Street Books, for an amazing team that worked very diligently and was sensitive to helping me tell my story my way.

My editor, Carrie Thornton, and assistant editor, Sean Newcott.

Publicists to be reckoned with, Shelby Meizlik and Joseph Papa; and social media and PR specialist, Michael Barrs, with much love and gratitude.

My agents at ICM, Dan Kirschen and Mark Siegel.

My partner in all business, Chris Brown, Esq.

My friends Maxia Barnett and Marselle Washington for the photography.

Special thanks to the following people for their contribution and support:

My wife, Alicia Etheredge-Brown; my brother, Tommy

Brown; my sisters Bethy, Tina, Leolah, and Carol Brown; my sons Landon Brown and Bobby Brown Jr.; my daughter LaPrincia Brown; Malika Williams-Payne; and Kim Ward.

All my true friends who have helped me through the last few years: Stanley and Heidi Freemen; Kelvin Bowers; William Brenson; JR Stafford; and the NE fam.

Blessings and gratitude to Jeanie Griffith; Tyler Perry; Rev. Michael Beckwith; and Michael Houston.

To my family:

My loving wife, Alicia; my children, Landon, LaPrincia, Bobby Jr., Cassius, Bodhi, and (baby); you are my force and light.

To the Etheredges: aunties, uncles, nieces, and nephews, thank you for your love.

To the memory of my loving parents: my mother, Carole, and father, Herbert Brown (Ma and Pop Brown). Your spirits, humor, and everlasting belief in me have carried me through my journey.

To my baby-girl angel, Bobbi Kristina: Daddy loves you and knows you are always guiding me.

And to all the fans: for your support and loyalty I am forever grateful.

And to the little boy in the tree, who's never given up on dreaming big.

ABOUT THE AUTHOR

Bobby Brown is a Grammy Award-winning singer, song-writer, dancer, producer, and actor. Before his solo career, he was the founding member of the iconic R & B group New Edition, which he started as an adolescent in the Orchard Park housing projects in Boston. As a solo artist and as a member of New Edition, Brown has sold over fifty million records worldwide and received accolades at the Grammy Awards and the American Music Awards, as well as a Soul Train Lifetime Achievement Award. He resides in Los Angeles with his wife and children.